Wind from Heaven

Wind From Heaven

John Paul II
The Poet Who Became Pope

MONIKA JABLONSKA

Foreword by Cardinal Stanisław Dziwisz

Dla Barbary i Grzegorza –
Niech Jan Paweł ma Was
w swojej modlitwie i opiece.
Best
Monika Jablonska

Angelico Press

Denver 04/21/2018

First published in Polish
by Wydawnictwo PETRUS
First published in the USA
by Angelico Press 2017
Copyright © Wydawnictwo PETRUS 2015
Copyright © Monika Jablonska 2017
Foreword © Stanisław Cardinal Dziwisz 2017
Epilogue © Krzysztof Dybciak 2017

For information, address:
Angelico Press, Ltd.
4709 Briar Knoll Dr.
Kettering, OH 45429
www.angelicopress.com

Unless otherwise indicated, all the translations in the text from original
Polish sources, including the writings of John Paul II and secondary
works, are by Monika Jablonska and Anna Chodakiewicz Wellisz.

978-1-62138-303-1 pbk
978-1-62138-304-8 cloth
978-1-62138-305-5 ebook

Cover design by Michael Schrauzer
Cover image courtesy of
Servizio Fotografico © *L'Osservatore Romano*

For Marek and Marysia

When the day of Pentecost had come, they were all together in one place. And suddenly a sound came from heaven like the rush of a mighty wind, and it filled all the house where they were sitting. And there appeared to them tongues as of fire, distributed and resting on each one of them. And they were all filled with the Holy Spirit and began to speak in other tongues, as the Spirit gave them utterance.

Acts 2:1–4

* * *

In creating a work of art, an artist articulates his own self to such a degree as to turn his creation into a particular expression of the artist's essence — of who he is and what he is…. For as an artist creates, not only does he bring a work of art into life, but through this act of creation somehow reveals his personality…. Works of art speak of their creators, allow us to understand their inner being, and demonstrate each individual artist's unique contribution to the history of culture.

— Letter of His Holiness Pope John Paul II to Artists (1999)

CONTENTS

ACKNOWLEDGMENTS

THERE ARE MANY PEOPLE TO WHOM I AM GRATEFUL FOR their participation in making this book possible. Thank you for being a part of this journey. I could not appreciate more all those who helped make it happen.

Above all, thank you, Saint John Paul II, for your inspiration, light, and protection. I am honored to write about you and carry your message through the world.

Thank you to my husband Marek and our precious daughter Marysia for your support, love, encouragement, and wisdom. Maria Sophie, I passionately enjoy being your mother, and I thank God for having you in my life.

Austin Ruse, the godfather of my book in the United States, I am grateful for your help in making this book possible. May John Paul II continue blessing you and your family.

Thank you to Anna Chodakiewicz Wellisz for working on this book with me. She has supported me in this project from the beginning. She encouraged me to follow my dream, and she has remained on call to read and add her perceptive "outsider" comments on the manuscript whenever asked.

Thank you to my dear and special friend Irena McLean Laks who believed in this book from the start and supported all my efforts. You really made my dream come true. I couldn't have done it without you, your friendship, love, and having you by my side.

Thank you to Lady Blanka Rosenstiel for your unstoppable friendship, generosity, and support. Words cannot express the depth of my gratitude for everything you did for me. I am so grateful and so happy to have you in my life as aunt, friend, and mentor.

Thank you to my parents Marian and Małgorzata Jabłoński for your love and support. Thank you for creating a warm, happy, and loving home for me and Michał, and for raising us with God always present in our lives. You were my open-window to the world through so many years.

Thank you to my brother Michał for being by my side always.

Thank you to my parents-in-law Witold and Agnieszka Chodakiewicz, who welcomed me to their family with open hearts.

Thank you to my beloved family: Anna and Chris Wellisz and the children; Hela Chodakiewicz; Monika and Jerzy Kamiński and the children; Marek Kalinowski; Dariusz and Krystyna Jabłoński and the children; and Leszek and Bogusława Jabłoński and the children. Thank you to my grandparents: Alfred and Stanisława Kalinowski; and Andrzej and Daniela Jabłoński.

Thank you to my wonderful friends Alex and Jola Wilk, who created a home away from home for me and my family, and who bring joy and happiness into my life.

Thank you to my dear friends who laugh, travel, talk, work, and joke with me: Alexandra Siwiec, Anna Marszałek, Marek Skulimowski, Krystyna Aldridge-Holc, Alicja Skrzypczak, Katarzyna Bosne, Anna Zalewska, Magdalena Poduszczak, Wanda Wadowska, Cheryl Cohen, David Tobon, Denise Pentimone, Edyta Roy, Marta Żmuda Trzebiatowska, Kamil Kula, Bruno Kula, and Ashley Weichert.

Thank you to John and Susan Lenczowski for your support and warm welcome in Washington D.C.

Thank you to Mike Reagan, Paul Kengor, Melissa and John O'Sullivan, David Fagerberg, Tracey Rowland, Kevin Vost, Krzysztof Dybciak, and Cardinal Stanisław Dziwisz for your trust in my book project and all your help.

Thank you to John Riess and the entire Angelico Press team for this beautiful journey. John, thank you for your good heart, experience, friendship, and enthusiasm for this project. Thanks also to Kari Riess for her patience and support.

Thank you to the *Nurture the World* team, the Kosciuszko Chair, and the Institute of World Politics.

Thank you to all who are a part of my past, present, and future.

FOREWORD

WIND FROM HEAVEN: JOHN PAUL II—THE POET WHO BECAME Pope offers a unique perspective on the life and literary output of John Paul II. The book paints a portrait of Karol Wojtyła as a great writer, an intellectual, a man of extraordinary sensitivity and wisdom. He was not only the world's spiritual shepherd, but also a humanist. Seriousness of tone, mature authorial voice, and deep respect for the reader permeate his poetry and prose.

Pope John Paul II reveals himself as a thinker of great spirit, an actor, a linguist, and a formidable and erudite writer. The essence of St. John Paul II's literary originality lies in his ability to deepen the significance of the written word; his writings imbue every aspect of life with meaning.

It is fortunate indeed that there is finally a book which tries to capture this particular aspect of the Polish pope's life and artistic expression. May the reader enjoy and profit from it.

His Eminence STANISŁAW CARDINAL DZIWISZ
Archbishop of Cracow

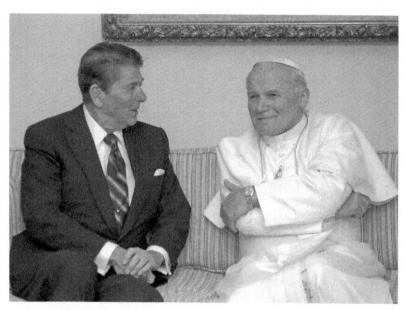

President Reagan meeting with Pope John Paul II in Fairbanks, Alaska.
May 2, 1984. Courtesy Ronald Reagan Library.

PROLOGUE

Ronald Reagan and John Paul II: The Friendly Alliance

POPE JOHN PAUL II ONCE SAID, "IN THE DESIGNS OF PROVidence, there are no mere coincidences."[1] That is one way to explain why a Polish pope, dedicated above all to defending the dignity of the human person, would step onto the world stage just as the most powerful country on earth was about to elect a president unwaveringly committed to the cause of freedom.

Pope John Paul II and President Ronald Reagan were both men of the theater. One became the spiritual leader of the world, the other the political leader of the free world. Theater has the potential to transcend the art of the

1 G. O'Connor, *Universal Father: A Life of John Paul II* (New York: Bloomsbury, 2005), 253.

word and gesture, and become the art of the Word. Both men recognized this instinctively. In their own way, they used the power of the Word to confront evil. It took moral courage to do so, but the evil confronting them was easy to identify — it had a face and a name. It was a totalitarian communist system that denied the existence of God and thrived only where human dignity was violated. The pope and the president fought that evil by refusing to compromise with it, and by speaking simply and clearly about what they stood for. Theirs was the theater of "But let your communication be, Yea, yea; Nay, nay: for whatsoever is more than these cometh of evil." [2]

The two great men are no longer with us, but our need for moral clarity and moral leadership remains. The world, however, seems different. While we feel that our values — Christian values, such as freedom of conscience and the traditional family — are being threatened, the *nature* of the threat is less obvious, precisely because the power of the Word — indeed, of any word — is being questioned. We are now battling confusion and obfuscation rather than a well-defined ideology. Various "isms" may seem to have disappeared, but the pernicious ideas they represented are still here, hiding behind new, more benevolent-sounding words. The result is moral chaos and uncertainty of values. Looking to St. John Paul II, as President Ronald Reagan did when the two first met in the Vatican and discovered their shared convictions, can help us rediscover the legacy of courage, hope, and freedom left for us by these two extraordinary leaders with such a sense of purpose. Let our own words be likewise yes and no.

* * *

On June 4, 1981, during Ronald Reagan's meeting with Mother Teresa of Calcutta, she said: "Mr. President Reagan, do you know that we stayed up for two straight nights praying for you after you were shot? We prayed very hard for you to live.... You have suffered the passion of the cross and have received grace. There is a purpose to this. Because of your suffering and pain you will now understand the suffering and pain of the world.... This has happened to you at this time because your country and the world need you." [3]

A year earlier, Ronald Wilson Reagan had been sworn in as the 40th President of the United States of America. He became the head of state at just the

2 Matthew 5:37.

3 L. Barett, *Gambling with History: Ronald Reagan in the White House* (New York: Doubleday, 1983), 124.

time when the world was looking for a strong leader who could fight against communism. Reagan was perfect for the role. He brought wisdom, values, a sense of humor, and confidence. He also refocused America's attention on God.

Bill Clark, Reagan's second national security adviser, remarked that "Reagan 'greatly' sympathized with Poland for a number of reasons; among them, no other country lost as high a percentage of its population in World War II." [4] The president knew that the Poles had endured almost 50 years of totalitarianism, first under the Nazis and then under the Soviets. Reagan "blasted this 'communistic atheism' that had preyed on Poland following World War II." [5]

Reagan considered communism a moral evil, an offense to human dignity, and a danger to freedom. He denounced fascism and communism, insisting that both denied the existence of God and those God-given liberties "that are the inalienable right of each person on this planet." [6] He believed that communist regimes were not "just another form of government ... but a monstrous aberration." [7]

The president had no doubt that one day "the wall around the atheistic communism is destined to come down within the Divine Plan because it lives a lie." He also knew that "in Poland, Communists picked a bad place to try to further their atheistic empire. Poland is a homogenous nation, with a population 95-percent ethnic Polish and Roman Catholic. The nation is an unshakable bastion of Catholicism. The routine Communist war on religion was a tall task there." [8]

According to Peter Schweizer, "Reagan was certainly mindful of the role the Church could play in bringing freedom to Poland." [9] He trusted that Poland, with its strong Church and unique commitment to God, would defeat the communist regime. In 1978 Poland received a great boost from God when

4 P. Kengor, *Crusader: Ronald Reagan and the Fall of Communism* (New York: Harper-Collin, 2006), 87.

5 Ibid., 88.

6 R. Reagan, Remarks to the People of Foreign Nations on New Year's Day, January 1, 1982, http://www.presidency.ucsb.edu/ws/index.php?pid=42242.

7 P. Schweizer, *Victory: The Reagan Administration's Secret Strategy That Hastened the Collapse of the Soviet Union* (New York: Atlantic Monthly Press, 1994), 13.

8 G. Simon, "The Catholic Church and the Communist State in the Soviet Union and Eastern Europe," in *Religion and Atheism in the USSR and Eastern Europe*, ed. B. R. Bociurkiw and J. W. Strong (London: Macmillan, 1975), 212–13.

9 P. Schweizer, *Reagan's War: The Epic Story of His Forty-Year Struggle and Final Triumph over Communism* (New York: Random House, 2002), 173.

John Paul II became pope. "It has been a long time since we've seen a leader of such courage and such uncompromising dedication to simple morality—to the belief that right does make might." [10] An astute observer remarked that "to Reagan, this pope represented the best of both worlds—unwavering faith in God and strident anti-Communism." [11]

The declaration of martial law in Poland on December 13, 1981, was a turning-point for the Reagan administration. The first concrete response came on January 20, 1982, when the president officially designated January 30 as Solidarity Day in the United States, a time for Americans to show "special affinity" with Solidarity. Reagan exhorted "the people of the United States, and free peoples everywhere, to observe this day in meetings, demonstrations, rallies, worship services, and all other appropriate expressions of support. We will show our solidarity with the courageous people of Poland." [12]

Almost three weeks before Ronald Reagan met John Paul II, the President signed secret national security decision directive NSDD 32. "The primary purposes of NSDD 32 were to destabilize the Polish government through covert operations involving propaganda and organizational aid to Solidarity; the promotion of human rights, particularly those related to the right of worship and the Catholic Church; economic pressure; and diplomatic isolation of the communist regime." [13]

On June 7, 1982, Ronald Reagan and John Paul II met for the first time, at the Vatican Library, where they talked for about an hour. "It is almost certain that both men were entirely candid. Each saw the other as a natural ally, and this could have been their only opportunity to compare notes in person.... What was important—and it turned out to be very important—was that Reagan had convinced the pope that he was sincerely committed to peace and disarmament and that these commitments would shape his policy." [14]

In spite of their differences, Reagan and John Paul II had much in common. They both detested Marxism and the Soviet Union. "They both believed that

10 *Reagan, In His Own Hand: The Writings of Ronald Reagan That Reveal His Revolutionary Vision for America*, ed. K. Skinner, A. Anderson, and M. Anderson (New York: Touchstone, 2002), 176–77.

11 Fr. Robert A. Sirico, "The Cold War's Magnificent Seven; Pope John Paul II: Awakener of the East," *Policy Review*, no. 59 (Winter 1992), 52.

12 R. Reagan, *Proclamation 4891—Solidarity Day* (Washington, DC, 1982).

13 C. Bernstein, "The Holy Alliance," *Time*, June 24, 2001, 4.

14 J. O'Sullivan, *The President, the Pope, and the Prime Minister: Three Who Changed the World* (Washington, DC: Regnery, 2008), 180.

Communism was a moral evil, not simply wrong-headed economics. They were both confident of the capacity of free people to meet the Communist challenge. Both were convinced that, in the contest with Communism, victory, not mere accommodation, was possible. Both had a sense of the drama of late twentieth-century history, and both were confident that the spoken word of truth could cut through the static of Communism's lies and rouse people from their acquiescence to servitude." [15]

Both men had survived assassination attempts. "On May 13, 1981, John Paul was struck by two bullets fired by Mehmet Ali Agca.... In fact, the attempted assassination of Reagan on March 30, 1981, came even closer to success than Agca's shooting of the pope.... Like John Paul, Reagan came within an inch of death." [16]

Both men were horrified by the prospect of atomic war. "Both were close to being nuclear pacifists; they reluctantly tolerated nuclear weapons as a temporary deterrent only until a defense against them could be found." [17]

Both opposed the decision of the Yalta Conference, which consigned half of Europe to the communist yoke. "Reagan and John Paul II refused to accept a fundamental political fact of their lifetimes: the division of Europe as mandated at Yalta and the communist dominance of Eastern Europe.... [As Reagan put it,] 'We both felt that a great mistake had been made at Yalta and something should be done.'" [18]

Finally, they both were actors, men of the theater. Both believed in the power of the spoken word: the word that could shape lives and destinies, and change minds and hearts. "The fact that they were both actors made a great difference — not only in terms of communication skills, but even more importantly in shaping how both men looked at the human condition and its possibilities. The president and the Pope never discussed their respective theatrical careers in any depth. They didn't have to. Each recognized in the other a shared sense of the drama of late 20th-century life and of Communism's role in that drama." [19]

15 G. Weigel, *Witness to Hope: The Biography of Pope John Paul II* (New York: Harper Perennial, 2004), 441.

16 O'Sullivan, *The President, the Pope and the Prime Minister*, 66–67, 71.

17 Ibid., 239–40.

18 Bernstein, "The Holy Alliance," 1.

19 G. Weigel, "The President and the Pope," *National Review*, April 2, 2005, http://www.nationalreview.com/article/214067/president-and-pope-george-weigel.

Reagan and John Paul II would prove to be arguably the greatest men on the world stage of the second half of the twentieth century. But, most importantly, both men's religious faith gave them a strong common ground on which to fight against communism. Both believed they were called by God to defend the world's freedom. In 1982, John Paul II insisted that America was "called, above all, to fulfill its mission in the service … of those indispensable conditions of justice and freedom, of truth and love that are the foundations of lasting peace." [20]

Reagan himself had been raised Protestant. But he was culturally a Catholic on account of his Irish Catholic father. Reagan's "belief in God was a key source of his optimism and boldness, his daring and self-security, and his confidence; these essential intangibles carried him throughout his presidency — and career as a whole — and enabled him to achieve what he did." [21] His spirituality, belief in the power of prayer, and belief in the application of religious principles to policy, all shaped his presidency. In his *Lessons My Father Taught Me*, the president's son Michael Reagan recalls:

> Dad viewed prayer as a key ingredient in healthy relationships. I know he prayed daily for each of his four children. As president, he prayed that his political relationships would work smoothly so that he, his allies, and his opponents could work together for the good of the nation…. On January 29, 1985, Dad proclaimed a National Day of Prayer. In his proclamation, he said, "Today our nation is at peace and is enjoying prosperity, but our need for prayer is even greater. We can give thanks to God for the ever-increasing abundance He has bestowed on us, and we can remember all those in our society who are in need of help, whether it be material assistance in the form of charity or simply a friendly word of encouragement. We are all God's handiwork, and it is appropriate for us as individuals and as a nation to call on Him in prayer." [22]

The first meeting between John Paul II and Ronald Reagan was very

20 R. Reagan, Remarks Following a Meeting With Pope John Paul II in Vatican City, June 7, 1982, http://www.presidency.ucsb.edu/ws/index.php?pid=42610.

21 P. Kengor, *God and Ronald Reagan: A Spiritual Life* (New York: HarperCollins, 2004), 175.

22 M. Reagan, *Lessons My Father Taught Me: The Strength, Integrity, and Faith of Ronald Reagan* (Florida: Humanix Books, 2016), 222–23.

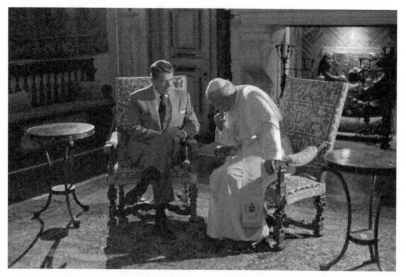

President Reagan meeting with Pope John Paul II at the Vizcaya Museum in Miami, Florida. September 10, 1987. Courtesy Ronald Reagan Library.

important for each of them: "both men displayed a calm but settled determination to trust their own instincts rather than the conventional wisdom of those in Washington and the Vatican who imagined themselves more realistic about world affairs."[23] They discussed many subjects during their first meeting, among them the assassination attempts. "They both believed they had survived the attacks, which occurred six weeks apart, because God had saved them for a special mission — a special role in the divine plan of life."[24]

Cardinal Laghi, then the apostolic delegate to Washington, DC, relates that Reagan said to the pope: "Look how the evil forces were put in our way and how Providence intervened."[25] The two men shared the belief, William Clark noted, that "atheistic communism lived a lie that, when fully understood, must ultimately fail."[26] Each was successful in translating a personal vision into an underlying policy, and implementing the strategy to defeat

23 Weigel, "The President and the Pope."

24 P. Kengor and P.C. Doerner, *The Judge: William P. Clark, Ronald Reagan's Top Hand* (San Francisco: Ignatius Press, 2007), 172.

25 Kengor, *God and Ronald Reagan*, 210.

26 "The Pope and the President, A Key Adviser Reflects on the Reagan Administration," a profile/interview with Bill Clark, *Catholic World Report* (November, 1999), and Bernstein, "The Holy Alliance," qtd. in P. Kengor and P. Doerner, op. cit., 172.

Soviet aggression and oppression.[27] According to journalist Carl Bernstein, "in that meeting, Reagan and the Pope agreed to undertake a clandestine campaign to hasten the dissolution of the communist empire.... Both the Pope and the President were convinced that Poland could be broken out of the Soviet orbit if the Vatican and the U.S. committed their resources to destabilizing the Polish [Communist] government and keeping the outlawed Solidarity movement alive after the declaration of martial law in 1981." [28] The American politician and the Roman pontiff alike strongly believed that Solidarity could tear the Iron Curtain and overturn communism. "Reagan and the Pope translated their divine mission into a practical mission to maintain Solidarity." [29]

In fact, communism would indeed collapse. According to a cardinal who was one of the pope's closest collaborators, "Nobody believed the collapse of communism would happen this fast or on this timetable. But in their first meeting, the Holy Father and the President committed themselves and the institutions of the Church and America to such a goal. And from that day, the focus was to bring it about in Poland." [30]

The meeting of two powerful minds brought significant change into the world. "Reagan and John Paul certainly cooperated to help free Poland and Eastern Europe from Communism. But there is an explanation for this cooperation that is far more plausible than a 'conspiracy' or 'deal': both Reagan and John Paul II were firmly anti-Communist, and they saw the Polish and European situations in much the same way." [31] As George Weigel put it: "if there was neither alliance nor conspiracy, there was a common purpose born of a set of shared convictions." [32] On one occasion, the pontiff remarked: "Everybody knows the position of President Reagan as a great policy leader in world politics. My position was that of a pastor, the bishop of Rome, of one with responsibility for the Gospel, which certainly contains principles of the moral and social order and those regarding human rights.... The Holy See's position, even in regard to my homeland, was guided by moral principle." [33]

27 Ibid.
28 Bernstein, "The Holy Alliance," 1.
29 P. Kengor, *God and Ronald Reagan*, 211.
30 Bernstein, op. cit., 35.
31 O'Sullivan, *The President, the Pope, and the Prime Minister*, 181.
32 G. Weigel, "The President and the Pope."
33 O'Sullivan, op. cit., 182.

The faith of Ronald Reagan and John Paul II had a profound effect on how they lived, what they did, and how they changed the world. Today we can look into the past and clearly see that the people trapped behind the Iron Curtain, for all their courage, could not defeat evil by themselves. They needed powerful champions in the free world to support them in their struggle and give them strength and hope, something both John Paul II and President Reagan understood. They also knew that "neither the Pope's soft-power revolution nor Reagan's hard-power challenge could have done the job by itself. Each needed the other. Together, they provided the keys to victory. Without formal coordination, even without very much discussion between the principals, Reagan and John Paul pursued, with astonishing success, parallel courses toward the same end: the defeat of Communism and the restoration of east-central Europe to freedom." 34

John Paul II and Ronald Reagan — may your moral clarity keep inspiring us!

34 Weigel, "The President and the Pope."

PART I

In the Hands of a Merciful Providence

ONE

Crossing the
Threshold of Homeland[1]

*Let your Spirit come! Let your Spirit come and renew the face of
the Earth. This earth!*[2]

JOHN PAUL II, Pentecost Sunday 1979

IN 1979, WHEN JOHN PAUL II EMBARKED ON HIS FIRST APOS-
tolic visit to Poland, the nation was entrenched in its struggle against the
Communist regime. "What we refer to as Communism has its own history.
It is the history of protest in the face of injustice, as I recalled in the encyclical
Laborem Exercens — a protest on the part of the great world of workers, which
then became an ideology."[3]

John Paul II had personal experience of the reign of ideologies of evil; he
knew that evil is always the absence of good, and that good has its foundation
in God alone. What is the root of the ideologies of evil? "The answer is simple,"
he wrote. Communism is in fact an ideology founded upon "the rejection of
God *qua* Creator, and consequently *qua* source determining what is good and
what is evil. It happens because of the rejection of what ultimately constitutes
us as human beings, that is, the notion of human nature as a 'given reality';
its place taken by a 'product of thought' freely formed and freely changeable
according to circumstances."[4]

1 This chapter is dedicated to the author's Polish friends.

2 Homily of His Holiness John Paul II, Victory Square, Warsaw, June 2, 1979 (Libreria
Editrice Vaticana, 1979), https://w2.vatican.va/content/john-paul-ii/en/homilies/1979/documents/
hf_jp-ii_hom_19790602_polonia-varsavia.html.

3 John Paul II, *Crossing the Threshold of Hope*, trans. Jenny McPhee and Martha McPhee
(New York: Alfred A. Knopf, 1994), 130–31.

4 John Paul II, *Memory and Identity: Conversations at the Dawn of a Millennium* (New
York: Rizzoli, 2005), 12.

The atmosphere in Poland at the time was tense. The Poles demanded their daily bread, social justice, and the right to freedom. A lost people yearned for a shepherd, and John Paul II was clearly their choice. Among the Polish people there was, from the moment he was elected, a sense of inevitability about the pope's visit to passionately Catholic Poland. However, organizing the pope's pilgrimage to his native country proved a complicated task, for the Communist government strenuously objected to the visit.

> The Kremlin had done all it could to prevent John Paul II from returning to Poland. For days Brezhnev kept repeating the same mantra: "That man will bring nothing but trouble!"... Moscow was absolutely opposed to this trip. Then there was the Polish regime, and that gave rise to another problem. You have to remember that Saint Stanislaus, Poland's first saint, was killed by a tyrannous king for having defended the people.... So the regime was terrified at the thought that the papal visit might coincide with the ninth centenary of the saint's martyrdom. [5]

Nonetheless, at 10:07 a.m. on June 2, 1979, John Paul II landed on Polish soil on the Italian airliner *Citta di Bergamo* for a ten-day visit. "He was the first Pope ever to set foot in a Communist country. And he was doing so in June 1979, at a time when Europe's heart was still rent in two by the Iron Curtain. Indeed, the whole world was divided ideologically. The international order, governed by the conflict between two superpowers — the United States and the Soviet Union — was based *de facto* on a balance of terror, on the mutual fear of the possible outbreak of nuclear war." [6]

In his opening remarks at the Okęcie airport in Warsaw, the Pope saluted his nation, his countrymen, and foreign guests:

> I am coming to you as a son of this land, of this nation, and also, by the inscrutable designs of Providence, as a Successor of Saint Peter in the See of Rome.
>
> ...
>
> I wish my stay in Poland to help to strengthen this unflagging will to live

5 Cardinal Stanislaw Dziwisz, *A Life with Karol: My Forty-Year Friendship with the Man Who Became Pope*, trans. Adrian J. Walker (New York: Doubleday, 2008), 115.
6 Ibid., 114–15.

on the part of my fellow-countrymen in the land that is our common
mother and homeland. May it be for the good of all the Poles, of all the
Polish families, of the nation, and of the State. May my stay — I wish to
repeat it once again — help the great cause of peace, friendship in relations
between nations, and social justice.[7]

During the same speech, the Holy Father also quoted the great Polish
romantic poet Cyprian Kamil Norwid's tribute to the Polish people: "out
of respect for heaven's gifts, people gather up every crumb that falls to the
ground."[8] Citing Polish Romantic poets became something of a rule when
John Paul II spoke in his homeland.

Thousands of pilgrims from all over Poland and the world were on hand
to witness the Pope's visit. Pictures of John Paul II were displayed in windows;
people waved flags and carried flowers as they sang and chanted joyously.
It was as if Poland were indeed reborn. As American religious and cultural
commentator George Weigel remarked in his *Witness to Hope*, "No hero in
Polish history — not King Jan III Sobieski, not Tadeusz Kościuszko, not Józef
Piłsudski — had ever entered Warsaw as John Paul II did on June 2, 1979."[9]

Following a visit to St. John's Cathedral, the Holy Father met with the First
Secretary of the Communist party, Edward Gierek, and other dignitaries at
the Belvedere Palace in Warsaw. The Pontiff explained that he arrived at "the
invitation of the Polish Episcopate, which expresses the will of the Catho-
lic society in our motherland."[10] The Pope had some strong words for the
Communist officials:

We Poles feel in a particularly deep way the fact that the *raison d'être*
of the State is the sovereignty of society, of the nation, of the mother-
land.... We can never forget that terrible historical lesson — the loss
of the independence of Poland from the end of the eighteenth century

7 Address of His Holiness John Paul II, Okęcie airport, Warsaw, June 2, 1979 (Libreria Editrice
Vaticana, 1979), https://w2.vatican.va/content/john-paul-ii/en/speeches/1979/june/documents/
hf_jp-ii_spe_19790602_polonia-varsavia-okecie-arrival.html.

8 Ibid.

9 Weigel, *Witness to Hope*, 292.

10 Address of His Holiness John Paul II to authorities of the Polish government, Warsaw,
June 2, 1979 (Libreria Editrice Vaticana, 1979), http://w2.vatican.va/content/john-paul-ii/en/
speeches/1979/june/documents/hf_jp-ii_spe_19790602_polonia-varsavia-autorita-civili.html.

until the beginning of the twentieth. This painful and essentially negative experience has become as it were a new forge of Polish patriotism. For us, the word "motherland" has a meaning, both for the mind and for the heart, such as the other nations of Europe and the world appear not to know, especially those nations that have not experienced, as ours has, historical wrongs, injustices and menaces. [11]

At the same time, John Paul II expressed his support for the primate of Poland, Stefan Cardinal Wyszyński: "For this activity the Church does not desire privileges, but only and exclusively *what is essential for the accomplishment of her mission*. And it is this objective that orientates the activity of the Episcopate, which has now been led for more than thirty years by a man of rare quality, Cardinal Stefan Wyszyński, Primate of Poland." [12]

Finally, the pope emphasized to the communist dignitaries the depth of his concern for, and commitment to, his native land:

> Gentlemen, permit me to continue to consider this good as my own, and to feel my participating in it as deeply as if I still lived in this land and were still a citizen of this State.
>
> And with the same, or perhaps even with increased intensity by reason of distance, I shall continue to feel in my heart everything that could threaten Poland, that could hurt her, that could be to her disadvantage, that could signify stagnation or a crisis. Permit me to continue to feel, to think, and to hope thus, and to pray for this.
>
> It is a son of the same motherland who is speaking to you. Particularly near to my heart is everything in which solicitude is expressed for the good and for the consolidation of the family and for the moral health of the young generation. [13]

Afterward, the Holy Father proceeded to Victory Square in the city center to celebrate Mass, with an estimated million faithful participating, while many more tuned in on their TVs and radios. As G. F. Svidercoschi observed, "And that service, which was attended by a flood of people, was like an image of

11 Ibid.
12 Ibid.
13 Ibid.

the explosive event that Cardinal König said was nothing less than a political earthquake. An apparently indestructible system, which had enforced its atheistic creed unopposed during more than thirty years of absolute rule, was suddenly forced to be the mute and powerless witness of the symbolic collapse of its ideology, its power, and, one might even say, its spell." [14]

Holy Mass in Victory Square took place the day before the feast of Pentecost, the birthday of the Church. One of the most memorable moments occurred when John Paul II declared that in the wake of Pentecost, "Christ cannot be kept out of the history of man in any part of the globe, at any longitude or latitude of geography." [15] And yet that is precisely what the Soviet-backed government had been trying to impose upon Poland. They wanted to remove Christ from people's lives. Nonetheless, as the pope reminded his audience:

> To Poland the Church brought Christ, *the key to understanding that great and fundamental reality that is man*....
>
> Without Christ it is impossible to understand the history of Poland, especially the history of the people who have passed or are passing through this land.... The history of people. The history of the nation is above all the history of people. And the history of each person unfolds in Jesus Christ. In him it becomes the history of salvation. [16]

The words of the Holy Father sounded a clear challenge to atheism and communist mendacity.

At long last the pope invoked the Holy Spirit:

> And I cry—I who am a son of the land of Poland and who am also Pope John Paul II—I cry from all the depths of this Millennium, I cry on the vigil of Pentecost:
>
> > Let your Spirit come.
> > Let your Spirit come,

14 Dziwisz, *A Life With Karol*, 106.

15 Homily of His Holiness John Paul II, Victory Square, Warsaw, June 2, 1979 (Libreria Editrice Vaticana, 1979), https://w2.vatican.va/content/john-paul-ii/en/homilies/1979/documents/hf_jp-ii_hom_19790602_polonia-varsavia.html.

16 Ibid.

and renew the face of the Earth,
the face of this earth.

Amen. [17]

From Warsaw the Pontiff proceeded to Gniezno, the cradle of Poland's Christianity. There he preached about the rights of man and of nations. He talked about human solidarity. He recalled the history of the Christianization of the nations of East-Central and Southern Europe.

During Mass in Gniezno — Poland's ancient capital, where the country was "inserted into the mysteries of the divine life through the sacraments of baptism and confirmation" [18] — John Paul II continued to weave together the history of his homeland and the Church:

> Once again the day of Pentecost has come and we are spiritually present in the Jerusalem cenacle, while at the same time we are present here in this cenacle of our Polish Millennium, in which we hear as forcefully as ever the voice of the mystery-filled date of that beginning from which we start to count the years of the history of our motherland and of the Church that has been made part of it. The history of Poland ever faithful. [19]

The feast of Pentecost that year marked a return to history and unity for all of Europe. Just as the Apostles, filled with the Holy Spirit, spread to all the Word of the Gospel, thanks to the gift of tongues, so the Polish pope, who would become known for speaking to all the faithful in their own tongues, could communicate directly with his own Slavic people, with nothing lost in translation. The pope spoke as though he knew that through him the Holy Spirit was about to remake the world, to free the oppressed from fear and give them courage to come forth and speak truth to earthly power. He remarked: "We cannot fail to hear also — as well as the language of our own forefathers — other Slavic languages and related languages, languages in which

17 Ibid.
18 Homily of His Holiness John Paul II, Cathedral of Gniezno, June 3, 1979 (Libreria Editrice Vaticana, 1979), https://w2.vatican.va/content/john-paul-ii/en/homilies/1979/documents/hf_jp-ii_hom_19790603_polonia-gniezno-cattedrale.html.
19 Ibid.

there then began to be heard the voice of the cenacle that was opened wide to history."[20] It was in Gniezno, the site of Poland's baptism, that John Paul II deliberately turned to "the other" Europe, the lands under Soviet occupation lying between the Baltic, the Adriatic, and the Black Sea. His mission was directed towards them — as also towards the whole European continent, which had yet to become one and free:

> Is it not Christ's will, is it not what the Holy Spirit disposes, that this Polish Pope, this Slavic Pope, should at this precise moment manifest the spiritual unity of Christian Europe?
>
> …
>
> Perhaps that is why Christ has chosen him, perhaps that is why the Holy Spirit has led him — in order that he might introduce into the communion of the Church the understanding of the words and of the languages that still sound strange to the ear accustomed to the Romance, Germanic, English, and Celtic tongues.
>
> …
>
> He comes here to point out the paths that in one way or another lead back towards the Pentecost cenacle, towards the Cross and Resurrection. He comes here to embrace all these peoples, together with his own nation, and to hold them close to the heart of the Church, to the heart of the Mother of the Church, in whom he has unlimited trust.[21]

During a subsequent meeting with young people, the Holy Father spoke about "Bogurodzica," or "Mother of God," a medieval Polish hymn to the Blessed Mother: "The most ancient monument of Polish literature is the 'Bogurodzica' — 'Mother of God.' Tradition makes its origin go back to Saint Wojciech (Adalbert). The history of literature enables us to place in the fifteenth century the date of the oldest texts of this *song-message*. I call it a song-message because the 'Bogurodzica' is not only a song but also a profession of faith, a Polish *credo*; it is a catechesis and even a document of Christian education. The principal truths of faith and the principles of morals are contained in it. It is not merely a historical object. It is a document of life."[22]

20 Ibid.
21 Ibid.
22 Address of His Holiness John Paul II to the Young People of Gniezno, June 3, 1979 (Libreria

John Paul II's understanding of culture occupies a central position in his papal teaching. Weigel describes this understanding in the following terms: "History is driven, over the long haul, by culture — by what men and women honor, cherish, and worship; by what societies deem to be true and good and noble; by the expression they give to those convictions in language, literature and the arts; by what individuals are willing to stake their lives on." [23] In his address to Polish youth at Gniezno, John Paul II goes further: "Culture is above all a common good of the nation. Polish culture is a good on which the spiritual life of Poles rests. It distinguishes us as a nation. It is decisive for us throughout the course of history, more decisive even than material power. Indeed, it is more decisive than political boundaries. The Polish nation, as is well known, passed through the hard trial of the loss of its independence for over a hundred years. And in the midst of this trial it preserved its own identity. It remained spiritually independent because it had its own culture." [24]

Częstochowa was the next recipient of a papal visit, made on June 4. John Paul II began his sermon at the Jasna Góra ("Bright Mountain") Shrine with an invocation borrowed from Romantic poet Adam Mickiewicz's *Lord Thaddeus*: "Holy Mother, you guard bright Częstochowa…." He soon continued:

> Jasna Góra has shown itself as an inward bond in Polish life, a force that touches the depths of our hearts and holds the entire nation in the humble yet strong attitude of fidelity to God, to the Church, and to her hierarchy.
>
> …
>
> One must listen in this holy place in order to hear the beating of the heart of the nation in the heart of the Mother. For her heart beats, we know, together with all the events of history, with all the happenings in our national life: how many times, in fact, has it vibrated with the laments of the historical sufferings of Poland, but also with the shouts of joy and victory! The history of Poland can be written in different ways; especially

Editrice Vaticana, 1979), https://w2.vatican.va/content/john-paul-ii/en/speeches/1979/june/documents/hf_jp-ii_spe_19790603_polonia-gniezno-giovani.html.

23 G. Weigel, *The Cube and the Cathedral: Europe, America, and Politics without God* (New York: Basic Books, 2005), 30.

24 Address of His Holiness John Paul II to the Young People of Gniezno.

in the case of the history of the last centuries, it can be interpreted along different lines. But if we want to know how this history is interpreted by the heart of the Poles, we must come here, we must listen to this shrine, we must hear the echo of the life of the whole nation in the heart of its Mother and Queen. [25]

In addition to the liturgy offered for the pilgrims gathered at the embankment of Jasna Góra, the Pope celebrated Mass for six thousand nuns, whom he extolled as "a *living sign* ... in the midst of humanity." [26] When he met with the sick, the Holy Father said to them: "You who are weak and humanly incapable, be a source of strength for your brother and father who are at your side in prayer and heart." [27] In another speech, to students, he said:

All that I can say to you is summed up in the words: *Get to know Christ and make yourselves known to him.* He knows each one of you in a particular way.... *Allow him to find you.*

...

You are the future of the world, of the nation, of the Church. "Tomorrow depends on you." Accept with a sense of responsibility the simple truth contained in this song of youth and ask Christ, through his Mother, that you may be able to face it.

You must carry into the future the whole of the experience of history that is called "Poland." It is a difficult experience, perhaps one of the most difficult in the world, in Europe, and in the Church. Do not be afraid of the toil; be afraid only of thoughtlessness and pusillanimity. From the difficult experience that we call "Poland" a better future can be drawn, but only on condition that you are honorable, temperate, believing, free in spirit, and strong in your convictions. Be consistent in your faith. Be faithful to the Mother of Fair Love. Have trust in her, as you shape your

25 Homily of His Holiness John Paul II, Częstochowa, Jasna Góra, June 4, 1979 (Libreria Editrice Vaticana, 1979), https://w2.vatican.va/content/john-paul-ii/en/homilies/1979/documents/hf_jp-ii_hom_19790604_polonia-jasna-gora.html.

26 Homily of His Holiness John Paul II to the Religious Women in Jasna Góra, Częstochowa, June 5, 1979 (Libreria Editrice Vaticana, 1979), https://w2.vatican.va/content/john-paul-ii/en/homilies/1979/documents/hf_jp-ii_hom_19790604_polonia-jasna-gora.html.

27 Address of His Holiness John Paul II to the Sick Gathered at the Shrine of Jasna Góra, Częstochowa, June 4, 1979 (Libreria Editrice Vaticana, 1979), http://w2.vatican.va/content/john-paul-ii/en/speeches/1979/june/documents/hf_jp-ii_spe_19790604_polonia-jasna-gora-ammalati.html.

love and form your young families. May Christ always be for you "the way, and the truth, and the life." [28]

On the evening of June 6, John Paul II flew to Kraków, where, despite a torrential downpour, a crowd of happy people had assembled to joyously greet him. The pope told the faithful:

> By the inscrutable design of Providence I had to leave the episcopal see of Saint Stanislaus at Kraków, and, from 16 October 1978, to occupy that of Saint Peter in Rome. The choice of the Sacred College was for me an expression of the will of Christ himself.
>
> ...
>
> Here, in this land, I was born. Here, in Kraków, I spent the greater part of my life, beginning with my enrollment in the Jagiellonian University in 1938. Here, I received the grace of my priestly vocation. I was consecrated Bishop in the Cathedral of Wawel, and in January 1964, I inherited the great patrimony of the Bishops of Kraków. Kraków, from the tenderest years of my life, has been for me a particular synthesis of all that it means to be Polish and Christian. I remember the old Kraków of the university years of my youth....
>
> Today, I greet my beloved Kraków as a pilgrim. [29]

Spontaneous meetings with young people were an important component of John Paul II's pilgrimage to Poland. Every night, conversations between the pope and young people, full of joy and laughter, could be heard below the windows of the papal residence in Kraków. One evening, in response to incessant singing, John Paul II looked out of his window and addressed the crowd: "When I was an archbishop, I did not have to jump up on the windowsill, and when I did lean out of the window, no one would grab my

28 Address of His Holiness John Paul II to University Students, Kraków, June 8, 1979 (Libreria Editrice Vaticana, 1979), https://w2.vatican.va/content/john-paul-ii/en/speeches/1979/june/documents/hf_jp-ii_spe_19790608_polonia-cracovia-universitari.html.

29 Address of His Holiness of John Paul II, Kraków, June 6, 1979 (Libreria Editrice Vaticana, 1979), https://w2.vatican.va/content/john-paul-ii/en/speeches/1979/june/documents/hf_jp-ii_spe_19790606_polonia-cracovia-arrivo.html.

cassock."[30] Then he joked: "It is hard to be a pope in Rome. But in Cracow, it would be even worse because I would have to remain by this window at all times and I would have time neither to sleep nor to think."[31]

In the morning of the following day, June 7, the Pontiff made a pilgrimage to Kalwaria Zebrzydowska, a Marian sanctuary: "I really do not know how to thank Divine Providence for granting me to revisit this place: Kalwaria Zebrzydowska, the Shrine of the Mother of God.... I came here alone, and, walking along the little ways of Jesus Christ and his Mother, I was able to meditate on their holy mysteries and commend to Christ through Mary the specially difficult and uniquely responsible problems in the complexity of my ministry. I can say that almost none of these problems reached its maturity except here, through ardent prayer before the great mystery of faith that Kalwaria holds within itself."[32]

Here, at the Marian Sanctuary, he begged the faithful for prayers: "May the Shrine of Kalwaria continue to gather pilgrims, and to serve the Archdiocese of Kraków and the whole of the Church in Poland. May a great work of renewal be accomplished here for men, women, young people, liturgical service of the altar, and for everyone. And I ask all those who will continue to come here to pray for one of the pilgrims of Kalwaria whom Christ has called with the same words that he spoke to Simon Peter: 'Feed my lambs ... Feed my sheep' (Jn 21:15–19). I ask you to pray for me here during my life and after my death. Amen."[33]

From Kalwaria the Pope traveled on to Wadowice, his birthplace. There, he was welcomed by Monsignor Edward Zacher, his former teacher. John Paul II thanked him in turn: "I want to express my feelings of deep gratitude to Monsignor Edward Zacher, who was my religion teacher in the Wadowice secondary school, who later spoke at my first Mass and at my first celebrations as Bishop, Archbishop, and Cardinal here in the Church of Wadowice, and who finally has spoken again today on the occasion of this new stage in my life."[34] He also addressed all the people of the town:

30 F. X. Murphy, M. Greene, and N. Schaifer, *Poland Greets the Pope* (South Hackensack, NJ: Shepherd Press, 1979), 33.

31 N. Ascherson, "The Pope's New Europe," *The Spectator*, June 16, 1979, 7.

32 Address of His Holiness John Paul II, Kalwaria Zebrzydowska, June 7, 1979 (Libreria Editrice Vaticana, 1979), http://w2.vatican.va/content/john-paul-ii/en/speeches/1979/june/documents/hf_jp-ii_spe_19790607_polonia-kalwaria-zebrzydowska.html.

33 Ibid.

34 Address of His Holiness John Paul II, Wadowice, June 7, 1979 (Libreria Editrice Vaticana, 1979), https://w2.vatican.va/content/john-paul-ii/en/speeches/1979/june/documents/hf_jp-ii_spe_19790607_polonia-wadowice.html.

It is with deep emotion that I arrive today in the town of my birth, in the parish in which I was baptized and accepted as part of the ecclesial community....

In mind and heart I go back to the elementary school in Rynek (Market Square) and to the Wadowice secondary school dedicated to Marcin Wadwita, where I was a student. In mind and heart I go back to *those who grew up with me*, the boys and girls who were with me in school, and to our parents and teachers....

We know how important the first years of life are, childhood and youth, for the development of human personality and character. These are the very years that bind me inseparably to Wadowice, to the town and the area around it, to the River Skawa and the Beskid Mountain Range. For that reason I have wanted very much to come here, in order to thank God with you for all the blessings that I have received. My prayer is for so many people who have died, beginning with *my parents*, my brother and my sister, whose memory is linked for me with this city.[35]

The next stage of the pope's visit brought him to the German concentration camp at Auschwitz: "Auschwitz is such a reckoning through these plaques which remind us of the sacrifices the nations suffered. It is impossible merely to visit it. It is necessary on this occasion to think with fear of how far hatred can go. Auschwitz is a testimony of war. War brings with it a disproportionate growth of hatred, destruction, and cruelty. It cannot be denied that it also manifests new capabilities of human courage, heroism, and patriotism, but the fact remains that it is the reckoning of the losses that prevails."[36]

Mass was said on an altar erected on the very ramp where trains carrying prisoners used to stop. In his homily John Paul II spoke of the reasons behind his visit: "I am here today as a pilgrim. It is well known that I have been here many times. So many times! And many times I have gone down to Maximilian Kolbe's death cell and knelt in front of the execution wall and passed among the ruins of the cremation furnaces of Birkenau. It was impossible for me not to come here as Pope."[37]

35 Ibid.

36 Homily of His Holiness John Paul II, Auschwitz-Bierkenau, June 7, 1979 (Libreria Editrice Vaticana, 1979), https://w2.vatican.va/content/john-paul-ii/en/homilies/1979/documents/ hf_jp-ii_hom_19790607_polonia-brzezinka.html.

37 Ibid.

The pontiff spoke also of St. Maximilian Kolbe, who gave his life for another inmate at Auschwitz:

> This victory through faith and love was won in this place by a man whose first name is Maximilian Mary. Surname: Kolbe. Profession (as registered in the books of the concentration camp): Catholic priest.
>
> ...
>
> Father Maximilian voluntarily offered himself for death in the starvation bunker for a brother [Stanisław Gajowniczek], and so won a spiritual victory like that of Christ himself. This brother still lives today in the land of Poland and is here with us.[38]

The pope stressed that Auschwitz is not only a difficult lesson of history, but fundamentally a call to respect man and his dignity as a human person and to recognize the right of nations to their own language, culture, and freedom. Auschwitz, he insisted, is an experience that must never be repeated: "Never one at the other's expense, at the cost of the enslavement of the other, at the cost of conquest, outrage, exploitation, and death!"[39] He added, "I ask all who hear me, that you focus, that you focus all your powers for the care of the human being. But those who listen to me with faith in Jesus Christ, I ask you, to focus in prayer for peace and reconciliation."[40] And here the pope quoted a Polish prayer:

> Holy is God! Holy and strong! Holy and Immortal! From plague, from famine, from fire and from war ... deliver us, Lord.[41]

John Paul II was received with exceptional warmth in Podhale, at the foothills of his beloved Tatra Mountains at the southern border of Poland. Here he spoke of the love of the land and of the value of farming:

> This has been the most closed and most shielded frontier, and at the same time the most open and friendly one.

38 Ibid.
39 Ibid.
40 Ibid.
41 Ibid.

...

Here, in this place, at Nowy Targ, I wish to speak of the Polish land, because here it shows itself particularly beautiful and rich in landscapes. Man needs the beauty of nature, and so it is not surprising that people come here from various parts of Poland and from abroad. They come both in summer and in winter. They seek rest. They want to find themselves again through contact with nature. They want to rebuild their energies through the wholesome physical exercise of walking, climbing, and skiing. This hospitable region is also a land of great pastoral work, because people come here to regain not only their physical strength but their spiritual strength too.

...

Hold in great esteem the work of the fields; appreciate it, and value it! And may Poland never want for bread and food! [42]

He also addressed the region's youth: "I also wish to speak to the young people, who love these places in a special way and seek here not only physical but also spiritual rest. 'To rest,' once wrote Norwid, 'means to begin anew.' Man's spiritual rest, as many groups of young people correctly realize, must lead to discovering and nurturing within oneself that 'new creature' that Saint Paul speaks of. To this end leads the path of the Word of God, read and celebrated with faith and love, participation in the Sacraments and especially in the Eucharist." [43]

At last John Paul II returned to Kraków. At the church of Skałka ("The Little Rock") he once again greeted the young. According to tradition, this small rocky hill is the place of martyrdom of the medieval bishop Stanislaus — Poland's Thomas Becket, martyred by his king like the English saint. The pope excused himself from preaching a sermon he had prepared earlier for the occasion, on account of a sore throat. He made a simple appeal: "'It's late, my friends. Let's go home quietly.' And they did. As the papal limousine drove slowly back to 3 Franciszkańska Street, the guitars played a farewell song. The white-clad figure inside the car covered his face with his hands and wept." [44]

42 Homily of His Holiness of John Paul II, Nowy Targ, June 8, 1979 (Libreria Editrice Vaticana, 1979), https://w2.vatican.va/content/john-paul-ii/en/homilies/1979/documents/hf_jp-ii_hom_19790608_polonia-nowy-targ.html.

43 Ibid.

44 Weigel, *Witness to Hope*, 317.

The following morning, after meeting the teachers and students of the Pontifical University and Faculty of Theology, John Paul II traveled by helicopter to the Cistercian monastery at Mogiła, near Kraków. "Forbidden by the authorities to visit the Ark Church, John Paul threw a bouquet of flowers over it from the window of the helicopter. Hundreds of thousands of Nowa Huta residents had assembled to meet the man who had defended their religious freedom so tenaciously during his episcopate. The parishioners of the Ark Church had wanted the Pope to crown a new statue of Mary, Queen of Poland, for their hard-fought sanctuary; when the authorities struck Nowa Huta from the papal itinerary, the parishioners decided to bring the statue to the Pope in Mogiła." [45]

The last day of the papal pilgrimage began with an outdoor Mass in Kraków. On the last day of his visit, two million people gathered in Błonie Park. "To conclude the jubilee of Saint Stanislaus, the Pope celebrated the Mass of the Most Holy Trinity. Both things — the jubilee and the Mass of the Trinity — called attention to one of the fundamental stages of Christian existence, the stage of mature responsibility that comes with the sacrament of Confirmation." [46]

The Holy Father then bid farewell to his countrymen:

> You must be strong, dear brothers and sisters. You must be strong with the strength that comes from faith. You must be strong with the strength of faith. You must be faithful.
>
> Today, more than in any other age, you need this strength. You must be strong with the strength of hope, hope that brings the perfect joy of life and does not allow us to grieve the Holy Spirit. You must be strong with *love*, which is stronger than death.
>
> ...
>
> When we are *strong with the Spirit of God*, we are also strong with faith in man.... There is therefore no need for fear.
>
> ...
>
> So, before going away, I beg you once again to accept the whole of the spiritual legacy which goes by the name of "Poland," with the faith, hope, and charity that Christ poured into us at our holy baptism.
>
> ...
>
> All this I beg of you. Amen. [47]

45 Ibid., 317–18.
46 Dziwisz, *A Life with Karol*, 106.
47 Homily of His Holiness John Paul II, Kraków, June 10, 1979 (Libreria Editrice Vaticana,

At the official farewell ceremony at the Balice airport outside Kraków, Cardinal Wyszyński thanked the pontiff for his visit: "You have uplifted our hearts with your living faith." The pope was visibly touched. "Then he kissed 'the soil from which his heart can never part,' and boarded the Polish Airlines LOT passenger jet to return to Rome." [48]

The first visit of John Paul II to his homeland was nothing short of a miracle. People could not believe their own eyes when they saw John Paul II standing before them. They were deeply touched by his presence. All anyone could do was cry. His words encouraged the Poles on their path to freedom. One of pope's closest collaborators, Cardinal Stanisław Dziwisz, remembers the pilgrimage as more than merely an "unforgettable experience":

> I had an impression that we were witnessing something that we could not comprehend with our reason. From that moment on, the people who saw and heard the pope felt free, internally free. They were not ruled by fear anymore. It was understood that the pope, by the mere fact of his presence, imparted a feeling of freedom not only in Poland but also in other countries, including the neighboring nations to the East, as well as in the Third World. This was the power, the novelty, of John Paul II's pontificate: to liberate people from the pressure of fear. [49]

The developments in Poland after the first apostolic visit of the Holy Father—the spontaneous creation of the Solidarity movement with the electrician Lech Wałęsa at the helm, and other events that eventually led to the fall of communism—showed how much the pontiff did for the Poles and Poland, indeed for the world, and demonstrated the significance of his pilgrimage. "In June 1979, John Paul II, by dispersing the lie, had helped make possible something unprecedented in postwar east central Europe. Poland now had a genuine citizenry, capable of building independent institutions whose very existence would demonstrate the hollowness of the communist system and its dependence on violence for survival." [50]

1979), https://w2.vatican.va/content/john-paul-ii/en/homilies/1979/documents/hf_jp-ii_hom_19790610_polonia-cracovia-blonia-k.html.

48 Murphy, Greene, and Schaifer, *Poland Greets the Pope*, 405.

49 Cardinal Stanisław Dziwisz, *Świadectwo, W rozmowie z Gian Franco Svidercoschim* [Testimony: Conversations with Gian Franco Svidercoschim] (Warsaw: Hausner, 2007), 110.

50 Weigel, *Witness to Hope*, 325.

TWO

A Benção João de Deus! [1]

WHEN JOHN PAUL II EMBARKED ON AN APOSTOLIC JOURNEY
to Brazil, the world's most populous predominantly Catholic country, his
native Poland continued to struggle against its totalitarian communist regime.
Protests broke out across the country. The heroes were workers, students, and
intellectuals who came together and spoke truth to power.

Yet "Poland was a pretty atypical case in the Communist archipelago. For
one thing, it had a strong, united, and well-organized Church. But its dissent
was also different from that of the other Eastern countries. In countries like
East Germany and Czechoslovakia, or like Bulgaria, Hungary, and Russia,
dissent was restricted to an intellectual elite, or to revisionist politicians, or to
members of small religious groups. On the shores of the Vistula, everything
was different. The phenomenon had grown into a mass movement repre-
senting the entire nation." [2] The Poles were openly distrustful of the state and
more willing to take political risks. As a result, Poland's rich culture remained
relatively free, as reflected in a plethora of internationally recognized artists:
composers (Lutosławski, Górecki, Kilar, and Penderecki), movie directors
(Wajda, Kieślowski, and Zanussi), and poets (Różewicz, Herbert, Miłosz, and
Szmborska). Both before and after de-Stalinization in 1956 (which entailed
a slight liberalization of the communist regime, including the suspension of
mass terror), Cardinal Stefan Wyszyński appealed to the government to end its
use of violence and detention. Karol Wojtyła joined him, stressing that peace
should be based solely on respect for human rights and freedom.

The Marxist doctrine that oppressed Poland had spread also in Latin
America. The pope was profoundly convinced that the future of the world
must not belong to Marxism, because humanity craves democracy, freedom,

1 This chapter is dedicated to the author's Brazilian friends.
2 Dziwisz, *A Life with Karol*, 47–48.

and solidarity. It is then hardly surprising that shortly after his elevation to the Throne of St. Peter, in the second year of his pontificate, John Paul II traveled to Brazil. South America appeared to him to present as much of a challenge as communist Eastern Europe.

From an external (European) viewpoint, the situation in the world's largest predominantly Catholic country developed as follows. In 1980 Brazilians were seeking to throw off a dictatorship. Nothing augured a triumph of the pontiff, who arrived in that divided nation with a disunited Church. Brazil's military junta, in power since 1964, encountered a great deal of opposition from the clergy. According to George Weigel,

> The Brazilian government, many of whose senior officials were Catholics, and the Church leadership were in conflict over the slow pace of democratization, the continued jailing of political prisoners, and the country's vast disparities in wealth. The government complained to the nuncio that Church leaders failed to condemn the violent left; the bishops responded that the government was doing virtually nothing on behalf of the poor. The Brazilian bishops were unhappy about the way their activities and ideas were reported to the Vatican; some in Rome thought the Brazilian bishops had gone off the theological and political deep end. There were even quarrels about where the pilgrimage would begin. [3]

The Brazilian economy, which had boomed earlier in the 1970s, had practically collapsed by 1980. "Like Poland under Edward Gierek, Brazil spiraled into debt. This exacerbated social tensions, thereby forcing the ruling junta to embark, however tentatively, on a program of political reform." [4] Mass strikes, arbitrary arrests of workers, persecutions, poverty, crime, and police violence afflicted the nation.

In this difficult time for Brazil, the pope had his heart set on visiting the country. He studied Portuguese in the weeks leading up to his arrival in this land of many races, cultures, and (despite its Catholic majority) religions. His visit itself would be filled with activity. It is enough to enumerate the cities visited by the pope to indicate the vast ground he covered: Brasília, Belo

3 Weigel, *Witness to Hope*, 379.
4 J. Moskwa, *Droga Karola Wojtyły. Zwiastun wyzwolenia 1978–1989* [The Road Traveled by Karol Wojtyła: The Harbinger of Liberation, 1978–1989], Vol. 2 (Warsaw: Świat Książki, 2010), 135.

A Benção João de Deus!

Horizonte, Rio de Janeiro, São Paulo, Aparecida, Porto Alegre, Curitiba, São Salvador, Bahia, Recife, Teresina, Belém, Fortaleza, and Manaus.

> So many thousands of miles in 12 days!... And then one must consider the exhausting flight from Rome to Brazil and then the return from Manaus to Rome. Whether flying on a jet plane or helicopter—preach to all nations. Four seasons, two climate zones in so little time. Freezing cold in Curitiba. A torrential downpour in São Paulo. Tropical heat in Manaus.... Dozens of lengthy homilies and speeches. Numerous field Masses and prayer services. Millions of faces looking up. An unceasing roar from the crowds. Hardly any sleep or rest. Spotlights, floodlights, cameras, flashes, TV cameras—*Big Brother is watching you!*—never leave the pope's face. [5]

On the first day of his visit, John Paul II met with President João Baptista de Figueiredo. Before government officials and other public figures, the Holy Father defended the right of Catholics to influence the social policies of their nation and spoke of the need for reform: "The Church never ceases to preach about the reforms needed to protect and spread those values without which no society worth its mettle could function: reforms which bring about a society that is more just and reflective of the dignity of the whole human person.... Introducing such reforms helps avoid solutions that embrace violence and the suspension—either direct or indirect—of fundamental rights and liberties, which are inseparable from human dignity." [6]

While addressing the diplomatic corps, the pope challenged the idea of a national security apparatus that demands civil rights be limited or suspended in its name: "It seems platitudinous to emphasize that every country has the right to protect its peace and internal security. Yet it must 'deserve' to have its peace protected, by having first secured the common good and respect for the law. The common good of society requires that it be just. When justice is lacking, society is threatened from within. This does not mean that the

5 T. Nowakowski, "João de Deus" [John of God], in K. Dybciak, *Jan Paweł II w literaturze polskiej. Antologia tekstów literackich* [John Paul II and Polish Literature: An Anthology of Literary Texts] (Warsaw: Centrum Myśli Jana Pawła II, 2008), 213.

6 Speech by Pope John Paul II, Meeting with the World of Culture in Rio de Janeiro, July 1, 1980 (Libreria Editrice Vaticana, 1980), https://w2.vatican.va/content/john-paul-ii/pt/speeches/1980/july/documents/hf_jp-ii_spe_19800701_cultura-brasile.html.

transformations required to bring about greater justice are to be realized through violence, revolution, and bloodshed, for violence creates a society based on violence, and we, as Christians, cannot accept that." [7]

Listening to the pope's speech was as difficult an experience for the Brazilian president as it was for the Brazilian clergymen, who supported ideologies similar to those prevailing in Fidel Castro's communist and pro-Soviet Cuba.

On the way to Rio de Janeiro, John Paul II stopped in the capital of the state of Minas Gerais, Belo Horizonte. According to a Polish journalist who frequently accompanied the pope, the atmosphere throughout Brazil was positively electric:

> At a bodega selling devotional items in Belo Horizonte, reminiscent of the industrial city of Łódź but with Tuscan beauty, I buy a few comic books about the pope. Karol Wojtyła, who does not always look like himself in those cartoons, often donning a fantastic jumpsuit or wearing a traditional Polish four-cornered military hat with a crowned eagle, is depicted as a master swimmer, mountain climber, biker, rower, singer, actor, and sharp-shooter. His colorful adventures under the German and Stalinist occupations recall James Bond movies. As in Mexico, here in Brazil we can admire portraits by homegrown painters in which *João de Deus* [John of God] has a halo over his head. [8]

During the Mass at Bello Horizonte, where half a million people gathered, the pontiff sang songs with Brazilian youth, and the young people chanted: "John of God is our King!" Addressing scholars, writers, and artists, the Holy Father said:

> Culture which is born free must ... spread under the conditions of liberty. An educated man should propagate his culture but he must not impose it. Coercion is antithetical to culture because it contradicts the process of free assimilation ... of thoughts and love, which are characteristic of the culture of the spirit. Culture that is imposed from above is not only at

7 Pope John Paul II, Speech to the Diplomatic Corps, Apostolic Nuncio, Brazil (Libreria Editrice Vaticana, 1980), https://w2.vatican.va/content/john-paul-ii/pt/speeches/1980/june/documents/hf_jp-ii_spe_19800630_corpo-diplomatico-brasile.html.

8 Nowakowski, "João de Deus" [John of God], 213.

odds with human freedom, but it is also is a barrier to the natural process of formation of the culture itself, which in all its entire complexity, from the achievements of science to the observance of local custom, is born out of social cooperation among people.[9]

In a country actively seeking a way out of a dictatorship, these sentiments strongly resonated with the Brazilian people.

In Rio de Janeiro, one of the most beautiful cities on earth, John Paul II ordained 84 priests. The Mass took place at the Maracana stadium, which is a temple also of Brazil's other national religion: soccer. Not surprisingly, "the swarm of journalists with a typically Brazilian temper [was] commenting on the papal Mass ... with the same excitement as if the World Cup was unfolding before their eyes."[10]

A gigantic electronic billboard read "João de Deus." This nickname would stick to the Polish pope for many years to come. Under this name he would later be immortalized in a song, "A benção João de Deus," written to commemorate the papal visit to Brazil. South Americans still hum it.

"I did not come here out of curiosity but because I love you," said John Paul II in the Vidigal *favela* (slum). As Cardinal Stanisław Dziwisz observed in a recollection of this part of the visit, "I remember his eyes. He looked desperately around, not knowing how he could alleviate the human suffering. Suddenly, he took his papal ring off his finger and gave it to these people."[11] Here the pope spoke of poverty and riches. He discussed the first of the eight beatitudes from the Sermon of the Mount: "Blessed are the poor in spirit, for theirs is the Kingdom of Heaven." He stressed that "the Church all over the world wants to be the Church of the poor. The Brazilian Church wants to be the Church of the poor; it wants to mine the whole truth contained in Christ's beatitudes, and most of all that contained in the first one."[12]

A different atmosphere filled the Morumbia stadium in São Paulo. Over 130,000 people occupied the bleachers, and more than 30,000 waited outside.

9 Speech by Pope John Paul II, Meeting with the World of Culture in Rio de Janeiro.
10 Nowakowski, "João de Deus" [John of God], 212–13.
11 Dziwisz, *Świadectwo* [Testimony], 94.
12 Speech by Pope John Paul II, Visit to the "Favela Vidigal" in Rio de Janeiro, July 2, 1980 (Libreria Editrice Vaticana, 1980), https://w2.vatican.va/content/john-paul-ii/pt/speeches/1980/july/documents/hf_jp-ii_spe_19800702_vidigal-brasile.html.

It was cold, and there was a horrible downpour. The political barometer indicated a storm. Seven kilometers from the stadium, the police and the military set up a triple defensive cordon. Helicopters patrol the gigantic bowl of the stadium.... The pope drove onto the field in a small black car, instead of the usual popemobile. He donned "a humble priest's street clothes" instead of liturgical vestments. A tornado of enthusiasm erupted. The applause continued for twenty-seven minutes before the crowd allowed the Pope to speak.... When John Paul II embraced a persecuted union activist, the entire stadium burst out into a battle cry against oppression and exploitation; the flame of *La Marseillaise* burst out beneath the Brazilian sky. Moved to tears, a Brazilian woman told me: "The song you can hear, sir, we have not sung in public in six years. It is banned because it calls on the people to take power...." A religious gathering quickly transforms into a great workers' rally, a political demonstration for human rights and civil liberties. The crowd is chanting: "Liberdade! Liberdade!" It is here [in São Paolo] that strikes took place three months ago. The regime declared them illegal, and the police tracked and hunted down the leaders, until, thanks to the intercession of Cardinal Arns, they were granted asylum in local churches.[13]

First-hand experience with hard labor in his youth and a deep personal understanding of the workers and their concerns brought the pope even closer to the workers of São Paulo. John Paul II spoke to the crowd of the evangelization of the poorest strata of society. "The Christian liturgy of joy is not a luxury reserved for the rich. Everyone is invited to take part."[14] He reminded his listeners of the duty to be active in advancing social justice: "When the Church preaches the Gospel, it strives to transform whatever is unjust in any aspect of social life into justice — and it does so without abandoning its special commitment to evangelization."[15] The pontiff also addressed socio-economic concerns, speaking on behalf of the workers: "Like the first

13 Nowakowski, "João de Deus" [John of God], 214.

14 M. Szafrańska-Brandt, et al., *Jan Paweł II w Brazylii, 30 VI–11 VII 1980. Przemówienia, homilie, modlitwy* [John Paul II in Brazil, June 30–July 11, 1980: Speeches, Homilies, Prayers], ed. A. Podsiad (Warsaw: PAX, 1985), 105.

15 Speech of Pope John Paul II to the Workers in São Pãolo, July 3, 1980 (Libreria Editrice Vaticana, 1980), https://w2.vatican.va/content/john-paul-ii/pt/speeches/1980/july/documents/hf_jp-ii_spe_19800703_operai-brasile.html.

Christians, who shared their possessions with their community, we would like for you to share with us what you produce…. May the worker overthrow the constraints imposed on him by the ruling system and, overcoming passivity, become an active agent of social change. We seek a new order where the worker will enjoy the fruits of his labor—where he will decide his own fate."[16] The pope's words here called to mind the radical political program of the Partido dos Trabalhadores, the Workers' Party led by Luiz Inácio de Silva, also known as Lulu. After the developments in Poland following the birth of the Solidarity movement under Lech Wałęsa, Lulu inevitably became "the Brazilian Wałęsa."

In Curitiba, home to Brazil's largest Polish community, John Paul II received a special greeting as a fellow Pole. Curitiba is the capital of the southeastern coastal state of Parana, which is inhabited mainly by Eastern European emigrants. Over 70,000 Brazilians, many of them with Polish roots, gathered to greet the pope at the Couto Pereira stadium in Curitiba. The pontiff was received as if he were a native son returning home: Polish songs were sung in his honor; a replica of a modest Tatra Mountain hut built by the first Polish pioneers in Brazil decorated the altar erected for the papal Mass. Even the Polish-Jewish immigrant community welcomed John Paul II warmly and participated in the festivities: "At the Polish Mass in Curitiba the Jewish community came waving the flag of Israel. This was a first. The crowd chanted: 'Shalom! Shalom!'"[17] In his welcoming speech, the Holy Father enthusiastically addressed the entire crowd in Polish: "You had every right to this meeting. And so did I. And our homeland was entitled to it. Many of you certainly never saw her. But this does not change the fact that your roots are there. And this is a key—one of many but such a crucial one—to the mystery of your hearts…. I stand before you as your fellow countryman but also as a Successor of Saint Peter and the Shepherd of the Universal Church. I stand before you as a witness of Christ and His Cross. The mystery of the Cross and the Resurrection is deeply ingrained in the history of our homeland."[18]

The inhabitants of Recife, the capital of the northeastern state of Pernambuco, gave the pope an equally cordial welcome. In front of 14,000 people

16 Szafrańska-Brandt, et al., *Jan Paweł II w Brazylii* [John Paul II in Brazil], 106.

17 Nowakowski, "João de Deus" [John of God], 215.

18 Homily of Pope John Paul II, Curitiba, July 6, 1980 (Libreria Editrice Vaticana, 1980), http://www.vatican.va/holy_father/john_paul_ii/travels/sub_index1980/trav_brazil.htm.

John Paul II embraced Brazil's most controversial churchman, Archbishop Hélder Câmara, and expressed support for his call for land reform: "Land is a gift from God. It is a gift that He bestows on all human beings.... It is not right, therefore, that it be a resource for only a few while the many are excluded from enjoying its bounty; to dispose of land in such a way that only a few benefit from it, while the multitudes are excluded, is not congruent with the Lord's plan."[19]

In Fortaleza, the Holy Father inaugurated the National Eucharistic Congress of Brazil. Here he met with 318 Brazilian bishops, to whom he delivered a four-hour exhortation. The pope spoke about the specific character of the Church as a religious community and about the necessity to strengthen the unity of Catholics. "John of God" exhorted the bishops to build a Church that cared for the poor, a Church of the people and for the people, but also a Church with a clear doctrine of faith and a consecrated hierarchy, with clergymen committed to social justice, yet not politician-priests or revolutionaries.

On the last day of his pilgrimage to Brazil, the Holy Father traveled to Manaus in the state of Amazonia. Following shortly after a stop in Minas Gerais, by most accounts Brazil's most Western and most modern city, the visit to Amazonas, or Amazonia, offered a study in contrasts. Traveling to Manaus directly from Minas Gerais brought this vast country's natural and human diversity into sharp focus. Tadeusz Nowakowski, who traveled with the pope in Brazil, vividly depicts the last day of the pontiff's pilgrimage as, essentially, a journey through time:

> Amazonas is no Minas Gerais: it has nothing to do with Europe. There, it is carrier pigeons and not phones that connect the jungle with the world — provided, however, they are not shot down with an archer's arrow and devoured by the natives. Sending a message in a bottle is not reliable either, since strong tides push the Amazon's waters away from the ocean.... The Indians who traveled from the forest to see the pope believe that any child noticed by the pope will experience urban prosperity. A frightening sight: native women chase the papal chariot barefoot with their infants held up high by their legs; the tiny heads of

19 Homily of Pope John Paul II, Recife, July 7, 1980 (Libreria Editrice Vaticana, 1980), https://w2.vatican.va/content/john-paul-ii/pt/homilies/1980/documents/hf_jp-ii_hom_19800707_recife-brazil.html.

the little ones bounce off the backs of their mothers to the rhythm of their mothers' stride. [20]

During his sojourn in Manaus, John Paul II met with the chiefs of five native tribes. They told him about the encroachment of civilization on their lands and the consequences of the economic conquest of the Amazon jungle. Ignored by the national government — complicit in the destruction of their land — the tribal chiefs pleaded for the pope's help: "We are being massacred, expelled from our land, destroyed by industrialization projects, on the initiative of corporations, by the invaders who rob our lands and the fruit of our labor and expel us from our small homeland in this limitless country." [21]

Responsive to the entreaties of the tribal chiefs, John Paul II took up their cause and appealed to the nation's government: "I ask the public authorities and other institutions responsible for such things to allow the Indians, who are the original inhabitants of this land, to live here in peace and quiet and without fear of expulsion for the benefit of others. I ask that they be given a safe place to live which would ensure their survival and allow them to retain their identity — their culture, and nation." [22]

On July 12, the papal pilgrimage to Brazil came to an end. After a farewell procession along the *Rio Negro* in Manaus, John Paul II boarded the plane that was to take him back to Rome. Millions of Brazilians had come to see him as their father and spiritual guide. Bidding him farewell, they chanted: "Come back! Come back!"

Tadeusz Nowakowski, looking back at Brazil, tried to assess that historic visit. "How was Brazil?" he asks. He answers with one word: "wonderful." And a glimpse at many headlines unequivocally says that it was, indeed, wonderful:

> It could not have been better. The pope had enjoyed yet another tangible success. And each success is a victory for the Cause he symbolizes.... The pope is an idol of the soccer fans — a first in the history of the papacy! Not only at Madison Square Garden in New York and the Parisian

20 Nowakowski, "João de Deus" [John of God], 216.

21 Domenico del Rio, *Wojtyła: un pontificato itinerante; quindici anni in missione per il mondo* [Wojtyła: A Pontificate on the Road; Fifteen Years on a Mission around the World] (Bologna: EDB, 1994), 183.

22 Homily of Pope John Paul II, Manaus, July 11, 1980 (Libreria Editrice Vaticana, 1980), http://www.vatican.va/holy_father/john_paul_ii/travels/sub_index1980/ trav_brazil.htm.

Parc-des-Princes, but now also in Rio and Fortaleza, John Paul II sweeps the youth off their feet. "Jesus carnival" is how a newspaper headline described the mood throughout the papal pilgrimage.... "What can one Pole from the small town of Wadowice do in this country?" they ask! This is not just the Pope—but [18th-century Polish liberation hero Tadeusz] Kościuszko.[23]

Indeed, what could one Pole from Wadowice do in Brazil? How much can change in the course of a twelve-day visit? His plane departed for Rome, but John Paul II did not abandon the people of Brazil. After seeing Brazil's dramatic reality up close, the pope called on the Brazilian church to fight on behalf of the country's downtrodden and poor and appealed to its leaders to advocate for human rights, social justice, freedom, and peace. His exhortations left the Brazilian church with an unprecedented sense of unity and purpose.

Just as John Paul II was returning to Rome, a foreign correspondent from Poland reported, "social unrest broke out in the pope's native country, which—despite many differences—was not unlike Brazil (disappointment and high national debt as a result of a failed industrial 'leap,' and a crumbling dictatorship)."[24] The words of the Holy Father decrying injustice and lack of freedom in Brazil would acquire a still deeper meaning during his next trip to Poland.

Today, John Paul II is no longer with us. Undoubtedly, in the words of then-Cardinal Ratzinger at the Polish pope's funeral, "We can be sure that our beloved Pope is standing today at the window of the Father's house, that he sees us and blesses us. Yes, bless us, Holy Father."[25] And with the Brazilians, let us once again sing: *A benção João de Deus.*

23 Nowakowski, "João de Deus" [John of God], 213, 215.
24 Moskwa, *Droga Karola Wojtyły* [The Road Traveled by Karol Wojtyła], 142.
25 Homily of His Eminence Card. Joseph Ratzinger, St. Peter's Square, April 8, 2005, http://www.vatican.va/gpII/documents/homily-card-ratzinger_20050408_en.html.

THREE

To Understand John Paul II

They try to understand me from outside.
But I can only be understood from inside. [1]

JOHN PAUL II

MANY HAVE TRIED TO DELVE INTO JOHN PAUL II, AND IN
particular into his Polish identity. To understand the pontiff from within
means to understand his Polishness and answer the question: how much
Poland was in the Polish pope? According to André Frossard, "His origin
and his language link him to all the Slav peoples who inhibit eastern Europe
and a good part of central Europe. Consequently, he and his people inherit
the common ground between two Christian traditions and of two cultures,
those of the West, centered on Rome, and those of the East, linked with
Constantinople.... The assertion of the inner freedom of the human being
is part of the spiritual heritage of the Pope from Poland." [2]

The Polish spiritual heritage, or Polishness, informs all of the rich tapes-
try of the life of Karol Wojtyła: his youth, teaching, scholarship, knowledge,
worldview, and poetry — not to mention his experience as a bishop, including
his acquired insights into family, youth, and humanity. Drama is another
element of Karol Wojtyła's Polishness: "His creative and active nature, which
simultaneously dwells in contemplation, possesses an inner dynamic and a
gift for historiographical generalizations, while grasping the personal, indi-
vidual soul; sensing the importance of the word, its shade, expression, and

1 Quoted in Weigel, *Witness to Hope*, preface to Polish ed., 7.
2 A. Frossard and John Paul II, *"Be Not Afraid!": Pope John Paul II Speaks Out on His Life,
His Beliefs, and His Inspiring Vision for Humanity*, trans. J. R. Foster (New York: Image Books,
1985), 23–24.

taste — because it concerns itself with the need to express the ineffable." [3] His Polishness also comprises an original cultural idiom, a pattern of behavior, a set of gestures, and even a way of smiling.

Although at a certain stage of his life Karol Wojtyła stopped being Karol of Wadowice and became Pope John Paul II of Rome, he never ceased to draw deeply upon his Polish roots. Indubitably, "in his attitude, emotions, and temperament, John Paul II was very characteristically Polish: the vibrations emanating from him are warmth and familiarity, resonating with others as though on the same wavelength. At the same time, we realize that this is not the 'average' Polishness. This uncommon man claimed the best of Poland and her culture." [4]

Karol Wojtyła was at heart the son of a nation that survived some of the most horrific historical experiences imaginable. The nation retained its identity and preserved itself despite various partitions and occupations. "It retained its sovereignty by embracing its own culture. By reminding us that culture is the most dynamic, timeless force in history — and projecting this characteristically Polish view of culture onto history — the Polish pope changed the course of the 20th century and pointed the way to a 21st century where liberty can fulfill itself in kindness and a flowering of humanity." [5] Let us remember also that the pope not only witnessed firsthand the 20th-century historical processes that eventuated in the eruption of evil in the forms of Nazism and communism, but also opposed them and witnessed their defeat. "Both the Nazis during the war and, later, the Communists in Eastern Europe tried to hide what they were doing from the public eye. For a long time, the West was unwilling to believe in the extermination of the Jews. Only later did this come fully to light. Not even in Poland did we know all that the Nazis had done and were still doing to the Poles, nor what the Soviets had done to the Polish officers in Katyń; and the appalling tragedy of the deportations was still known only in part." [6]

Once such things became common knowledge, the foundations of the philosophy of evil collapsed. "It is true that the collapse of communism

3 Z. Żakiewicz, "Twórczy śmiech Pana Boga" [Creative Laughter of God], in K. Dybciak, *Jan Paweł II w literaturze polskiej. Antologia tekstów literackich* [John Paul II and Polish Literature: An Anthology of Literary Texts] (Warsaw, 2008), 189.

4 Ibid., 189.

5 Weigel, *Witness to Hope*, preface to Polish ed., 9.

6 John Paul II, *Memory and Identity*, 13–14.

resulted from the collapse of its political and ideological program, its social system, and in particular its economic plans. But it is also true that even before the final collapse—as John Paul II would argue in his encyclical *Centesimus Annus*—'Communism was a spiritual failure because of its Promethean attempt to build a new world, one from which God would be banished, and to create a new man, whose conscience had no room for God.'[7]

Today it would be hard to imagine Poland without John Paul II, because for so many years we watched as the Holy Father, who had been nurtured on Polish culture, infused the Church and the world with the experience of his nation.

As Cardinal Stanisław Dziwisz aptly put it,

> There is an extraordinary continuity between the Wojtyła of Polish years and Wojtyła as Pope—a continuity in behavior, actions, even words. It is as if his experiences as a young man, and then as a priest and bishop, had been necessary stages for the responsibility of the papacy. That's right. Think of everything Karol Wojtyła brought with him to Rome—his teaching, his scholarship, his knowledge, his holiness, his way of looking at things, plus his major concerns as a bishop with the family, youth, human rights, doctrinal orthodoxy, the education of the clergy. And I think that all of this, his contribution, we might say, was something he lived out and brought to maturity in the universal horizon that is the papacy's native turf. In the end, he transformed it all into something profoundly new, something that put the stamp of change on his pontificate.[8]

John Paul II's appropriation of Polishness realized itself in many dimensions. It reflected both the organic continuity of Poland's national experience and the need for a reinterpretation of this experience with regard to literature, Christianity, culture, and patriotism.

Polish literature was an integral part of that experience. Wojtyła's masters in this domain were the great Romantic and neo-Romantic poets, in particular Cyprian Kamil Norwid, a national prophet and religious thinker. Wojtyła's fascination with Norwid's works began during his youth, taking on a definite shape during his literary studies at the Jagiellonian University. It would

7 Dziwisz, *Świadectwo* [Testimony], 162.
8 Dziwisz, *A Life with Karol*, 231.

eventually leave its mark on his pontificate. "The work of Norwid was shaped by a deep aesthetic of faith in God and our divine humanity; his faith in Love revealing itself in beauty that inspires creative labor … opens up Norwid's words to the mystery of God's everlasting covenant with man that enables him to live as God lives. *Promethidion*, Norwid's poem about labor and the beauty of love, points to the very act of creation, through which God reveals to men the indissoluble link between labor and love."[9]

And so the man who ascended to St. Peter's throne would rely on Norwid to interpret the history of his nation and of humanity. John Paul II appealed to the thoughts and works of Norwid many times in his sermons and quoted him freely. The pope referred to Norwid's theory of labor as an expression of love in his 1981 encyclical *Laborem Exercens* — during the very year in which the Solidarity movement in his native Poland restored dignity to workers just when martial law seemed poised to replace that sense of dignity with fear. On June 21, 1983, the pontiff invoked in a homily Norwid's "Memorial to the Young Emigré": "That righteous hunger and thirst for justice in the life of our nation must find a response that allows the entire nation to regain common trust. One must neither destroy nor squelch nor neglect it, for as the poet says, 'Fatherland is a great — collective — duty.'"[10]

During an address to artists on love, truth, and beauty at the Church of the Holy Cross in Warsaw in 1987, the Pope quoted Norwid's *Promethidion*: "The human spirit lives on truth and love. Thus the need for beauty is born. As the poet says, 'What do you know of beauty?… Its shape is Love.' It is a creative love, love which inspires. It provides the deepest motivation in the creative activity of man."[11]

On the 180th anniversary of Norwid's birth, during an audience with the faculty of the Polish Institute in Rome and literary scholars specializing in Norwid's work, John Paul II paid tribute to the poet. The pope stressed the poet's place in the pantheon of Polish writers and praised the decision to move his remains from a common grave in Paris — where he died in abject

9 Ibid., 69.

10 John Paul II, Homily, Coronation of Our Lady of the Snow at the Hippodrome of Wrocław, June 21, 1983, in *Musicie od siebie wymagać* [You Must Demand of Yourselves] (Poznań: W drodze, 1984), 337–39.

11 John Paul II, Liturgy of the Word for the World of Culture and Art in Warsaw, June 13, 1987 (Libreria Editrice Vaticana, 1987), https://w2.vatican.va/content/john-paul-ii/pl/homilies/1987/documents/hf_jp-ii_hom_19870613_mondo-cultura-varsavia.html.

poverty — to the Wawel Castle National Cathedral in Kraków, the burial place
of Polish kings:

> We are all deeply indebted to this poet ... and would like to make the most
> of this occasion to repay him, at least in part. I have always maintained
> that Cyprian Norwid should have lain in the crypt of the great poets in
> Wawel Cathedral.... It is right that at least the urn with earth from the
> common grave in which the poet was buried should now stand in Wawel,
> in the place in our country that Norwid deserves, because our country,
> he wrote, "is the place where we can find rest and death." [12]

A particularly touching example of the spiritual bond between John Paul II
and Norwid is contained in the following passage from the Pope's allocution:
"I would like to pay my personal debt to the poet to whom I have been closely
tied spiritually since my high school days.... Under the German occupation, the
thoughts of Norwid most articulately expressed our hope and faith in God; in
the time of the injustice and scorn with which communism treated man, they
helped us persevere, remain faithful to the truth, and live decently in the period
of the injustice and scorn with which the communist system treated man." [13]

For all his pilgrimages around the world, it seems that the Holy Father
felt happiest at home; nowhere was he more spontaneous and joyful than in
Poland. This could be plainly seen during his eight visits there as pope — in
his gestures, jokes, and sermons. His sermons in particular testified to his
encyclopedic knowledge of the history of his country. In his pastoral travels
throughout the world, the pope spoke about the past of his homeland on
numerous occasions, as though the Polish experience was essentially the
experience of the Catholic Church, and could be universally understood by
the faithful around the world. His teachings undoubtedly helped forge ties
between the Church in Poland and its counterparts elsewhere.

John Paul II prayed for the whole world, including Poland. Once he averred
that we pray best in our native language. We may surmise that he prayed

12 Address of John Paul II to the Representatives of the Institute of Polish National Patri-
mony, July 1, 2001 (Libreria Editrice Vaticana, 2001), https://w2.vatican.va/content/john-paul-ii/
en/speeches/2001/july/documents/hf_jp-ii_spe_20010701_norwid.html.

13 K. Dybciak, *Nowy elementarz Jana Pawła II na trzecie milenium* [A New John Paul II
Reader for the Third Millennium] (Kraków: Literackie, 2005), 68.

most often in Polish. For what did he pray? The Holy Father once said: "The pope's prayer, however, has an added special dimension. *In his concern for all the churches* every day the Pontiff must open his prayer, his thought, his heart to the entire world. Thus a kind of *geography of the Pope's prayer* is sketched out. It is a geography of communities, churches, societies, and also of the problems that trouble the world today. In this sense the Pope is called to a *universal prayer* in which the *sollicitudo omnium Ecclesiarum* (concern for all the churches; 2 Cor 11:28) permits him to set forth before God all the joys and hopes as well as the griefs and anxieties that the Church shares with humanity today." [14]

A tangible reminder of Poland, the Black Madonna of Częstochowa, always accompanied the Holy Father in his prayer at the chapel in his private apartments at the Vatican. He kept another reproduction of it in his private office.

Poland also markedly influenced John Paul II's broader understanding of culture. As a young boy, Wojtyła learned the most important historical lesson about Poland: that the nation persevered because of its culture — language, literature, and religion — when the Polish state had been erased from the maps of the world. "As he pondered that problem, his reflection deepening with the experiences of the Nazi occupation and the communist usurpation of Poland's freedom, Karol Wojtyła reached a conclusion that was to alter the events of the 20th century: culture is the engine of history. In the long run neither politics nor economics determines history." [15] This is a matter of the culture of the spirit, the transcendental element within an individual along with its inner relationship to truth, beauty, goodness, and God. Reminding the world that culture is a timeless force in history, John Paul II also fought to restore true culture to his own nation — the culture that the Nazis had attempted to uproot, and the communists endeavored to create anew.

The way John Paul II understood patriotism must also be viewed through the prism of his native country, where patriotism is seen as the virtue of loving one's motherland. The pope defined patriotism as "a love for everything to do with our native land: its history, its tradition, its language, its general features." [16] This is a personalistic understanding of patriotism. Accordingly, it pursues the welfare of the homeland, which here acquires the character of

14 John Paul II, *Crossing the Threshold of Hope*, 23.
15 Weigel, *Witness to Hope*, preface to Polish ed., 8.
16 John Paul II, *Memory and Identity*, 65–66.

a communion of individuals. For John Paul II patriotism was not something to be understood on the political plane, but by considering the nation in religious terms. One of the pope's goals was to help shape properly a modern patriotism. For John Paul II, Adam Chmielowski, the future Brother Albert, was an outstanding example of heroic love for the motherland. A hero of the anti-Russian insurrection of January 1863 (canonized in 1989), he exerted a tremendous influence on the young Wojtyła, whose fascination with Brother Albert would translate itself into the play *Brother of Our God.*

Not surprisingly, the turbulent history of his native country informed the pope's perspective on national freedom, as reflected in his sermons during the pilgrimages to Poland in 1997 and 1999. Following the collapse of communism, Poland became, in a sense, the western world's first experiment in building liberty via democratic institutions and a free-market economy. The elevation to Saint Peter's throne of a Pole, who from the beginning of his ministry guarded freedom and human dignity, was of enormous significance not only for Poland — which during his pontificate would free itself from a Marxist yoke — but also for the rest of the world.

Among his Polish experiences, Karol Wojtyła's relations with his Jewish neighbors and friends are especially noteworthy. Wadowice, his birthplace, had a population of about 10,000 at the time of Wojtyła's birth, approximately 30% of them Jewish. As pope, he would recall that "at least one-third of my classmates at elementary school in Wadowice were Jews. At secondary school they were fewer. With some I was on very friendly terms. And what struck me about some of them was their Polish patriotism. Fundamental to the Polish spirit, then, is multiplicity and pluralism, not limitation and closure." [17]

It was thorough those friendships and shared "Polish spirit" that Karol Wojtyła was able to learn about Judaism from within, as it were. One can suppose that the patriotic fraternity of Karol Wojtyła and his Jewish friends was a foundation upon which Catholic-Jewish dialogue commenced — something that would develop dynamically during John Paul II's pontificate. In light of this, it is easier to understand why the pope traveled to the death camp at Auschwitz where over one million people were murdered, mostly Jews, and said: "I could not have missed visiting this place." And thus he resolved to accomplish what none of his predecessors at the helm of the Catholic Church

17 Ibid., 87.

had managed to do before him: as pontiff, he entered a synagogue in a historic gesture of solidarity and reconciliation with the Jewish nation.

It seems highly probable that the Church needed a Polish pope, the son of a country where Christians and Jews lived peacefully side-by-side for a millennium, to remind the world about the historical connection between Judaism and Christianity. In the words of Gian Franco Svidercoschi, "It took a Pope like him, who always thought of Catholicism, and lived it out, as the continuation of the Old Testament — yes, it took a Pope like him to pray together with our 'older brothers,' which was how his faith in and great love for Holy Scripture taught him to call the Jewish people. As far as the Holy Father was concerned, the visit couldn't have ended any better than with Rabbi Toaff's remark in their private, informal conversation that took place after they had concluded the 'official' visit: 'We Jews are grateful to you Catholics for bringing the idea of the monotheistic God to the world.'"[18]

With John Paul II ever-present on the world stage, Poland, too, found its voice. The pope became its spokesman and a *de facto* leader during the late Communist period. Stefan Cardinal Wyszyński, one of the great Catholics of the 20th century and Poland's "Primate of the Millennium," commented on the miracle of the Polish pope's pontificate: "At a time when Poland is about to find itself in a difficult predicament, Providence has placed at the Vatican a man who may be — *via facti* — a defender of Poland. And he is. And now Poland will persevere."[19] And indeed it did.

If we assume, as British historian Norman Davies argues, that before the founding of the Solidarity movement "the essence of Poland's contemporary experience [was] humiliation,"[20] then it was John Paul II who relieved his people of this burden. The emergence of Solidarity, a peaceful movement of social self-defense led by Lech Wałęsa and focused on the moral rejuvenation of the Polish nation, served as an opening of Poland to the world.

> The foundation and development of Solidarity constituted a historical confirmation of the social order envisioned by the Pope and based upon

18 Dziwisz: *A Life with Karol*, 235.

19 Stefan Cardinal Wyszyński, Do Senatu Akademii Teologii Katolickiej [To the Senate of the Academy of Catholic Theology], Warsaw, March 9, 1981 — authorized text.

20 N. Davies, *Heart of Europe: A Short History of Poland* (London: Oxford University Press, 1995), 159.

a personalistic axiological-moral foundation.... The phenomenon of Solidarity is, in a way, a fulfillment of the historical experience of Polishness, because it is where the most mature elements of Polish culture, grafted onto the trunk of Christianity, reveal themselves. In the political and economic struggle Solidarity was waging against the Communist system, John Paul II saw the primacy of ethical rules. He recognized that the uniqueness and, in a sense, the paradigmatic aspect and moral force of the activities of Solidarity were based upon promoting the drive to reclaim the subjectivity of the working man. Thus it was not a matter merely of structural changes in the labor system, but of their realization in such a manner as not to lose sight of the crucial relationship between labor and man. [21]

There is no doubt the pope carried the spirit of Poland within himself. Not surprisingly, then, there is much that is essentially Polish in character that John Paul II injected into the history he helped shape throughout his pontificate. The Catholic Church of the 21st century has now absorbed many Polish traditions. And along with the love the world had for the Polish pope, many vestiges of his native country were retained as well in the hearts of the faithful around the globe. Poland, it seems, traveled with the pope. Indeed, as Svidercoschi put it, "To understand John Paul II is to understand his motherland, Poland." [22]

21 A. M. Wierzbicki, *Polska Jana Pawła II* [Poland of John Paul II] (Lublin: Instytut Jana Pawła II KUL, 2011), 12.

22 Dziwisz, *Świadectwo* [Testimony], 231.

FOUR

The Polish Pope and the Pontificate That Changed the World

John Paul II — a bolt of lightning across the Polish sky, illuminating our hearts and minds.... The voice of a comet calling from above, "Do not fear".... A fisher of men, he can silence the sea of human voices and summon the Holy Spirit; a shepherd who loves his fellow man; a teacher of nations; a green light given to great deeds by men with ordinary hearts; a hero of our times, he was able to forge the past of many nations into the present. A philosopher, artist ... with religion and the Lord God on his side; with truth and hope, the poetry of [the Polish romantic poet] Norwid, the sweetness of blackberries and honey on his side; on his side he has the lightness of a bee in flight, the tenderness of chirping songbirds, the breath of forests and mountains, the shadow of a pine tree, the rhythm of mountain streams, the fragrance of grass, and as his source the word; whoever wants to reach his ancient origins must walk uphill, against the current; cut through, and never give up.[1]

THE TREMENDOUS IMPACT—ON BOTH THE CHURCH AND the world—of John Paul II's pontificate was due not so much to the pope's accomplishments as a world leader as to his teaching and presence: his personal example, which opened up new paths to the Church.

John Paul II brought to his pontificate the experiences of a writer, priest, professor, bishop, and philosopher; he was a man capable of profound reflection. His philosophical system, born at the intersection of Thomism and phenomenology, was supplemented by a contemplative literary and theological vision.

1 A. Liszowski, *Dzieci Gór Sowich* [Children of the Owl Mountains], selected and with an introduction by B. Hebzda-Sologub (Studio Edytor: Dzierżoniów, 2007), 91–92.

39

At 26 years, John Paul II's pontificate was one of the longest in the two millennia of Christian history. After his passing, the editor of the Polish-language edition of *L'Osservatore Romano*, who was a personal friend of the Polish pope, believed that "the mystery of this pontificate was a limitless trust in Christ, which was marked by a deep, personal attachment to the Savior's Mother. *Totus Tuus* was for him a very real personal motto and program." [2]

In his teaching, John Paul II constantly invoked two synodal texts: the 22nd and 24th sections of Vatican II's Pastoral Constitution on the Church in the Modern World, *Gaudium et spes* (*Joy and Hope*). The teaching in section 22 stresses that Christ reveals his divine face and also the true meaning of human existence. Section 24 reminds us that human life reaches fulfillment in the giving of oneself to others, not in imposing one's own will on them.

> John Paul II radically recast the papacy for the twenty-first century and the third millennium by returning the Office of Peter to its evangelical roots. The world and the Church no longer think of the pope as the chief executive officer of the Roman Catholic Church; the world and the Church experience the pope as a pastor, an evangelist, and a witness. John Paul II broke the modern papal mold he inherited, not simply by being the first Slavic pope in history and the first non-Italian pope in centuries, but by living the kind of papal primacy envisioned in the New Testament: Peter as the Church's first evangelist, the Church's first witness to the truths revealed in the life, death, and resurrection of Jesus Christ.... Here, perhaps, is the most telling example of John Paul II, the radical—the man of bold innovation for whom change means returning to the Church's roots, which he believes are expressions of Christ's will for his Church. [3]

The Holy Father breathed a new life into the oldest institution in the world, the Church, by taking it back to its evangelizing beginnings: like the Apostles, he took the truth of the Gospels into the world through his pilgrimages, writings, speeches, and meetings with the powers that be. He was the most well-traveled of all popes, and perhaps of all statesmen. "We cannot wait for

2 A. Boniecki, "Jan Paweł Wielki" [John Paul the Great], *Tygodnik Powszechny* 5 (April 10, 2005), 3.
3 Weigel, *Witness to Hope*, 846.

the faithful at St. Peter's Square; we must go out to them," he used to say. [4] He made a total of 104 trips to 132 nations. He covered 1,247,613 kilometers—the equivalent of circumnavigating the earth more than thirty times. In Italy alone he undertook 146 short pastoral visits. The pope celebrated Mass in plazas, stadiums, and airports. He felt at ease outside the Vatican; indeed, it would seem he was more truly himself outside Italy's borders than in his private apartments at the Vatican. Even when he stayed put, he traveled, if only in his heart and mind: "My spirituality has something of a geographic dimension," he used to say. [5]

John Paul II commenced nearly every pilgrimage he undertook by kissing the soil as a gesture of respect for the inhabitants of the host nation. During most of his apostolic visits, he would at some point announce: "I have come here as a pope-pilgrim." The aim of each pilgrimage was to meet the faithful of the local church and strengthen them in their faith. There was an additional ritual from which the pope did not waver. Just as the kissing of the soil opened every visit, so did each culminate in Holy Mass. At its conclusion, John Paul II would entrust his host country to the Mother of God, to whom he had also entrusted himself.

"Because of his authenticity and fervent prayer, his demeanor and gestures, John Paul II became a favorite of the media. Practically all meetings of John II with the faithful were broadcast on television." [6] Thanks to the mass media, up to half a billion people could watch him simultaneously. Television viewers watched the pope pray for peace on earth, call for respect for the human person, and emphasize the right to liberty, faith, and freedom of conscience.

During his pontificate, John Paul II published 14 encyclicals, 15 exhortations, 13 apostolic constitutions, and 45 apostolic letters. In his first encyclical, *Redemptor hominis* (*Redeemer of Man*), he articulated the underlying principle of his pontificate: *The way of the Church ... is man.* "To realize how enormous was the scholarly contribution of our pope [John Paul II], one need only remember that his collected papal writings, published at the Vatican under his authorization, beginning in 1979 (as the series *Insegnamenti di Giovanni*

4 Dziwisz, *Świadectwo* [Testimony], 91.

5 Ibid., 92–93.

6 Centrum Jana Pawła II [John Paul II Center], http://www.janpawel2.pl/papie; accessed August 24, 2017.

Paolo II), contain over 20 volumes of about 1,000 pages each." [7] The pope promulgated two new codes of canon law, and the *Catechism of the Catholic Church*, the first work of this kind in over 400 years. He also penned many philosophical, theological, and literary works, including *"Be Not Afraid!"* (1982), *Crossing the Threshold of Hope* (1993), *Roman Triptych (Meditation)* (2003), *Rise, Let Us Be on Our Way* (2004), and *Memory and Identity* (2005).

John Paul II was responsible also for an unprecedented number of beatifications and canonizations. The Holy Father beatified 1,338 men and women in 138 ceremonies. During 51 canonization ceremonies, he proclaimed 482 new saints. He elevated 232 clergymen to the cardinalate, most likely a record in Church history. He also inaugurated many missionary activities, including World Youth Day, World Family Congress, and World Day of the Sick. "Even the pope's windows entered the history of pontifical preaching: at the Apostolic Palace in the Vatican, at the Kraków curia at 3 Franciszkańska Street, and at the Gemelli hospital. The windows became a symbol of unity and of the pope praying together with the faithful, for on nearly every Sunday and holy day there were crowds gathered outside, and additional millions tuned in to their TV's and radios to pray the Angelus with the Holy Father." [8] Those crowds would keep their vigil under the very same windows when John Paul II was called back to the Father.

Each pope has brought his own style to the Church. John Paul II's style was based on going out to the people. The Holy Father welcomed millions of believers from every corner of the world during general audiences. Over the years he entertained thousands of lunch or dinner guests, whether at his private apartments or during trips abroad. The pope spoke with the rich and the poor, the famous and the obscure. He admitted into his presence leaders whose hands were stained with blood. He walked among the destitute in the slums of Latin America and in other third-world countries.

John Paul II's fondness for entertaining friends is made touchingly clear in the following story. "Piotr and Teresa Małecki, longtime members of Karol Wojtyła's circle of friends, were staying in the papal villa at Castel Gandolfo in the late summer of 1997 as the Pope's guests. Their bedroom was just below his, and before dawn each morning they knew by the thumping of his cane

7 Dybciak, *Nowy elementarz Jana Pawła II* [A New John Paul II Reader], 255.

8 Centrum Jana Pawła II [John Paul II Center], http://www.janpawel2.pl/papie; accessed August 24, 2017.

that he was up and about. One morning, at breakfast, the Pope asked whether the noise was disturbing them. No, they answered, they were getting up for Mass anyway. 'But Uncle,' they asked, 'why do you get up at that hour of the morning?' Because, said Karol Wojtyła, the 264th Bishop of Rome, 'I like to watch the sun rise.'" 9

The pope highly respected women and dialogued with them.

> Ever since he was a boy, Karol Wojtyła's heart was saturated with a feeling that was characteristic of his people and its traditions. I mean a great respect for, and consideration of, women, especially women who were mothers. In the world at large, though, he saw the opposite tendency gaining ground: serious disrespect for women, to the point of regarding them as objects of enjoyment and pleasure. Well, all of that reinforced the Pope's determination to help women to recover their dignity and to acknowledge their specific role in society and the life of the Church. Pope John Paul II turned this "respect" and "consideration" into the Apostolic Letter *Mulieris Dignitatem* (*On the Dignity of Women*), which reads like a paean to women. *Mulieris Dignitatem* was just one of many expressions of that attitude. 10

At the beginning of his pontificate, John Paul told the young people of the world, "You are my hope." He said this because he believed it. The Holy Father inspired the young. He was emotionally tied to them. He was a father to them, a teacher, and, most of all, a friend. The pope demanded much of young people, but his demands were infused with so much love and care that he mobilized them to perform good deeds. He always maintained unequivocally that the role of young people in the Church was crucial. In an epistle he addressed them thus:

> You, young people, are ... the youth of nations and societies; you are the youth of every family and of all humanity; you are also the youth of the Church. So your youth ... is a special possession belonging to everyone. It is a possession of humanity itself.

9 Weigel, *Witness to Hope*, 864.
10 Dziwisz, *A Life with Karol*, 167.

In you there is hope, for you belong to the future, just as the future belongs to you.... To you belongs responsibility for what will one day become reality together with yourselves, but which still lies in the future. [11]

The same young people responded to the Holy Father's call. They flocked to the windows of the Apostolic Palace when the dying pope was preparing to stand before the Heavenly Father. "I was looking for you and now you have come to me and I thank you for it." So did the pope address the young people who had gathered to keep vigil for him at his residence when he was on his deathbed.

The greatness of John Paul II manifested itself in particular in his dialogue with world religions. He never wavered in his attempts to maintain a challenging interreligious dialogue. He broke down the barriers between the Catholic Church and Judaism. At the same time, he endeavored to protect the world from a war between Christians and Muslims. John Paul II's symbolic meetings with Muslims in Casablanca and in Damascus's Umayyad mosque were unprecedented. In Morocco, for the first time in history, a pope was invited officially by the Muslim state authorities to address the Muslim people. In Syria, he became the first pope ever to enter a mosque.

There is no exhaustive list of all the achievements and deeds of the Polish pope. Nor, for that matter, is there any one single key to the mystery of John Paul II. However, hope was undoubtedly one of the central themes of his pontificate. It was no accident that George Weigel entitled his papal biography *Witness to Hope*. Thus the pope had described himself when speaking at the United Nations in 1995: "I come before you as a witness: a witness to human dignity, a witness to hope, a witness to the conviction that the destiny of all nations lies in the hands of a merciful Providence." [12]

To recall John Paul II is to recall his sense of humor and, in his old age, a certain sense of dignity and of distance from his own sickness and weakness; it is to recall a man who fascinated people with his extraordinary personality, kind smile, and magical spontaneity; it is to recall a Polish pope who drew crowds because of his "otherness" — because he was truly "different": "It was

11 John Paul II, *Dilecti Amici* (Libreria Editrice Vaticana, 1985), https://w2.vatican.va/content/john-paul-ii/en/apost_letters/1985/documents/hf_jp-ii_apl_31031985_dilecti-amici.html.

12 Address of His Holiness John Paul II, United Nations Headquarters, New York, October 5, 1995 (Libreria Editrice Vaticana, 1995), https://w2.vatican.va/content/john-paul-ii/en/speeches/1995/october/documents/hf_jp-ii_spe_05101995_address-to-uno.html.

not only that he was a pope from a far-off country, but also that he surprised us with his free spirit." [13]

Furthermore, one cannot consider the legacy of John Paul II without taking into account his literary output, perhaps especially his plays. One must also think of the people Karol Wojtyła encountered on his way: he inspired them, supported them, gave them hope. Then there are the places to which he was devoted and which he visited as a priest, bishop, cardinal, and finally pope. Although the Holy Father's pilgrimage destinations, his writings, and his speeches do not reveal the full truth about his life, still they can illustrate the scope of his activities and testify to his great energy. "His entire pontificate, including all his globetrotting, presents a very unique type of theater. His radiant personality indicated a new kind of understanding of the papal office. It will be hard for the successors of our pope to reach the greatness of John Paul II, or [for their flocks] to have such a joyful relationship with the vicar of Christ on St. Peter's throne." [14]

Is that all there was to John Paul II? Of course not!

> It would seem that John Paul II said everything he had to say in his homilies and letters. However, he planted the most beautiful seed of all in the last days of his life. Out of his suffering he produced the most beautiful "encyclical," one distinct from its predecessors in that it can be read and understood by anyone and everyone. The sufferings of the pope were turned into this most beautiful text, one that required no commentary.... It was transparent and clear both to the mighty and to the humble of the world, to those vivacious in their youth and those with graying temples, and even to those standing apart from the Church. This "encyclical" differs from the previous ones the pope penned. It can be read more easily, although often with tears. It was addressed to the entire world. One could, if one wished, read it straight through. The media broadcast the suffering pope: extremely expressive, straightforward, in harrowing pain, and inspiringly heroic. [15]

13 K. Kutz, "Papież Jan Paweł II: 'Miejcie odwagę żyć dla miłości'" [Pope John Paul II: "Dare to Live for Love"], in *Sławni o Papieżu* [Celebrities on the Pope], http://www.papa.friko.pl/c/slawni.html.

14 Ibid.

15 J. M. Lipniak, *Jan Paweł II — Sługa miłosierdzia* [John Paul II: The Servant of Mercy] (Świdnica, 2006), 54.

On April 2, 2005, John Paul II returned to the House of the Father. What did this moment mean to the world? To the Poles?

> In a basic sense, it meant the same as it did to hundreds of millions of individuals of other nations on earth. Like us, they also felt orphaned following the passing of the Holy Father. But this pope served and "loved more than others" not only the Church universal but also specifically his native Polish "flock." And he felt especially responsible for it. We must remember, when we attempt to understand what Karol of Wadowice did for our community and what he expected from it — from us — [that his] mission was not, of course, aimed solely at the Poles. In John Paul II's spiritual struggles, the whole world was at stake. He opened the door to Christ and Christian hope not only in Poland, or Eastern Europe, but also in poor countries of the Third World. It was with special care that he responded to challenges in Africa, where he visited many times, as well as Latin America and Asia. As far as the nations of "old" Europe and the wealthy societies of North America were concerned, John Paul II passionately undertook a program of new evangelization, a return to the Christian order, which he called the civilization of love, in contrast to the culture of death: egotism, abortion, and euthanasia.[16]

Who was this native of Wadowice who became pope, who changed the face of the world and the Church? This "'peace-bringing' man believed in people to such a degree — even to the point of reaching out to those who sought to harm him — that he could ignite in them a desire to trust each other. And he believed in God to such an extent that he led them, perhaps, to desire of such faith as he himself felt. Such is the Pope. The *acta apostolica*, the crowds and the newspapers call him John Paul II. But the name that Christ gives him is Peter."[17]

16 A. Nowak, *Jan Pawel II: Kronika życia i pontyfikatu* [John Paul II: A Chronicle of His Life and Pontificate] (Kraków: Kluszczyński, 2014), 324.

17 A. Frossard, *Be Not Afraid: Pope John Paul II Speaks Out on His Life, His Beliefs, and His Inspiring Vision for Humanity,* translated by J.R. Foster (New York: St. Martin's Press, 1984), 252.

An Interesting Life in Difficult Times

FIVE

Karol Wojtyła's Life

Beauty is to enthuse us for work, and work is to raise us up.

C. K. NORWID, *Promethidion*

AS GEORGE WEIGEL STATED, "THE SHEER DRAMA OF KAROL
Wojtyła's life would defy the imagination of the most fanciful screenwriter." [1]
His childhood was marked by the deaths of those closest to him. Just when
a child most needs his parents and their love, Karol, known to family and
friends as Lolek, became a half-orphan. His beloved mother died when he
was not even ten. He never met his sister, who died before he was born. A few
years after his mother's death, Wojtyła lost his older brother. In an interview
with André Frossard, John Paul II recalled:

> At twenty, I had already lost all the people I loved and even the ones
> that I might have loved, such as the big sister who had died, so I was
> told, six years before my birth. I was not old enough to make my first
> communion when I lost my mother, who did not have the happiness of
> seeing the day to which she looked forward as a great day....
>
> My brother Edmund died from scarlet fever in a virulent epidemic
> at the hospital where he was starting as a doctor. Today antibiotics
> would have saved him. I was twelve. My mother's death made a deep
> impression on my memory and my brother's perhaps a still deeper one,
> because of the dramatic circumstances in which it occurred and because
> I was more mature.
>
> Thus quite soon I became a motherless only child. My father was
> admirable and almost all the memories of my childhood and adolescence

1 Weigel, *Witness to Hope*, 2.

are connected with him…. The mere fact of seeing him on his knees had a decisive influence on my early years. He was so hard on himself that he had no need to be hard on his son; his example alone was sufficient to inculcate discipline and a sense of duty. He was an exceptional person. He died almost suddenly during the war, under the Nazi occupation. I was not yet twenty-one. [2]

Karol Wojtyła was brought up in a patriotic tradition. Its central symbols included the royal Wawel Castle, the churches of Kraków — especially the cathedral — and the great tradition of Romantic poetry, in particular the Polish rhapsody of Juliusz Słowacki's *King-Spirit* and the symbolic "national theater," depicted by the playwright Stanisław Wyspiański in his historical drama cycle. Wojtyła viewed his own personal experiences of the war and German occupation through the prism of this literary tradition.

In difficult moments only faith kept him alive. His faith together with his strong character kept him safe from the temptations and illusions of youth. Later on, his faith would help him survive forced labor at a quarry in Kraków under the Nazis:

A few months after my father's death, I was transferred from the quarry to the factory itself, to the section which purified the water for the boilers. How did I come to be engaged in manual work? In the autumn of 1938, after leaving the lycée in Wadowice, I had enrolled at the Jagiellonian University of Cracow to study philosophy and Polish philology. A year later, the university was closed by the occupying power, and its teachers, many of them elderly and eminent, were deported to the concentration camp at Sachsenhausen. Hence the stone quarry, where several of my fellow students came to work with me. No doubt I owe much to one single year's study at Poland's most ancient university, but I am not afraid to say that the following four years, in a working-class environment, were for me a blessing sent by Providence. The experience that I acquired in that period of my life was priceless. I have often said that I considered it possibly more valuable than a doctorate, which does not mean that I have a poor opinion of university degrees! [3]

2 Frossard and John Paul II, "*Be Not Afraid!*," 13–14.
3 Ibid., 14–15.

It was during the Second World War that Karol Wojtyła came to sense a calling to the priesthood. War was ravaging everything around him. He had earlier rejected the priestly calling as a student, but, witnessing the reign of evil and the atrocities of war, he felt the meaning of priesthood and its purpose once again become crystal-clear to him. In *Gift and Mystery*, John Paul II writes:

> My priestly vocation took definitive shape at the time of the Second World War, during the Nazi occupation. Was this a mere coincidence or was there a more profound connection between what was developing within me and external historical events? It is hard to answer such a question. Certainly, in God's plan nothing happens by chance. All I can say is that the tragedy of the war had its effect on my gradual choice of a vocation. It helped me to understand in a new way the value and importance of a vocation. In the face of the spread of evil and the atrocities of the war, the meaning of the priesthood and its mission in the world became much clearer to me. [4]

George Weigel elaborates further on Wojtyła's discernment process: "Now, an idea that would eventually become one of his deepest convictions began to take shape: that in the sometimes baffling designs of Providence, there is no such thing as a mere coincidence. An orphan before his majority; his intellectual gifts and his longstanding bent toward a life of prayer; the hardships he had endured during the Occupation; his passion for the theater — like the people who had touched his life most profoundly, these were not fragmentary incidents in a life, but signposts along a path pointing in the direction of the priesthood." [5]

Wojtyła would discover his vocation at the underground Rhapsodic Theater, where, along with other literature lovers, he recited poetry. John Paul II later recalled: "After my father's death, which occurred in February 1941, I gradually became aware of my true path. I was working at the factory and devoting myself, as far as the terrors of the occupation allowed, to my taste for literature and drama. My priestly vocation took shape in the midst of all that, like an inner fact of unquestionable and absolute clarity. The following

4 John Paul II, *Gift and Mystery: On the Fiftieth Anniversary of My Priestly Ordination* (New York: Image Books, 1996), 34.
5 Weigel, *Witness to Hope*, 69.

year, in the autumn, I knew that I was called. I could see clearly what I had to give up and the goal that I had to attain, 'without a backward glance.' I would be a priest."[6]

In October 1942, Wojtyła entered an underground Catholic seminary. He commenced his studies under the Faculty of Theology at the Jagiellonian University in Kraków, which, of course, operated in secret. He also continued to work as a laborer at Solvay. But he stopped acting in the Rhapsodic Theater.

On November 1, 1946, Wojtyła was ordained a priest by the metropolitan archbishop of Kraków, Adam Stefan Sapieha. Karol Wojtyła turned his mind to this day of utmost importance many times, as in the following account: "My ordination took place on an unusual day for such celebrations: it was on 1 November, the Solemnity of All Saints, when the Church's liturgy is wholly directed to celebrating the mystery of the Communion of Saints and preparing to commemorate the faithful departed. The Archbishop had chosen that date because I was scheduled to leave for Rome to continue my studies. I was ordained by myself, in the private chapel of the Archbishop of Cracow."[7]

The future pope spent the next two years in Rome. Wojtyła later recalled his intensely active sojourn in Rome as follows:

> I will never forget my feelings during those first "Roman" days of mine, when in 1946, I began to get to know the Eternal City. *I enrolled in the two-year doctoral program at the Angelicum....*
>
> I came to Rome with an eager desire to see the Eternal City, beginning with the catacombs. And so it happened. Together with friends from the Belgian College, where I lived, I was able systematically to explore the city under the guidance of those who knew its monuments and history.
>
> But Rome was always the center of our experience....
>
> ...
>
> My priesthood and my theological and pastoral formation were part of my Roman experience from the beginning.... At the beginning of July 1948 I defended my doctoral dissertation at the Angelicum and then immediately left for Poland. As I mentioned earlier, I had made every effort during my two-year stay in the Eternal City to "learn" Rome: the Rome of the catacombs, the Rome of the confessors of the faith. I often

6 Frossard and John Paul II, "*Be Not Afraid!*," 15.
7 John Paul II, *Gift and Mystery*, 41.

think back on those years with great emotion. As I left, I took with me not only a much broader theological education but also a strengthened priesthood and a more profound vision of the Church. That period of intense study close to the tombs of the Apostles had given me much, from every point of view. [8]

Wojtyła's first priestly assignment was as a vicar at the Church of the Assumption of the Mother of God in Niegowić. After a year he was transferred to the parish of St. Florian in Kraków. "During his years at St. Florian's, Father Wojtyła initiated a series of intellectual, liturgical, cultural, and pastoral innovations that changed the character of student chaplaincy in the Archdiocese of Kraków while rebutting, point-for-point, the effort by Poland's Stalinist rulers to reinvent the country's history and culture." [9]

In 1954, Karol Wojtyła earned his habilitation, a post-doctoral degree, at the Jagiellonian University. His thesis focused on the possibility of constructing a Christian ethics using the philosophical system of Max Scheler. Upon the dissolution of the Jagiellonian University's Department of Theology by the communists, Wojtyła began to lecture at the Catholic University of Lublin, the only non-state-run institution of higher learning in the Soviet bloc. There he was appointed to the Chair of Ethics in the Department of Philosophy. Appointment as an auxiliary bishop of Kraków followed soon after. In 1963 Pope Paul VI raised him to the level of an ordinary, as metropolitan archbishop of Kraków.

At that time, the communist regime was putting increasing pressure on the Church. The new metropolitan was faced with an urgent question: "How to overcome the reality of a new communist occupation and transform Poland's liberation into 'a gateway to Christ'? This question must have bothered Wojtyła, first as a young priest and then as a bishop. And in this context one should perhaps understand those activities of his that ultimately led him to St. Peter's Square in Rome, where, echoing his words from about 40 years before, he repeated: 'Open up the gates for Christ.' At this moment, he, the pope from Poland, became the keymaster of the 'gates of Christ,' opening them up for the whole world." [10]

8 Ibid., 51–52, 69, 75–76.
9 Weigel, *Witness to Hope*, 95.
10 A. Nowak, Introduction to B. Gancarz, J. Szarkowa, Okarm, *Alfabet Jana Pawła II* [John Paul's Alphabet: 1920–2005] (Kraków: Kluszczyński, 2005), 6.

Dominus adest et vocat te (The Lord is here and he is calling you). Those words, spoken to Karol Wojtyła during the conclave in October 1978, marked the beginning of the pontificate of John Paul II.

> The Lord called upon the priest from Kraków to serve the Church universal; he called upon the actor of the Rhapsodic Theater to play the most important role of his life, to serve as the successor of Saint Peter, who was to guide humanity across the threshold of the approaching third millennium.... Wojtyła accepted his election as a providential fulfillment of the prophecy expressed in [Polish Romantic poet Julius] Słowacki's poem about a Slavic pope. He accepted the election as confirmation of the mission which he first considered while a twenty-year-old student. The mission was no longer limited to the part of Europe which was closest to him for it was Slavic and sharing the same fate — communist persecution. After the election of the pope from Poland, the mission now encompassed the whole world.[11]

> In the middle of the battle God will ring a vast bell.
> For a Slavic Pope
> He has also prepared a throne.
> Listen, a Slavic Pope will come
> A brother of the people.[12]

Cardinal Stanisław Dziwisz recalled Wojtyła's elevation to the Throne of Saint Peter as follows:

> Well, then, the conclave began on October 14, 1978. The whole next day was a contest between supporters of Giuseppe Siri, the archbishop of Genoa, and backers of Giovanni Benelli, the archbishop of Florence.... The following day, October 16, began with two rounds of voting, in which Wojtyła garnered a certain amount of support.... On the eighth day of voting, the archbishop of Cracow was elected, collecting almost 100 [99 out of 111] votes. The cardinals decided to elect a person from a "far-away land," from behind the Iron Curtain. This was the first Slavic pope. This was

11 Ibid., 39.
12 Julius Słowacki, "The Slavic Pope," in *Poems*, vol. 1 (Wrocław: Ossoliński, 1959), 250–51.

the first non-Italian pope in almost five hundred years. I was at the square
next to the gate of the Vatican Basilica, when I heard his name spoken
by Cardinal Pericle Felici. For a moment I feared that my heart would
burst. I screamed like a madman, but everyone around was screaming as
well. I thought about him, dressed in white. I thought about my Poland,
celebrating for sure, surprised, shocked to the core. The primate [Cardinal
Stefan Wyszyński] then went to Wojtyła's room to comfort and encourage
him — and to urge him to accept. He repeated to Wojtyła the question at
the heart of Sienkiewicz's novel *Quo Vadis?* (Where Are You Going?),
which Jesus asks Peter as the apostle tries to slip out of Rome. But then
he softened his tone and begged Wojtyła not to refuse if he should be
elected. And he added, "The new Pope's task will be to lead the Church
into the third millennium".... Meanwhile, the white smoke was rising from
the chimney of the Sistine Chapel.... But there were some who weren't
rejoicing, who were literally in a state of shock and trauma on account of
Wojtyła's election. In Poland, the news was held back from publication,
because the Central Committee of the Communist Party was at a loss as
to how to convey it, how to mitigate the explosive repercussions Karol
Wojtyła's election to the Holy See was bound to have. It wasn't just in
Poland that there was such huge dismay. It was all over the Communist
world, especially in the Kremlin. For ten days, there was absolute silence
in the empire. No statement. No comment. History had taken sensational
revenge on those who thought they could erase God from men's lives.[13]

What a glorious moment! Back in Poland, Jarosław Iwaszkiewicz, then the
chairman of the Union of Polish Writers (the only official organization of its
kind in Poland), was visibly touched:

John Paul II has now ushered Polish history and culture into the worldwide
orbit of politics and global issues. Karol Wojtyła ascended the throne [of
St. Peter] armed with the experience of his nation's one-thousand-year
history, with the intense historical experience of his own life.... Poland's
European culture ascended the throne together with him. More precisely,
perhaps, it was the culture of Kraków.... By being called to St. Peter's

13 Dziwisz, *A Life with Karol*, 60–62, 65.

beyond the gates of the Vatican, Polish culture has experienced a great honor in the person of a graduate of two Polish universities, ... a scholar and a Polish poet.... I believe that the election of Cardinal Wojtyła as pope could be an opening of a window to Polish culture, which is so stubbornly ignored in the West, for the whole world to see.[14]

The election of a pope from Kraków had a symbolic dimension. It was not only the calling of one man, but of the entire Polish Church of which he had been a part since his birth:

It is a Church marked by a thousand-year-old heritage of faith, a Church which down the centuries has produced many saints and blesseds, and is entrusted to the patronage of two saintly Bishops and Martyrs: Adalbert and Stanislaus. It is a Church closely linked to the Polish people and their culture, a Church which has always upheld and defended that people, especially in the tragic periods of its history. It is also a Church which has experienced severe trials in this century: it had to endure a dramatic struggle for survival against *two totalitarian systems*: the regime inspired by the *Nazi ideology* during the Second World War and then, in the long postwar period, a *communist dictatorship* and its militant atheism. From both trials the Polish Church emerged victorious, thanks to the sacrifices of Bishops, priests and countless lay people; thanks too to the Polish family, which is "strong in God." Among the Bishops of the war period I cannot fail to mention the staunch figure of the Prince Metropolitan of Cracow, Adam Stefan Sapieha, and, among those of the postwar years, that of the Servant of God Stefan, Cardinal Wyszyński. The Polish Church is a Church which has defended man, his dignity and his fundamental rights; it is a Church which has fought courageously for the right of believers to profess their faith. And it is a Church which has remained extraordinarily dynamic, despite the difficulties and obstacles which stood in its path.[15]

The election of a Pole as a successor of Saint Peter indirectly meant the calling of the nation to which Karol Wojtyła belonged. He came to Rome

14 Dybciak, *Jan Paweł II w literaturze polskiej* [John Paul II in Polish Literature] (Warsaw: Centrum Myśli Jana Pawła II [Center for the Thought of John Paul II], 2008), 129–30.
15 John Paul II, *Gift and Mystery*, 65–66.

from a distant land: "In fact, the geographical distance is not great. By air, the journey takes barely two hours. In calling it a 'far country' I intended to allude to the presence of the 'iron curtain.' The Pope from behind the iron curtain truly came from afar, even if, in reality, he came from the very center of Europe. The geographical center of the Continent is actually located on Polish territory."[16] The election of the Polish pope focused the world's attention on Poland as the new Pope and his fellow countrymen had always seen it, long before his elevation to the throne of St. Peter: "Poland has generally been described, even in the official gazette of the Apostolic See, as the *antemurale christianitatis*, the 'rampart of Christendom.'"[17] And "the Pope, who was recalled from the ramparts, brings us the experience of this long Polish watch which still goes on."[18]

On the day of the official inauguration of the Slavic pope, October 22, 1978, John Paul II spoke to the world, but he addressed in particular his fellow countrymen who suffered under the communist yoke: "To the See of Peter in Rome there succeeds today a Bishop who is not a Roman. A Bishop who is a son of Poland. But from this moment he too becomes a Roman. Yes — a Roman. He is a Roman also because he is the son of a nation whose history, from its first dawning, and whose thousand-year-old traditions are marked by a living, strong, unbroken and deeply felt link with the See of Peter, a nation which has ever remained faithful to this See of Rome. Inscrutable is the design of Divine Providence!"[19]

Afterwards, John Paul II addressed the fears of modern man: "Brothers and sisters, do not be afraid to welcome Christ and accept his power. Help the Pope and all those who wish to serve Christ and with Christ's power to serve the human person and the whole of mankind. Do not be afraid. Open wide the doors for Christ. To his saving power open the boundaries of States, economic and political systems, the vast fields of culture, civilization and development. Do not be afraid. Christ knows 'what is in man.' He alone knows it."[20]

16 John Paul II, *Memory and Identity*, 142.

17 Letter of [future Pope] John Paul II to Cardinal Wyszyński, Primate of Poland, *Acta Apostolicae Sedis* (December 17, 1965), 58.

18 Dziwisz, *A Life with Karol*, 22–23.

19 Homily of His Holiness John Paul II for the Inauguration of His Pontificate, St. Peter's Square, October 22, 1978 (Libreria Editrice Vaticana, 1978), https://w2.vatican.va/content/john-paul-ii/en/homilies/1978/documents/hf_jp-ii_hom_19781022_inizio-pontificato.html.

20 Ibid.

The idea of opening the doors for Christ was metaphorical, of course. After all,

> It is all about the place of religion in the life of societies. The experience of Poland under communism suggests to Karol Wojtyła that freedom of religion is an indispensable part of civil liberty. Even more: it is its crown. Marxist regimes close their doors not only to God, but also to the world. This laconic phrase contains the program of John Paul II's entire pontificate.... But for now, the door of his homeland remains closed even to him.... There is no doubt that the Pope's visit to Poland will serve as a litmus test for his treatment by the movers and shakers of the communist empire. They seem to take the election of John Paul II as a challenge, perhaps even the result of an anti-communist plot. [21]

Subsequently, the communist authorities would do everything in their power to prevent the Pope's visit to his homeland, because they feared he could awaken a yearning for freedom among the Poles. In particular, the regime feared the starting date of his planned pilgrimage: the 900th anniversary of the martyrdom of Saint Stanislaus, the bishop who had died defying secular authorities. Shortly before the conclave in 1978, Wojtyła wrote a poem entitled "Stanislaus," and now it acquired a symbolic dimension. The poem describes martyrdom as the source of Polish national identity and the universal paradigm of the Christian vocation. Poland is "a land of difficult unity, a land of people seeking their own way.... This is a land subject to the liberty of each vis-à-vis all others. This is a land ultimately torn up for nearly six generations, torn out of the maps of the world! And the same applies to the fate of its sons!" [22] However, during the national martyrdom, just as in the martyrdom of Bishop Stanislaus, Poland remained "united as ever in the hearts of the Poles." [23]

Loneliness and pain had accompanied Wojtyła since childhood, when he lost so much of his family. Later he would suffer a serious accident: a German truck hit him during the Second World War. He also suffered as a forced laborer in a Nazi quarry. He carried the burden of grave responsibility as a

21 Moskwa, *Droga Karola Wojtyły* [The Road Traveled by Karol Wojtyła], 5–8.

22 K. Wojtyła, "Stanislaw," in *Poezje i dramaty* [Poetry and Drama] (Kraków: Znak, 1998), 118–21.

23 Tenże, *Wstańcie, chodźmy!* [Arise, let's go!] (Kraków: Św. Stanisława BM, 2004), 76.

bishop under the communist regime in Poland. Later, during the final years of his pontificate, he would struggle with Parkinson's disease, moving about in a wheelchair and losing his voice. Nonetheless, John Paul II endured his final illness and physical pain with great patience and serenity of spirit. The Lord's Athlete (*Atleta di Dio*), as the Italians dubbed him, even when bent under the weight of the cross of his illness, never retreated into the privacy of the Vatican but remained with the people and the world until the end.

Almost the entire life of the Holy Father was one of breaking down walls and building bridges. All the circumstances of his life came together to shape a man of an incredible boldness, who knew about life, poverty, loneliness, pain, and violence, but also faith, solidarity, love, and hope.

In the following reminiscence, Gian Franco Svidercoschi vividly captures the nature and depth of the impact John Paul II had on so many:

> Of all images of Karol Wojtyła, the one that has remained most vividly in my mind's eye and in my heart comes from his first papal visit to Poland, in June 1979, and, in particular, from his now-famous meeting with the university students.... As soon as the pope started speaking, the whole crowd was seized with excitement. And at the end of Wojtyła's speech, his thousands of young listeners, as if on cue, simultaneously raised their little wooden crosses toward him.
>
> At the time, I grasped only the political implications of what was happening.... But the sea of wooden crosses contained the seeds of something much greater than a popular revolution. They held a "mystery," of which I wasn't completely aware at the time. I saw this mystery again twenty-six years later in the endless throngs that came to say their last farewell to John Paul II. This second time, I knew what I was seeing.
>
> These crowds revealed, I think, the profound meaning of Karol Wojtyła's legacy. He showed the face of God, God's human visage, if you will. He displayed the features of God incarnate. He thus became an interpreter and instrument of God's fatherhood, a man who narrowed the gap between heaven and earth, transcendence and immanence. And in so doing, he laid the groundwork for a new spirituality and a new way of living the faith in modern society. [24]

24 Svidercoschi, preface to Dziwisz, *A Life with Karol*, xi–xii.

SIX

Wadowice, My Town

It was here, in this town of Wadowice, that it all began. My life began. And school began, my studies began, and theater began, and priesthood began.... As they say, there is no place like home. [1]

JOHN PAUL II

KAROL WOJTYŁA WAS BORN ON MAY 18, 1920, IN WADOWICE. In this little town on the Skawa River in a mountainous region of southern Poland, the future pope attended grade school, and then the state high school.

Quite early on, Wojtyła developed an interest in Polish literature. "From my earliest childhood I have loved books. It was my father who introduced me to reading. He would sit beside me and read to me, for example, Sienkiewicz and other Polish writers. After my mother died, the two of us remained alone. He continued to encourage me to explore good literature and he never stood in the way of my interest in the theater." [2]

Already in high school, young Wojtyła intensively absorbed the classics of Polish romanticism. The great poets of the nineteenth century were defenders of the soul of the nation during that period, an era of partitions, uprisings, and stubborn efforts by the two partitioning powers of Russia and Germany to destroy the native Polish culture and language through forced absorption into their own traditions.

Further, Wadowice boasted of being a regional center of literary culture, including municipal and amateur theater. While in high school, Karol Wojtyła zealously participated in local literary activities. The theatrical debut of the

1 Homily of His Holiness John Paul II at Wadowice, Poland, June 16, 1999: https://www.youtube.com/watch?v=4GAalKFGZlQ.

2 John Paul II, *Rise, Let Us Be on Our Way*, trans. Walter Zięmba (New York: Warner Books, 2004), 94.

future pope was a role in Polish Renaissance poet Jan Kochanowski's *Sobótka*; he gained local fame by starring in the *Lancers of Prince Joseph* (Ułani księcia Józefa). In high school, he also starred in *Balladyna* and *Kordian* by Słowacki, *Zygmunt August* by Wyspiański, and *Śluby Panieńskie* by Fredro. According to his classmate and, later, a Cracow theater actress, Halina Królikowska-Kwiatkowska, "in general, we believed in high school that Karol Wojtyła would become an actor. He was well built and handsome; he had a beautiful voice, incredible memory, and very good elocution. He was a deep thinker and a sensitive person. Everything predestined him to be an actor." [3]

After sixty-four years had passed, Karol Wojtyła still remembered the role of Haemon in Sophocles's *Antigone*, and during his first papal pilgrimage to Poland, he recited his lines at the Wadowice marketplace: "O beloved sister of mine, Ismene, can't you see that the fates shall spare us none of Oedipus's tragedy?" [4]

As he approached high school graduation, Wojtyła became increasingly involved in theatrical performances at the Catholic House, a clubhouse erected in Wadowice by the local parish with the help of the Diocese of Kraków. At age sixteen, he was a lead actor in the great classics of Polish drama. Directing *The Apocalypse of St. John* was also a formative experience for him.

Around this time, the young man began to write ballads about the Beskidy mountains. Although now lost, the ballads were a reaction — partly negative — to *Beskid Pugsinogi* by Emil Zegadłowicz, a regional poet inspired by folklore who used local dialect in his compositions.

Finally, while in high school, Wojtyła met the great dramatist Mieczysław Kotlarczyk, who was to become a good friend. "I met him as a pioneer of original theater in the most noble meaning of this word, as an exponent of both Polish and Christian traditions of this art form, which have been bestowed upon us through our literature, and, principally, our great Romantic and neo-Romantic literature," [5] he would later recall.

3 H. Królikowska-Kwiatkowska, "Teatralne poczatki" [Theatrical Beginnings], in Dybciak, *Jan Paweł II w literaturze polskiej* [John Paul II in Polish Literature], 42.

4 T. Ponikło, ed. *Jan Paweł II: Święty z Wadowic* [John Paul II: The Saint from Wadowice] (Kraków: Wydawnictwo M, 2014), 26–27. http://www.encyklopediateatru.pl/artykuly/10846/jan-pawel-ii-gralem-hajmona.

5 Cardinal K. Wojtyła, afterword to M. Kotlarczyk, *Sztuka żywego słowa. Dykcja, ekspresja, magia* [The Art of the Living Word: Diction, Expression, Magic] (Rome: Gregorian University Press, 1975), 28.

"Kotlarczyk was both a 'deep Christian believer' and 'a man of one idea, the theater,' for whom the drama was the most important thing in life because it was a 'way of perfection,' a means of 'transmitting the Word of God,' the truth about life." [6] He believed in the power of words to evoke emotions as well as communicate ideas. The actor's role was to introduce the listener to the truth of the spoken word that could reach and touch him deeply. Kotlarczyk's "theater of inner word" gives absolute priority to "the word." "It's certain that Kotlarczyk understood *the liturgical character of theatrical action,* the way in which it revives the presence of a universal value which renews mundane existence, judging its falsity but at the same time offering the possibility of entering into a new dimension and an unexpected authenticity. If one radicalized this perspective, there is little distance between the profession of the actor and that of the priest." [7] His "theater of the inner word" would make present universal truths and universal moral values, standing in judgment on the here-and-now and offering the world the possibility of authentic transformation.

As Rocco Buttiglione said: "Kotlarczyk's theory of Rhapsodic Theatre was not to attain its complete formulation until the years of Resistance, when he had moved to Cracow.... He spoke especially of the evocative power of words, which not only communicate a meaning but also elicit an emotion, at once both entirely subjective and entirely objective; it is this power through which speech is lived. The value is in the profound intimacy of the speaker with those who listen: it is the actor who, through a unique personal ascesis, introduces us to that intimacy. The import of the performance, the plot, the communicative function in the usual sense is, of course, drastically reduced in this type of theatre." [8]

Undoubtedly, Karol Wojtyła's encounter with Mieczysław Kotlarczyk and the Theater of the Word, together with his immersion as a young high school student in the literature of Polish romanticism, constituted a foundation for future reflection about his coming choices in life and the possibility of reconciling religion and art. However, if the thought of the priestly vocation came into his head from time to time, it was but a fleeting thought. His high

6 Weigel, *Witness to Hope,* 37.

7 R. Buttiglione, *Karol Wojtyła: The Thought of the Man Who Became Pope John Paul II,* trans. P. Guietti and F. Murphy (Grand Rapids, MI: William B. Eerdmans, 1997), 22.

8 Ibid., 21.

school friend Antoni Bohdanowicz recalls, "in the first years I knew Lolek I was convinced that he would be a priest. And it looked like I was right when suddenly theater appeared on his road of life.... Theater changed his aspirations; hence, he studied Polish literature at the UJ [Jagiellonian University]. But it changed nothing in his burning zeal for God and religion." 9

Wojtyła wanted first and foremost to create, to be a poet. After high school graduation he resolved to study literature at the Jagiellonian University in Kraków. It proved to be an important decision in his intellectual and spiritual journey. The study of Polish philology was to be a gateway to literature; literature led to philosophy and theology—and finally to priesthood. Providence put him on a path to become a poet first, before becoming pope.

9 A. Bohdanowicz, "Żywot gimnazjalny" [Life in High School], in Dybciak, *Jan Paweł II w literaturze polskiej* [John Paul II in Polish Literature], 41.

Alma Mater:
The Jagiellonian University

As for my studies, I would like to emphasize that my choice of Polish
language and letters was determined by a clear inclination towards
the study of literature. Right from the beginning of the first year,
however, I found myself attracted to the study of the language itself. [1]

JOHN PAUL II

IN THE SUMMER OF 1938 KAROL WOJTYŁA LEFT WADOWICE
and moved to Kraków, where he enrolled as a freshman for the fall semester
at the Jagiellonian University. His college and wartime friend Tadeusz Kwi-
atkowski recalled when he was first introduced to the future pope at a college
preparatory camp: "He came from Wadowice — [his friend] Jurek told us. . . .
Jurek mentioned that Wojtyła was a good poet and that he wrote deep poetry,
which the guys at the camp didn't understand. I was surprised because our new
acquaintance did not look like an exalted poet who could fascinate me with
his creativity. . . . I had not spoken to him enough to gauge whether he really
was as brilliant as Jurek would have it. I familiarized myself with Wojtyła's
poems only at the beginning of the semester." [2]

At the time, Kraków was among the cultural and intellectual hubs of Poland,
along with Warsaw, Lwów, and Wilno. The department of Polish philology
was a safe haven for future writers at the Jagiellonian University, one of the
oldest of central European universities (having been founded in 1364) and
one of the most illustrious centers of Polish scholarship — Copernicus, for
instance, studied there. This was where Christian and humanistic culture

1 John Paul II, *Gift and Mystery*, 7.

2 T. Kwiatkowski, "Byl od nas zupelnie inny" [He Was Quite Different from Us], in Dybciak,
Jan Pawel II w literaturze polskiej [John Paul II in Polish Literature], 50.

met. "As Karol Wojtyła would write years later, it was difficult to study at such a university without being moved emotionally; its pathways could not be walked 'without due piety.'" [3]

The young man from Wadowice soon entered the circle of writers-in-training among the university students. Shortly after commencing his studies, he began participating in evening soirées of young poets. He delighted them with his reading.

> His was an expressive form of recitation, yet a simple one at the same time. It was characterized by a flawlessly precise diction and a feel for the phrase of the poem that was totally *sui generis*. Then we heard his voice: unique in timbre, it was beautifully accented, warm, soft, not too low, expressing some kind of irreplaceable intimacy that was his own and belonged only to him. The voice carried and rang; it was magnificently audible. Already then it was destined to be heard in large plazas, gigantic stadiums, on airport tarmacs, and under the cupolas of the most splendid basilicas of all the earth's continents, from Guadalupe to the desert interior of Australia's outback. [4]

Karol Wojtyła soon also joined the Literature Club. This was a student organization devoted not only to reading literary works, including the members' own, but also to debating problems of contemporary culture. He studied French. He enrolled in the lectures of the most brilliant experts on Polish language and literature of his day: Zenon Klemensiewicz, Stanisław Kot, Kazimierz Nitsch, and Stanisław Pigoń.

Yet, reflecting the place and time, Wojtyła really led the normal life of a young student of Polish literature. He did not pay much attention to his success. His friends remembered him as being very sociable, recalling only positive aspects of his character.

> He was a funny man, friendly, and the first one to offer help to the unfortunate and sick. He played sports. He was not at all rigid. However, we were always aware that somehow he possessed a hermetic intellectual

3 Weigel, *Witness to Hope*, 40.

4 D. Michałowska, "Decydujące dwa tygodnie" [Two Decisive Weeks], in Dybciak, *Jan Paweł II w literaturze polskiej* [John Paul II in Polish Literature], 59.

universe, that he was deeply religious, that he was the most capable of us all, that he read difficult philosophical treatises, and that he studied much and did not waste any time. We knew that he wrote — poetry, poetical works, and philosophical dramas, which were too complicated for us. When he talked with you, he always listened carefully, but there would be always — there still is, even today — a touch of humor, or a hint of mild irony, or, perhaps, merely indulgence for every person with whom he spoke, for he never condemned, never lectured, but he always understood. [5]

During his freshman year, Karol Wojtyła began to grasp the nature of language — that without genuinely mastering it, there is no proper communication. Recalling his student days at the Jagiellonian University, the pope wrote in *Gift and Mystery*:

> We studied the descriptive grammar of modern Polish as well as the historical evolution of the language, with a special interest in its ancient Slavic roots. This opened up completely new horizons for me; it introduced me to *the mystery of language itself, perhaps even into the mystery of the word.* The word, before it is ever spoken on the stage, is already present in human history as a fundamental dimension of man's spiritual experience. Ultimately, the mystery of language brings us back to the inscrutable mystery of God himself. As I came to appreciate the power of the word in my literary and linguistic studies, I inevitably drew closer to the mystery of the Word — that Word of which we speak every day in the Angelus: "And the Word became flesh and dwelt among us" (Jn 1:14). Later I came to realize that my study of Polish language and letters had prepared the ground for a different kind of interest and study. It had prepared me for an encounter with philosophy and theology. [6]

Unfortunately, the outbreak of the Second World War in September 1939 dramatically changed the life of our young student: "True, the professors of the Jagiellonian University tried to start the new academic year in the usual

5 Królikowska-Kwiatkowska, "Teatralne poczatki" [The Theatrical Beginnings], in Dybciak, *Jan Paweł II w literaturze polskiej* [John Paul II in Polish Literature], 43.
6 John Paul II, *Gift and Mystery*, 7–8.

way, but the lectures lasted only until November 6, 1939.... On that day the German authorities assembled all the teachers in a meeting which ended with the deportation of those distinguished scholars to the Sachsenhausen concentration camp. The period of my life devoted to the study of Polish language and letters thus came to an end, and the period of the German occupation began."[7]

7 Ibid., 8.

EIGHT

Theater in the Life of Karol Wojtyła

I believe in my theater and I would absolutely like to co-create it,
for my theater would be different from all others, and it would not
break man; instead, it would uplift and inspire him; it would not
corrupt but over-angelify. There is such a desire in me to work in
my homeland [once this war ends]. As an artist, I do not carry the
sword. But I long to build a theater and write poetry for my home-
land, even for next to nothing, with all my Slavic soul, eagerness,
and youth, with my sleeves rolled up. [1]

WHEN YOUNG KAROL WOJTYŁA FIRST MET THEATER DIREC-
tor Mieczysław Kotlarczyk, he was Wojtyła's high school Polish language
teacher. It was at this time that Kotlarczyk began to develop his concept of
Rhapsodic Theater, initially known as "the theater of the inner word." Wojtyła
would later recall his own involvement in this project:

> At the beginning my involvement in the theater was helped by having
> Kotlarczyk and his wife Sofia as guests in my home; they had managed
> to move from Wadowice to Cracow, within the Governorate General
> territory. We all lived in the same house. I was working as a laborer, he
> as a tram-driver at first, and later as an office-worker. Sharing the same
> house, we were able not only to continue our conversations about the
> theater, but also to attempt some actual performances. These took the
> form, precisely, of a theater of the word. It was all quite simple. The scenery
> and decoration were kept to a minimum; our efforts were concentrated
> essentially on the delivery of the poetic text. [2]

1 K. Wojtyła, Letter to Mieczysław Kotlarczyk, November 1939, from the author's collection.
2 John Paul II, *Gift and Mystery*, 10–11.

The artistic foundation of the Rhapsodic Theater was "the cult of the living and pure Word. That was autonomous, and even authoritative, in this theater. That means it was absolutely independent from the conventional props of a traditional theater. It was a theater without the curtain or the stage, without decorations, costumes, or masks. It was more focused, more spiritual, more inward. This was the theater of the living and pure Word." 3 The primary goal was an active, scenic revaluation of the poetic word and its artistic values, mainly stemming from Polish romanticism and post-romanticism — finding a place where word spoken and word incarnate coexist and together enter "into a new dimension and unexpected authenticity." 4 Karol Wojtyła, who as both a thinker and a performer was the pillar of Kotlarczyk's theater of the word, undoubtedly pondered the step towards the priesthood as he commenced his studies and his focus on the word at the Jagiellonian University.

But his studies were not destined to last. As a result of the signing on August 23, 1939 of the secret Ribbentrop-Molotov Pact, which created the Nazi-Soviet alliance, Hitler's armies invaded Poland on September 1, 1939, and Stalin's troops joined them on September 17. Poland was partitioned and fell under two totalitarian occupations. It was against this inauspicious backdrop that the theater of the word took shape as a performing ensemble:

> Kotlarczyk and his crew commenced public activities, although clandes-
> tine and illegal on account of the Nazis, and he continued this through-
> out the occupation.... Over twenty performances took place in private
> apartments, sometimes in the presence of such important individuals
> as Zofia Kossak-Szczucka [prominent Catholic writer and founder of
> Żegota, the only clandestine organization in Nazi-occupied Europe
> devoted entirely to the rescue of Jews] and Juliusz Osterwa [renowned
> actor and theater director], the latter a great friend of the Rhapsodian
> actors. A memorable launching of the theater, with an opening per-
> formance of the Polish romantic poem *King-Spirit*, took place at the
> dwelling of Mrs. Dębowska in an atmosphere of great concentration....

3 M. Kotlarczyk and K. Wojtyła, *O Teatrze Rapsodycznym* [Rhapsodic Theater], ed. J. K. Popiel, comp. T. Malak and J. K. Popiel (Kraków: Państwowa Wyższa Szkoła Teatralna im. L. Solskiego, 2001), 309.

4 Buttiglione, *Karol Wojtyła*, 22.

On a dark window curtain there was a mask suspended resembling the likeness of Słowacki.[5]

The future pope's work with Kotlarczyk's theater proved to be a deeply formative experience for him. Wojtyła's early poetry stems from this period: *David* was written for Christmas 1939, and *Job* for Easter 1940, and around this time he also produced a translation of Sophocles's *Oedipus Rex*. It is also for the Rhapsodic Theater that Wojtyła would write *Przed sklepem jubilera* [The Jeweler's Shop] (1960) and *Promieniowanie ojcostwa* [Radiation of Fatherhood] (1964).

Did his experience in the Rhapsodic Theater help the pope carry out his mission? His high school friend Halina Kwiatkowska writes, "I believe that ... his theatrical experience gave him his strong voice and magnificent diction, shaped his beautiful sense of gesture, taught him to appreciate the value of a pause, suitable for homilies. Thanks to the Rhapsodic Theater, he developed an ease of connecting with an audience, and especially an ability to express the inner truth in a convincing manner."[6]

In the middle of 1942 the artistic activities of Karol Wojtyła were interrupted. At that time, he decided to enter a seminary in the Kraków diocese. "I must admit that that whole experience of the theater left a deep impression on me, even though at a certain point I came to realize that *this was not my real vocation.*"[7]

5 T. Kudliński, "Porzucenie teatru" [Abandoning the Theater], in Dybciak, *Jan Paweł II w literaturze polskiej* [John Paul II in Polish Literature], 63.

6 H. Kwiatkowska, *Wielki Kolega* [A Great Friend] (Kraków: Kwadrat, 2004), 74–76.

7 Wojtyła, *Gift and Mystery*, 11.

NINE

Notes on Selected Works

KAROL WOJTYŁA'S WORK WITH YOUNG PEOPLE LED HIM TO write his first ethical study of love and marriage. *Love and Responsibility* was published in 1960, when the author was already an auxiliary bishop of Kraków. This profound philosophical treatise was a pioneering work in the Catholic world. It was translated into many languages, including French, Italian, Spanish, English, and Japanese. It brought Wojtyła to the attention of influential Church figures.

Love and Responsibility was born out of "pastoral necessity," as its author put it. Wojtyła's extensive pastoral experience preparing couples for marriage and hearing young people's confessions had convinced him that Catholic sexual ethics needed a fresh presentation and elaboration. He resolved to write a book exploring the moral dimension of human sexuality, and he sought to write it through dialogue with lay men and women. It is a book about responsible love.

> The text is not an exposition of doctrine. It is, rather, the result above all of an incessant confrontation of doctrine with life. Doctrine — the teaching of the Church — in the sphere of "sexual" morality is based upon the New Testament.... The present book was born principally of the need to put the norms of Catholic sexual morality on a firm basis, a basis as definitive as possible, relying on the most elementary and incontrovertible moral truths and the most fundamental values or goods. Such a good is the person, and the moral truth most closely bound up with the world of persons is "the commandment to love" — for love is a good peculiar to the world of persons. And therefore the most

fundamental way of looking at sexual morality is in the context of "love and responsibility" — which is why the whole book bears that title. [1]

Love and Responsibility "taught that sexuality was a good, because sexual desire led men and women into marriage, a difficult, but finally helpful, school in which we learn, 'in patience, in dedication, and also in suffering what life is, and how the fundamental law of life, that is, self-giving, concretely shapes itself.'" [2] As Buttiglione says: "The human being has the capacity to know the truth and to want the good. Being endowed with reason, he questions his own being and considers his beginning and end. His search is oriented by two fundamental questions: 'What is the first cause of everything'? and 'How can I be good, and how can I reach the fullness of the good?' The entire theoretical and practical ethical activity of human beings is referred to these two questions." [3]

In *Love and Responsibility*, Wojtyła leads a dialogue with Scheler's ontology and Aristotelian-Thomistic ethics. It is divided into five chapters: "The Person and the Sexual Urge," "The Person and Love," "The Person and Chastity," "Justice towards the Creator," and, lastly, "Sexology and Ethics," which serves as an appendix.

The first chapter contains an analysis of the person as subject and object, as well as a consideration of the very meaning of the concept of a "person." This provides a foundation for further exploration of the principles of sexual ethics and of the nature of man:

> As an object, a man is "somebody" — and this sets him apart from every other entity in the visible world, which as an object is always only "something".... The world of objects, to which we belong, consists of people and things.... *A person is an objective entity, which as a definite subject has the closest contacts with the whole (external) world and is most intimately involved with it precisely because of its inwardness, its interior life.* It must be added that it communicates thus not only with the visible, but also with the invisible world, and most importantly, with God. This is a

1 Karol Wojtyła (Pope John Paul II), *Love and Responsibility*, trans. H. T. Willetts (San Francisco: Ignatius Press, 1981), 15–16.
2 Buttiglione, *Karol Wojtyła*, 105.
3 Ibid., 89.

further indication of the person's uniqueness in the visible world.... For
a man is not only the subject, but can also be the object of an action.... In
dealings between persons of different sexes, and especially in the sexual
relationship, the woman is always the object of activity on the part of a man,
and the man the object of activity on the part of the woman.... We know
already that the subject and the object of the action alike are persons. [4]

The following chapters discuss the rules of conduct governing the use of
another person as the object of action. Wojtyła analyzes in detail the phrase
"to use." He presents love as that which is diametrically opposed to using a
person as a means to an end. Love constitutes the only correct attitude toward
a person, in which a person is not treated as an object to be used, but from a
perspective appropriate to his or her autonomy.

At this point Wojtyła offers his interpretation of the sexual drive. He
argues that the experience of sexuality is not something that happens within
a person, but is rather a series of conscious acts through which a person
consciously realizes himself in the sexual sphere in accordance with the
measure of his dignity.

In the second chapter, Wojtyła offers a psychological and moral analysis
of love.

Love is always a mutual relationship between persons.... This relation-
ship in turn is based on particular attitudes to the good, adopted by
each of them individually and by both jointly.... The love of man and
woman takes shape deep down in the psyche of the two persons, and is
bound up with the high sexual vitality of human beings, so that what is
really needed is a psycho-physiological or bio-psychological analysis....
The love of man and woman is a mutual relationship between persons
and possesses a personal character. Its profound ethical significance is
intimately bound up with this—in this ethical sense it constitutes the
content of the greatest commandment in the Gospel. [5]

According to Wojtyła, there are at least three elements common to all love:
attraction, desire, and goodwill.

4 K. Wojtyła, *Love and Responsibility*, 21–24.
5 Ibid., 73–74.

Love signifies a mutual relationship between two people, a man and a woman, based on a particular attitude to the good. This attitude to the good originates in their liking for, their attraction to each other. To attract someone means more or less the same as to be regarded as "a good." A woman is readily seen by a man, and a man by a woman, as "a good." That the two parties so easily attract each other is the result of the sexual urge, understood as an attribute and a force of human nature, but a force which operates in persons and insists on being raised to the personal level.... Like attraction, desire is of the essence of love, and is sometimes the most powerful element so that those medieval think-ers who spoke of "love as desire" (*amor concupiscentia*) and "love of attraction" (*amor complacentia*), were entirely right to do so. Desire too belongs to the very essence of the love which springs up between man and woman.... Goodwill is quite free of self-interest, the traces of which are conspicuous in love as desire. Goodwill is the same as selflessness in love: not "I long for you as a good" but "I long for your good," "I long for that which is good for you." The person of goodwill longs for this with no selfish ulterior motive, no personal consideration. Love as goodwill, *amor benevolentiae*, is therefore love in a more unconditional sense than love-desire. It is the purest form of love. Goodwill brings us as close to the "pure essence" of love as it is possible to get.[6]

Wojtyła analyzes the word *love* and discusses the various kinds of love. He associates love as attraction particularly with intellectual knowledge. Love is more than just a sexual drive, or even emotional engagement. Love assumes a judgment about the value of a person and her real goodness.

The third chapter of *Love and Responsibility* is divided into three major parts. The first is devoted to a rehabilitation of chastity, the second to the "metaphysics of shame," and the third to the subject of continence and the difference between continence and chastity. The opening section begins with a brief summary of the Aristotelian-Thomistic understanding of the virtues perfecting human persons — the cardinal virtues of prudence, justice, fortitude, and temperance. In this schema chastity is linked to the virtue of temperance or moderation. Wojtyła here attempts to correct a common but

6 Ibid., 74, 80, 83–84.

excessively severe conception of the nature of chastity:

> Chastity is very often understood as a "blind" inhibition of sensuality and of physical impulses such that the values of the "body" and of sex are pushed down into the subconscious, where they await an opportunity to explode. This is an obviously erroneous conception of the virtue of chastity, which, if practiced only in this way, does indeed create the danger of such "explosions".... The essence of chastity consists in quickness to affirm the value of the person in every situation, and in raising to the personal level all reactions to the value of "the body and sex".... Chastity does not lead to disdain of the body, but it does involve a certain humility of the body. Humility is the proper attitude towards all true greatness, including one's own greatness as a human being, but above all towards the greatness which is not oneself, which is beyond one's self.[7]

Indeed, chastity is not a mere negation, but a practice fundamentally ordered towards love: "The virtue of chastity, whose function it is to free love from utilitarian attitudes, must control not only sensuality and carnal concupiscence as such, but — perhaps more importantly — those centers deep within the human being in which the utilitarian attitude is hatched and grows.... The more successfully the utilitarian attitude is camouflaged in the will the more dangerous it is.... To be chaste means to have a 'transparent' attitude to a person of the other sex — chastity means just that — the interior 'transparency' without which love is not itself."[8] Chastity is a matter of respect for the human person.

Wojtyła identifies two components of chastity: shame and continence. Shame arises "when something which of its very nature or in view of its purpose ought to be private passes the bounds of a person's privacy and somehow becomes public."[9] Shame is a natural form of self-defense of the person, and can be "absorbed" by mature love for another person as a human being. "Where there is love, shame as the natural way of avoiding the utilitarian attitude loses its raison d'être and gives ground.... Looking at the problem in its entirety ... we are bound to say that only true love, a love which possesses

7 Ibid., 170–72.
8 Ibid., 170–71.
9 Ibid., 174.

in full the ethical essence proper to it, is capable of absorbing shame."[10] A discussion of continence follows. "Continence, efficiency in curbing the lust of the body by the exercise of the will, the capacity for successful moderation of the sensations connected with sensual and even with emotional reactions, is the indispensable method of self-mastery, but it does not in itself amount to a full achievement of virtue. Above all, continence cannot be an end in itself."[11]

It is the moral disposition of a person that allows him or her to control the sexual drive and harness it within the order of love. This involves purity, shame, and moderation. Wojtyła invokes Aristotle and St. Thomas Aquinas to describe the final causes of human acts, expressed as a hierarchy of goods. "The traditional Aristotelian-Thomistic conception of the final causes of human acts, expressed as a hierarchy of goods classified as goods of pleasure (*bonum delectabile*), useful goods (*bonum utile*), and goods for their own sake or ends in themselves (*bonum honestum*), required a faculty of practical reason able not only to connect means to ends, but also and chiefly to cognize the full structure of the human being and his 'hierarchy of goods,' and thereby set for the will (defined as an inclination of rational nature, or *appetitus rationalis*) the final ends after which it ought to strive."[12]

In the fourth chapter, Wojtyła treats of marriage and its indissolubility. He devotes much space to the marital act and the order that is tied to it. The question of marriage reflects the personalist norm which, according to its own rule, is consistent with monogamy and the durability of marriage. "In effect, in all these cases [of polygamy or the dissolution of marriage] a person is put in the position of an object of use for another person. Marriage itself is then only (or at any rate mainly) an institutional framework within which a man and a woman obtain sexual pleasure, and not a durable union of persons based on mutual affirmation of the value of the person."[13]

Wojtyła also examines here the value of the institution of marriage, which justifies the intimate sexual relationship between husband and wife in the eyes of society; he considers the topics of procreation and parenthood as well. He then seems to distinguish sharply (while nonetheless integrating)

10 Ibid., 183.
11 Ibid., 197.
12 Karol Wojtyła, "The Role of Reason in Ethics," in Wojtyła, *Person and Community. Selected Essays* (Bern: Peter Lang Pub. Inc., 2008), 67.
13 Ibid., 223.

two orders that "meet" in the sexual union of man and woman: the *"order of nature,* which has as its object reproduction, and the *personal order,* which finds its expression in the love of persons and aims at the fullest realization of that love." [14] Yet these two orders are inseparable; Wojtyła insists that "the correct attitude toward procreation is a condition for the realization of love." [15]

This chapter also addresses the real meaning of love. Love is the acceptance of a person by a person. This acceptance is possible only because of God. He who loves, desires for his beloved a greater good than he himself is capable of giving: he desires the perfect happiness that is God. The meaning of "marriage" includes sensual love and the sexual drive, which together form its foundation.

Chapter five of *Love and Responsibility* is labeled a "supplementary survey" and treats of various topics. The introductory remarks to this chapter emphasize the superiority of ethics (a normative science) over empirical studies; Wojtyła repudiates what he calls "pure sexology." He speaks about the sexual urge, marriage and marital intercourse, and the problem of birth control.

Love and Responsibility is not a manual, but a dense philosophical treatise filled with deep psychological insights. In one writer's words,

> John Paul II has challenged the world by presenting the truth about the human person as the foundation for all social policy and personal morality and by insisting that human freedom cannot be separated from truth, and that freedom must be directed toward love....
>
> The generation of men and women who have experienced the emptiness and unfulfilment predicted by Fr. Wojtyła forty years ago have a right to be presented with an authentic ethic of love. They need more than a system for calculating the risks involved in various choices, they need to be exposed to the vision of true betrothed love presented in *Love and Responsibility.* [16]

<div align="center">✳ ✳ ✳</div>

After the Second Vatican Council, which followed shortly after the publication of *Love and Responsibility,* Wojtyła wrote *Person and Act.* Whereas *Love and*

14 Ibid., 226.

15 Ibid.

16 D. O'Leary, "How not to be used: Love and Responsibility," *Catholic Online,* http://www.catholic.org/featured/headline.php?ID=321, accessed July 5, 2017.

Responsibility treated the way in which a person's traits reveal themselves in sexual marital love, *Person and Act* turns toward the realm of human labor, civil society, and politics.

The focus of *Person and Act* is human action and, simultaneously, man himself, insofar as he reveals himself and is comprehended through his actions. Thus it is a work of philosophical anthropology. Wojtyła here mines two great sources: on the one hand, he positions himself within the magnificent tradition of Thomistic realism; on the other, he assimilates his study of phenomenology and Max Scheler. Following the introduction, which ponders the question of experience, there are four parts.

Part One treats of consciousness and the active causality of the person. Here Wojtyła sheds light on the function of consciousness and the fundamental experience of being the cause of one's own activities, which forces us to admit that a person is not only a locus of psychical occurrences, where a sequence of feeling and experiencing values takes place, but also a true subject of action.

In Part Two, "Wojtyła shows how, in moral action, that *somebody* begins to experience his or her own transcendence. Our personhood, he argues, is constituted by the fact of our freedom, which we come to know through truly 'human acts'…. I am freely choosing what is good. In that free choosing, I am also binding myself to what I know is good and true. In this free choice of the good and the true, Wojtyła suggests, we can discern the transcendence of the human person. I go beyond myself, I grow as a *person*, by realizing my freedom and conforming it to the good and the true. Through my freedom, I narrow the gap between the person-I-am and the person-I-ought-to-be." [17]

Part Three is devoted to the conscious integration of the person's body and mind in action. A person realizes the structure of self-independence, not through suppressing the natural dynamics of the body and psyche, but by directing them and integrating them in action, which expresses the unity of a person. The person not only transcends himself, his body, and his psyche, but also is the cause of their integration in action.

Part Four focuses on participation — acting in concert with others, or the conscious engagement of one person with another. "In working out his theory of 'participation,' Wojtyła analyzes four 'attitudes' toward life in society. Two are incapable of nurturing a truly human society. 'Conformism' is inauthentic

17 Weigel, *Witness to Hope*, 175–76.

because it means abandoning my freedom. 'Others' take me over so completely that my self is lost in the process. 'Non-involvement' is inauthentic, because it is solipsistic. Cutting myself off from the 'others' eventually results in the implosion of myself. 'Opposition' (or what might be called 'resistance') can be an authentic approach to life in society, if it involves resistance to unjust customs or laws in order to liberate the full humanity of others. Then there is 'solidarity,' the primary authentic attitude toward society, in which individual freedom is deployed to serve the common good, and the community sustains and supports individuals as they grow into a truly human maturity." [18]

* * *

The years that followed brought more publications by Karol Wojtyła. *Sources of Renewal: The Implementation of Vatican II* (1979) is an organized and copiously annotated collection of quotations from the documents of the Second Vatican Council. It allows the reader to look at the Council as the author himself, who was an active participant, experienced it. At the same time the book helps us to understand why John Paul II cared so much about the teachings of the Council.

This work is divided into three parts. The first part, entitled "The Basic Significance of Conciliar Initiation," is a short introduction explaining that Vatican II was, in Karol Wojtyła's understanding, a council about Christian faith; its key purpose was the enrichment of faith — "handed down once for all to the holy ones" (Jd 1:3). The second part, entitled "The Formation of Consciousness," describes in detail various aspects of the self-consciousness of the Church as the People of God and how this self-consciousness relates to the awareness of the existence of God as Creator and Redeemer. The third part, "The Formation of Attitudes," stresses that the enrichment of the faith expresses itself in a deepening of the consciousness of the individual believer, which in turn reveals itself in a Christian's life and choices.

In this book, Wojtyła does not address the implementation of the Council's resolutions; he is interested only in reflecting upon the texts of the Council, upon the crucial elements of its teachings that the Church should realize. The message of the book — written for the Church in Poland — appears in hindsight as an outline of what would become the future pope's vision for the universal Church.

18 Ibid., 176.

* * *

Sign of Contradiction, published in 1976, is a collection of conferences preached by Wojtyła (then the Archbishop of Kraków) at the Vatican in 1976 at the personal request of Pope Paul VI. In these talks Wojtyła reveals himself as a visionary with an incisive understanding of the changes taking place in the modern world and of the role of the Church in this new reality. Here the future pope obviously impressed the then-sitting pontiff as well as the cardinals of the Roman curia, who would participate in the conclave electing John Paul II soon thereafter.

In this work one can find all the themes that Wojtyła would later develop in greater detail in his teachings as pope. For example, he talks about the need for a new evangelization, the role of the laity in the Church, the dignity of woman, the dignity of the human person, the defense of the weak and the unborn, the value of ecumenism, and the need for condemnation of totalitarianism and all sorts of tyranny. The book is enriched with images by the Polish photographer Adam Bujak, depicting crosses all over the world — the sign of Christ, "the sign of contradiction."

* * *

In 1979, there appeared in Poland the first volume of a collected edition of Wojtyła's works, *Karol Wojtyła: Poetry and Drama*. It contained almost all the known literary works of the pope. At the time, Polish writer Marek Skwarnicki observed:

> The publication of this volume is not only a literary phenomenon, but also a spiritual and religious event. It is so because Karol Wojtyła's poetry is of a thoroughly religious character, and also because, while interacting with it, one cannot forget about the poet who created it in the past and currently is the pope, the Holy Father, a Catholic imprinting his person-ality on the life of the Church, the People of God, Christianity, the entire world. People are fascinated by the fact that Pope John Paul II was, as a priest and hierarch, also a poet. The joining of those two vocations in one person is received in the time of secular modern culture as something surprising. It is because of a now nearly universally held conviction that religion and art belong to two separate orders: *sacrum et profanum*....
> Looking at the definitive collection of Karol Wojtyła's works before us

we realize that it is to a large degree a source from which to learn the mystery of a mutual cross-pollination of those "two vocations," although this shall forever remain a secret.[19]

"Go ahead and ask me questions," said John Paul II to André Frossard, a French journalist. So he asked about seventy of them and turned the Pope's answers into the book "*Be Not Afraid!*" He asked biographical questions (the only ones the pope would answer with reticence), questions about his vocation, faith, habits, and moral teachings; about the Church and her role in the world; about ecumenism and modernity.

Frossard's book is a journalistic interview. The work consists of six parts: "His Person," "Faith," "Morals," "The Church," "The World," and "The Assassination Attempt." The last part consists in large part of conversations with the witnesses of the assassination attempt of May 13, 1981 and John Paul II's recovery.

Frossard's unlikely conversion to Catholicism — he came from a Jewish family and then turned atheist before becoming a Roman Catholic — made him an exceptional witness to the Christian faith and a leading French Catholic intellectual; it also contributed to the creation of a book charged with a high level of emotion.

* * *

In 1994 John Paul II published a book with Vittorio Messori in a genre that was new for him, that of an extended interview: *Crossing the Threshold of Hope*. In the introduction, co-author Vittorio Messori explained how the book came to be written:

> One day another telephone call came from the Vatican — again entirely unforeseen. On the line was the Press Secretary for the Holy See, Dr. Joaquín Navarro-Valls, a very efficient, cordial and friendly Spanish psychiatrist who had gone into journalism and who had been one of the staunchest supporters of the interview. Dr. Navarro-Valls was the bearer of a message that (he assured me) had surprised him. The Pope, he said, sent him to say: "Even if there wasn't a way to respond to you in person, I kept your questions on my desk. They interested me. I didn't

19 M. Skwarnicki, Introduction to Wojtyła, *Poezje i dramaty* [Poetry and Drama], 5–6.

think it would be wise to let them go to waste. So I thought about them and, after some time, during the brief moments when I was free from obligations, I responded to them in writing. You have asked me questions, therefore you have a right to responses.... I am working on them. I will let you have them. Then do with them what you think is appropriate"....

Once again John Paul II confirmed his reputation for being "the Pope of surprises"—an attribute that has characterized him from the time of his election, which upset all predictions. [20]

Crossing the Threshold of Hope contains a unique mixture of intimate thoughts, personal reflections, spiritual guidance, mystical meditations, and contemplation of the past with theological and philosophical musings. Reading through the text, it is clear why Messori believed that any added commentary would be superfluous, so rich in meaning were John Paul II's own words. "Above all else, the pages that follow make it clear that this is a Pope who is impatient in his apostolic zeal; a shepherd to whom the usual paths always seem insufficient; who looks for every means to spread the Good News to men; who—evangelically—wants to shout from the rooftops that there is hope, that it has been confirmed, that it is offered to whoever wants to accept it." [21] Each page of the book thus must be read carefully, for whoever tries to reach beyond the surface of the colloquial language can encounter an astonishing depth. Indeed, certain passages require particular concentration.

A leading theologian and personal friend of Vittorio Messori read the manuscript and commented on it before publication:

> This book is a revelation—a direct one, free of stereotypes and filters—of the religious and intellectual world of John Paul II. Because of this it is an interpretive key to his teachings.... Not only contemporary commentators but also future historians will not be able to understand the first Polish pope if they do not read these pages. Written under a gust of inspiration, testifying to something that someone fearful could consider a sign of "spontaneity" or perhaps a generous "lack of prudence," they show us in an extremely clear way not only the mind but also the heart

20 Vittorio Messori, "How This Book Came to Be," in John Paul II, *Crossing the Threshold of Hope*, vi–vii.

21 Ibid., viii.

of the man to whom we owe so many encyclicals, apostolic letters, and speeches. All that finds its roots in here. This is therefore a document for our own age, but also for history. [22]

"*Be Not Afraid!*" appeared during the early years of John Paul II's pontificate. *Crossing the Threshold of Hope*, by contrast, reflects the experience of fifteen years as a successor of Saint Peter — encompassing such earth-shattering events as the collapse of communism. That which remained untouched throughout it all, as testified by the book, was the pope's ability to focus his attention on the future, looking toward "the third millennium of Christianity," about which he constantly spoke with such great zeal and hope.

* * *

In 2003 John Paul II published his *Roman Triptych*. This was an unusual event for at least several reasons. First, the Pope had not published any poetry since 1979. Second, the author was 83 years old at the time. And finally, no Church dignitary of his rank had ever published poetry before.

As the title suggests, *Roman Triptych* consists of three poems. In the first, called "The Stream," sitting by a mountain spring, John Paul II contemplates the mystery of life that leads him to discover its divine source. He meditates on the wonder of creation. The poem is addressed to an unknown god and is dedicated to a mysterious "*Ruah*." The pope draws upon contemporary philosophical currents, including existentialism and personalism. He depicts man in relation to other creatures, to himself, and to his Creator. The first part here is purely descriptive, with elements of reflection and confession. When vivid images or metaphors appear, they are either symbolic in nature or else interpretations of other images. As in Wojtyła's early works, the device of personification is employed.

Things are different in the second poem, which is the longest and most significant: "Meditations on the Book of Genesis at the Threshold of the Sistine Chapel." Here John Paul II reflects on passages from the book of Genesis depicted by Michelangelo's frescoes in the Sistine Chapel: God's separation of light from darkness, the story of Adam and Eve, and the story of Noah. This poem concentrates on the fundamental truth about man: that he was created

22 V. Messori, "Introduction," in John Paul II, *Crossing the Threshold of Hope*, 5: http://www.rodaknet.com/rp_sw_papiez_jpII_przekroczyc_prog_nadziei.pdf.

in the image of God. It is in many respects a philosophical poem; among its main themes are the mysteries of the Catholic faith, including the creation of being and time and the relation between the divine Word and human speech, and the relation between linguistic and iconographic signs. Yet, as Dybciak aptly puts it, "the second part of the Triptych also displays some of the features of lyric poetry. In the monologue, the speaker's remarks identify him as the author. For instance, recalling a Latin sentence, he writes: 'For eight years I read these words every day / as I entered the gate of the gymnasium in Wadowice.' Then, in the fragment titled 'Afterword,' he recalls a past [papal] conclave, and he muses about the conclave to occur after the author's death. The speaker next converses with his forefather Adam." [23]

Throughout this second poem one is gripped by its refrain: "*Omnia nuda et aperta sunt ante oculis Eius*" ("All are naked and unveiled before His eyes"). This sentence is key to understanding the second part of the poem. It is through the prism of the all-seeing eyes of God that *Roman Triptych* focuses on God Himself, on man in his original innocence, and on God and man in the act of the Last Judgment.

If the first part of the *Roman Triptych* is a series of questions about the meaning of life, the passing of time, and the essence of humanity, the second part is an answer to the third of these questions, and the third part of the work — "A Hill in the Land of Moriah" — is a practical answer to the first.

The third part of the triptych is nearly an epic poem. Written in blank verse, it is divided into four sections. It is a reflection on Mount Moriah, where Abraham was asked to sacrifice his only son Isaac. The poet invites the reader to travel back in time and reflect on the mystery of redemption. He contemplates the story of Abraham, his attempted sacrifice of Isaac, and his covenant with God. At first glance one notices that many synonyms are used to refer to the Creator. Indeed, the word God appears only four times in the entire third poem, even though it focuses on the relationship between God and man.

Roman Triptych is an artistic message for the third millennium. It is a unique portrait of the moment of creation, its beauty and its life. It vividly brings to life the meaning of love, suffering, and life eternal. It is also the artistic farewell of a great pope, a great Pole, and a great artist.

23 K. Dybciak, "Tryptyk rzymski" — nowa forma literacka [*Roman Triptych*: A New Literary Form], in Wokół, "Tryptyku rzymskiego" Jana Pawła II [On the *Roman Triptych* of John Paul II], ed. by A. Wierzbicki (Lublin: Towarzystwo Naukowe KUL, 2003), 247.

* * *

Memory and Identity came out on February 23, 2005, shortly before John Paul II's death. In it, he reflects on his personal experience in the face of the evils of German national socialism and communism — an experience that remained "indelibly fixed in [his] memory."[24] Nonetheless, it never deprived him of his confidence that only good would ultimately prevail.

This book grew out of John Paul II's conversations with two Polish philosophers, Father Józef Tischner and Krzysztof Michalski, the latter the director of the international Institute for Human Sciences in Vienna and organizer of academic symposia with prominent scholars at Castel Gandolfo. It was there that in 1993 these philosophers came to speak with the Holy Father about how to respond to the key problems of the 20th century. What ensued was a critical historical and philosophical analysis of Nazism and communism.

The text is divided into five parts: "The Measure Marked for Evil," "Freedom and Responsibility," "Thinking of the Fatherland (Fatherland, Nation, State)," "Thinking of Europe (Poland, Europe, Church)," and "Democracy: Possibilities and Threats." A section entitled "Who Guides the Bullets" is included as an appendix. This final conversation took place in the small dining room of the papal palace at Castel Gandolfo. Here the pope's secretary, Archbishop Stanisław Dziwisz, also took part. This final section provides an account of the assassination attempt against John Paul II. The pope also narrates the story of his meeting with his would-be assassin, Ali Agca, in 1983.

In *Memory and Identity* John Paul II reaches for the roots. He discusses the Latin word *patria*, which "is associated with the idea and the reality of 'father' (*pater*). The native land (or fatherland) can in some ways be identified with patrimony — that is, the totality of goods bequeathed to us by our forefathers. In this context, it is significant that one frequently hears the expression 'motherland.' Through personal experience, we all know to what extent the transmission of our spiritual patrimony takes place through our mothers. Our native land is thus our heritage, and it is also the whole patrimony derived from that heritage. It refers to the land, the territory, but more importantly, the concept of *patria* includes the values and the spiritual content that make up the culture of a given nation."[25] The pope's reflections on homeland, and

24 John Paul II, *Memory and Identity*, 15.
25 Ibid., 60.

on Poland, are inextricably connected with the value of human life, the rights of the human person, and the fundamental role of the family in the life of the individual and the nation. Indubitably these values, in addition to Christianity, were the foundations of the pope's identity.

The question of the meaning of fatherland brings into focus patriotism. "Patriotism is a love for everything to do with our native land: its history, its tradition, its language, its natural features. It is a love which extends also to the works of our compatriots and the fruits of their genius. Every danger that threatens the overall good of our native land becomes an occasion to demonstrate this love." [26]

The pope also touches upon the idea of culture: its sense, origin, and role in the life of the nation. "In the opening pages of the Book of Genesis, we discover the essence of culture, and we grasp its origin and fundamental meaning; from here we can proceed, step by step, toward the truth of modern industrial civilization.... Man lives a really human life thanks to culture.... Culture is a specific way of man's 'existing' and 'being'.... Culture is that through which man, as man, becomes more man, 'is' more.... The nation is, in fact, the great community of men who are united by various ties, but above all, precisely by culture." [27]

John Paul II contemplates the problem of individual evil, but also the phenomenon of the outbreak of evil on a vast scale in the 20th century in the rise of criminal ideologies. He offers a critical analysis of Nazism and communism and observes the danger of civilizational and violent cultural changes, which define anew the meaning of the freedom of man. The pope calls for responsible use of the freedom gained by individuals and nations after the fall of communism. The development of the Christian tradition, he reminds us, is based most of all on the return to the Source that is Christ and on the celebration of the Eucharist, and it is through these that man can find his true identity.

Memory and Identity brings the pope's "Polishness" to the fore. John Paul II draws heavily upon the Polish experience in his consideration of issues relating to the ideas of fatherland, patriotism, nation, and culture. He discusses the most universal questions, and ponders the problems of the state, Church, and Europe, with reference to Polish history and culture. He discusses

26 Ibid., 66.
27 Ibid., 84–85.

the merits and attributes of the Polish people, their forgotten achievements, and their moments of glory and magnificence; and yet, he does not neglect Polish flaws, weaknesses, sins, and omissions. He provides a full picture of "Polishness" as a valuable element of a diverse and culturally rich Europe. This book is written in the light of eternal truths, yet at the same time is immersed in human problems occurring here and now. For John Paul II, the deepest meaning of history transcends history. It reaches beyond the borders of time into the sphere of faith and hope, and into the future. Only in love, which has its source in the heart of Christ, is there hope for the future of the world. Therein rests the secret and the ultimate calling of humanity.

PART III

The Poetry of Karol Wojtyła

TEN

An Introduction

But poetry is the most general and supraindividual form in which
the experience of a nation, or of a generation, is expressed. [1]

KAROL WOJTYŁA

TO QUOTE ROCCO BUTTIGLIONE, "WOJTYŁA BEGAN HIS philosophical journey within the pages of literature. It was only later that he came to academic philosophy *per se*. But his love for literature, which he has carried with him throughout his life and which is a distinctive trait of his personality, has from the outset taken the form of a search for the truth of man." [2]

Karol Wojtyła had a profound understanding of the literary and artistic culture that formed the greatest Polish writers. In *Memory and Identity*, he observes:

> It is well known that the nineteenth century marked a high point in Polish culture. Never before had the Polish nation produced writers of such genius as Adam Mickiewicz, Juliusz Słowacki, Zygmunt Krasiński, and Cyprian Norwid. Polish music had never before reached such heights as in the works of Fryderyk Chopin, Stanisław Moniuszko, and other composers, through whom the artistic patrimony of the nineteenth century was enriched for future generations. The same can be said of the visual arts, painting and sculpture. The nineteenth century is the century of Jan Matejko and Artur Grottger; at the turn of the twentieth century, Stanisław Wyspiański appears on the scene, an extraordinary genius in several fields, followed by [the painter] Jacek Malczewski and others....
> The nineteenth century was a pioneering century for theatrical arts; at

1 Quoted in Buttiglione, *Karol Wojtyła*, 233.
2 Ibid., 232.

the beginning we find the great Wojciech Bogusławski, whose artistic teaching was received and developed by numerous others, especially in Southern Poland, in Kraków and in Lviv, which was then part of Poland. The theater was living through its golden age, both in serious drama and in popular plays.[3]

Karol Wojtyła had several pen-names. He chose as his pseudonyms, variously, Andrzej Jawień, Stanisław Andrzej Gruda, and Piotr Jasień; he also published as "A. J." Wojtyła kept his identity as poet strictly in secret, entrusting it only to a narrow circle of close friends and collaborators, both lay and religious.

In spite of his belief in the inability of words to capture the full truth, Karol Wojtyła was a poet. "Herein lies the paradox of the integrity of poetry, which wishes to express the inexpressible, and through that motion of the heart and the hand toward Light it names something new after all, thus discovering it. At any rate, it leaves a trace of man's longing for Infinity."[4]

For Karol Wojtyła poetry "is not only art, because that would make it a realistic truth, or merely a game, but above everything it is a superstructure; it is a view ahead and above; it is a companion of religion and a guide along the way to God. It has the dimensions of a Romantic rainbow! From earth and from man's heart toward Infinity!"[5]

As Krzysztof Dybciak observed, Karol Wojtyła "arrived on the Polish literary scene in his thirtieth year as a 'fully formed poet,' who used his own artistic language, knew what he wanted from literature and issues he wanted to tackle. He began with large forms; in 1950–52 he published three long poems in *Tygodnik Powszechny* (the *Universal Weekly*): 'Song of the Brightness of Water,' the 'Meditation on Death' of 1975, and 'Thinking My Country' in 1974, from which a unified poetic universe emerged."[6]

Wojtyła's very first literary efforts were in the form of lengthy dramatic folk ballads. Their focus was local, pertaining to the Beskidy Mountains. In

3 John Paul II, *Memory and Identity*, 60–61.
4 M. Skwarnicki, "Wstęp" [Foreword], in Karol Wojtyła, *Poezje, dramaty, szkice. Jan Paweł II, Tryptyk Rzymski* [Poetry, Drama, Drafts. John Paul II, Roman Triptych] (Znak: Kraków, 2004), 9–10.
5 W. Smaszcz, "O czytaniu poezji Karola Wojtyły" [On Reading the Poetry of Karol Wojtyła], in Wojtyła, *Poezje i dramaty* [Poetry and Drama] (PAX: Warsaw, 1999), 105.
6 K. Dybciak, *Karol Wojtyła a literatura* [Karol Wojtyła and Literature] (Biblos: Tarnów, 1991), 35–36.

his early poetry, published under the pseudonym of Jawień, religious and philosophical themes dominated. Here he pondered the basic questions of individual human existence. In the mid-sixties, historical, social, and ecclesiological motifs began to appear in his work. He devoted several poems to his homeland, to other nations, to the Church, and to the unfolding of history. They included "Easter Vigil 1966" written to commemorate the millennium of Poland's Christianity, a meditation on his native realm, "Thinking My Country" (1974), and a poetic consideration of martyrdom and speaking truth to power, "Stanislaus" (1979).

According to literary historian Jarosław Maciejewski, Wojtyła "exhibited a tendency to objectify language, using silence, symbol, and repetition, while avoiding rhymes, assonance, and rhythm since the 1960s."[7]

In his introduction to Wojtyła's *Poems and Dramas*, Marek Skwarnicki, himself a Catholic poet, translator, and commentator, astutely observed:

> Poetic creativity, next to scholarly work, in particular philosophy, became for him ... a way to study and delve into human reality. It was the closest to his heart perhaps, but not the most important in fulfilling his duties....
> In this manner poetry can also fulfill a cognitive role, like any artistic pursuit. Other forms of purely intellectual or scholarly activity cannot substitute for it. Reading a number of Karol Wojtyła's works from his mature period of poetic creativity prompts one to suppose that it served precisely as his "laboratory" of the heart, imagination, and mind, where he "tested" that which cannot be expressed in any other way: the mystery of human love, the Church, motherhood, fatherhood, human death, and also the mystery of a mountain stream.[8]

The poetry of Karol Wojtyła is indeed thematically rich. It is replete with insights into human relations, the struggle of individual conscience, and mystical experience. Wojtyła presents the drama of human life and the transformation of man's heart, and offers a constant exploration of one's own reality. He focuses on existential situations inseparable from human life. "Mostly it is contemplative poetry, and the glow lighting up its innermost center has

7 J. Maciejewski, "Karol Wojtyła i Jan Paweł II wobec literatury" [Karol Wojtyła and John Paul II on literature], *W Drodze* [On the Way], 7(119), 1983, 57 and 8(119), 1983, 51.

8 Skwarnicki, Foreword to Wojtyła, *Poezje i dramaty* [Poetry and Drama], 9.

a mystical source. If we do not understand that, we can barely stand at its threshold. Beauty, which is the measure of [his poetry's] meaning, is hidden within; imagination, together with a heart full of love for God and man, strives to reach it. As man discovers, his heart and mind are rendered speechless, in awe. And sometimes they are faced with darkness." 9

According to George Weigel,

> the poems oscillate between extreme concreteness and abstraction.... Sometimes carefully crafted, at other times written hastily on the margins of official papers and then dispatched "as is" to *Tygodnik Powszechny* (where the editors ran them in the form in which they arrived), Wojtyła's poems were simply the way one wrote about a particular idea or experience. They were the appropriate medium of expression for a certain kind of reflection, even a form of prayer. The experiences that compelled this kind of expression could, for Wojtyła, be drawn from such personal encounters as being a confessor or confirming young people in a mountain village, or from great historical events like the Second Vatican Council or the millennium of Polish Christianity. While Wojtyła's poetry "fits" within the tradition of contemplative religious poetry, there are few exhortations in it, and even these are delivered in a thoroughly humanistic voice. The poet rarely praises or condemns; he most often describes. This is not, in other words, "Christian apologetics in verse." Yet the poet's optic on the lives on which he is reflecting is profoundly Christian. Against the temptation to see life as a relatively flat terrain in which decency is rather cost-free, Wojtyła almost relentlessly lays bare the dramatic tension to be found in every life. He does not scold, but suggests to his readers that the great choice posed to the human person in the modern world is the choice "between sanctity and the loss of [one's] humanity." To know this can be both fascinating and terrifying, for we are dealing here with the sacred. 10

In his *Poetry of Universal Values*, a study of Wojtyła's work, Father Janusz Stanisław Pasierb remarks:

9 Ibid.
10 Weigel, *Witness to Hope*, 117–18.

[Wojtyła's] poetics is close to the Bible in its methodology.... [His poetry] is not so much associated with history as it is with the eternal — with universal values. One cannot but think here that the poetry ... must have played a great role in preparing its author for his ultimate vocation as the shepherd of the Catholic Church. Of course, these eternal and universal matters were experienced historically and personally witnessed by that author. For all his discreetness, the link between Wojtyła's poetry and his life, in particular his inner life, is palpable in his writing.... Literary creativity was clearly not something that occurred at the margins of the life, work, and scholarly pursuits of this priest, professor, bishop, and cardinal — similarly, it remains an aspect of the pope's courage and his teachings. [11]

Indeed, his poetry has a quality of a witness report, an objective narrative. "Instead of unmediated subjective emotions, the subject exercises self-control and attempts to process his thoughts and reactions to render them in universal values in terms that are generally accessible. Any emotional effusiveness is clearly restrained and thus, perhaps, all the stronger: it is expressed infrequently and discreetly — and therefore with greater efficacy." [12] The author's tools include reflection, calm confession, and even eye-witness account. His language is carefully considered. Wojtyła obviously aims for laser-sharp precision, so that neither the thought nor the vision ever faces a barrier of inaccuracy in presenting an image or its meaning to the reader.

Even though his poetry is of a religious nature, it contains few artistic expressions or figures of speech that directly invoke God or call Him by His name. "Under no circumstances does this poetry descend into ostentatious piety. Since the entire poetic space he creates is suffused with God, and his poetry's subject is human existence, one can say that his art transcends the deep cleaving of contemporary culture into the seemingly autonomous spheres of *sacrum* and *profanum*. His poetry sacralizes the fullness of human existence; it is an exceptional achievement, and not only a literary one." [13]

Dybciak, who extensively comments on Karol Wojtyła's poetry, has rightly observed the presence of symbols in the poet's work:

11 J. S. Pasierb, *Poezja uniwersaliów* [Poetry of Universal Values] (Znak: Kraków, 1981), 4–5.
12 Dybciak, *Karol Wojtyła a literatura* [Karol Wojtyła and Literature], 38.
13 Skwarnicki, Foreword to Wojtyła, *Poezje i dramaty* [Poetry and Drama], 9.

One can discover ever-surfacing symbolic images and objects that are the carriers of the central ideas of his worldview. These can be called "topics" in the sense in which the Franco-Swiss school of topical criticism uses the word. Thus, they are repetitive elements of depiction that serve as the author's main tools to describe the world. Such central topical tools for articulating the experience of the depth of being — in the material of speech-signs — are, among others, glowing objects, the depths of the soul, an unbearable vision, light reflected on water, reflection in a mirror, the opening of consciousness, spiritual space, transcending oneself, personal unification, and the all-seeing, all-encompassing eye. [14]

These themes are not merely incidental in Wojtyła's poetry. As a rule, they provide order and direction for the development of his subjects and the trajectory of his poetic meditation. They remind us of the rules by which man searches for and learns about God.

To define the genealogical coordinates of his works, Wojtyła seems to come to his reader's rescue:

Rather precisely, [he] subordinates the titles of his poems to particular genres. The word "deliberation" appears in the title of as many as two of Wojtyła's poems. The word "meditation" turns up in a subtitle. In other titles we find the word "thoughts" and again "thought" in a subtitle. Thus, the author places these works in a broader category of meditative creations, so important in European literature.... This is by no means a homogeneous collection of literary coordinates. We can divide it into subtle sub-sets of meaning. First — according to Wojtyła himself — "meditation" refers to religious reflection, of the kind developed in medieval times, such as meditation on the passion and death of Christ. Two of Wojtyła's poems directly invoke this tradition — "Meditation on Death" and "The Quarry" — as they explore different aspects of human mortality. The term "meditation" also describes a type of philosophical work, such as Descartes's *Meditations on First Philosophy*. Not surprisingly: philosophical discourse constitutes an integral part of all Wojtyła's literary works. More metaphorically perhaps, the term "meditation" belongs to

14 Dybciak, *Karol Wojtyła a literatura* [Karol Wojtyła and Literature], 39.

the tradition of lyrical poetry, particularly in the Baroque, in Romanticism, and in the present day. [15]

Wojtyła's poetry is a demanding read, whether in the original or in translation. It asks of the reader a strenuous personal effort, both intellectual and spiritual. It requires cooperation with the author to discover the mystery of the links between God, man, the natural world, and infinity. An analysis of his poetry leads us to conclusions of anthropological, cultural, and theological significance.

In a way, Karol Wojtyła's entire life, no less so when he lived it as John Paul II, possessed a thoroughly artistic — even poetic — character.

> [Throughout] his program, which exhorts man to rise anew from existential, social, and national crisis and conflict ... [throughout] his teaching — the coherent, suggestive style, at times filled with pathos, of his encyclicals and letters;...[in] the showmanship of his pilgrimages, so full of symbolism, he creates his greatest poem, touching in it upon the most important problems of modernity. In this way he creates a modern theodicy, perhaps an epic of the end of the 20th century. This [composition of words and gestures] is naturally not a poetic text in the conventional meaning of the term. Thus [his] are not merely skillfully selected and meticulously arranged words. This is poetry in the broadest sense of the term; thus, [Wojtyła's] is a vision of the world or shaping of the world to make it, as Słowacki said, "a poem for God," or put another way: "a beautiful gift for the Lord." [16]

Ultimately, there is a moral and creative continuity between Karol Wojtyła and John Paul II. Wojtyła's poetry and his "work was and is the key to the inner life of John Paul II from his youth to today. It will remain so for most readers. No writings of Karol Wojtyła depict the current of his inner life and his many private thoughts and mystical experiences more richly than his poetry. That is what his poems, dramas, and meditations reveal." [17]

15 Ibid., 36.

16 Maciejewski, *Karol Wojtyła i Jan Paweł wobec literatury* [Karol Wojtyła and John Paul on Literature], 8.

17 M. Skwarnicki, "Poetycka droga papieża Wojtyły" [Pope Wojtyła's Poetic Journey],

Not all of us are called to be artists in the strict sense of the word. "Yet, as Genesis has it, all men and women are entrusted with the task of fashioning their own life: in a certain sense, they are to make of it a work of art, a masterpiece."[18] Undoubtedly, Karol Wojtyła made of his life an artistic masterpiece. God endowed him with wisdom and blessed him with the ability to write and thereby understand himself, his vocation, and his mission as the successor to the Throne of Saint Peter.

Introduction to Karol Wojtyła, *Poezje, Dramaty, Szkice. Jan Paweł II — Tryptyk Rzymski* [Poems, Dramas, Drafts by John Paul II — Roman Triptych] (Znak: Kraków, 2004), 9–10.

18 John Paul II, *Letter to Artists* (Libreria Editrice Vaticana, 1999), no. 2. https://w2.vatican.va/content/john-paul-ii/en/letters/1999/documents/hf_jp-ii_let_23041999_artists.html.

Labor

Labor began within; and without, it can avail itself of so much
space that it consumes the palms of one's hands in an instant, and
reaches the limits of one's breath. [1]

KAROL WOJTYŁA, "The Quarry"

KAROL WOJTYŁA'S "THE QUARRY" MUST BE ONE OF THE most beautiful poems about labor in all of Polish literature. As W. P. Szymański remarked, "I do not know any other poetic work that would show equally concisely the drama and the essence of the history of my fatherland.... The final part of the poem is one of the most profound, if not the most profound, descriptions of the truth about the 'Polish realm.'" [2]

"The Quarry" was written in 1956, during Poznań workers' protests against communist rule in Poland. Karol Wojtyła did not participate in the protests or witness the bloody government crackdown, but he followed them closely. Published in the November 1957 issue of the Catholic journal *Znak* [The Sign] under the pseudonym of Andrzej Jawień to evade the communist censors, the poem demonstrates the depth of Wojtyła's empathy and the seriousness of his philosophical engagement. The poet dedicated "The Quarry" to a fellow worker, like Wojtyła himself forced into hard labor during World War II, who died in a quarry accident in 1940. In the poem, Wojtyła returns to his experience in German-occupied Poland and to that fateful day in the Zakrzówek quarry near Kracó w.

It is not hard to identify the words at the heart of the poem's meaning: hands, heart, labor, exertion, hammer, explosion, tearing, hitting, current,

1 Wojtyła, "Kamieniołom" [The Quarry], in *Poezje i dramaty* [Poetry and Drama], 46.
2 W. P. Szymański, *Z mroku korzeni (O poezji Karola Wojtyły)* [From the Darkness of the Roots (On the Poetry of Karol Wojtyła)] (Calvarianum: Kalwaria Zebrzydowska, 1989), 40.

stone, love, anger. The poet ponders the process of labor in all its complexity and considers all its richness. He sees that process not only as an encounter with nature and an excavation of its resources, but also, in equal (or perhaps even greater) measure, as a force shaping the human person and an aspect of forging bonds between individual people.

In "The Quarry," Wojtyła presents the harshness and the murderous pace of a worker's life, the dignity and the drama, and shows the toll hard physical labor takes on a worker's body. For the poet sees labor for what it really is: an exhausted human frame drenched with sweat; unending human effort underpinning the entire civilization. Exploding rocks become a metaphor for the eternal struggle between the inexorable force of nature and the will power and labor of man. In Wojtyła's poem, man matures through labor. His exertion has a metaphysical dimension, his laboring figure reminiscent of a temple: "And when for a moment he is transformed into a cross-section of a Gothic structure, cut through with a vertical line born of his thought and sight — this is not merely a profile! Not merely a figure in between stone and God, destined for greatness and error!" [3]

Work acquires a redemptive, sacred quality which no one can take away from man. The unique dignity of human labor stems from the fact that it is a part of creation. Its greatness resides entirely inside man. Labor is born in his heart. Through the strain of work, man draws closer to God.

"The Quarry" possesses a deep layer of meaning. One can hear an inner monologue — or, rather, dialogue, because two voices participate in it. The poet depicts the genesis of human action — a deliberate act of free will — born out of inspiration, which in turn feeds on love and anger. The poem explains that those two forces at the heart of inspiration and free will can only be harnessed with "words of utmost simplicity." [4] And it is indeed with words of utmost simplicity that the poem explores the essence of man through labor.

"The Quarry" consists of four parts of unequal length: "Material," "Inspiration," "Participation," and an untitled part, dedicated "To the Memory of a Fellow Worker." Each part takes up a different aspect of human labor, with a general focus on man as the subject of work.

Part One, "Material," consists of four fragments subdivided into stanzas. This part focuses upon the mutual interdependence of material things, here

3 Wojtyła, "Kamieniołom" ["The Quarry"], in *Poezje i dramaty* [Poetry and Drama], 46.
4 Ibid., 47.

represented by the stones of the quarry and various forms of energy applied to the matter, including hammer-blows and electric current detonating explosives. "Material" depicts the energy of pain, the labor of human thought, and the beating of the heart. But it is the image of the human hand that most fully and accurately reflects the drudgery of hard physical labor: "Hands are the landscape of the heart. Hands crack at times like canyons, through which rolls an unknown force. The same hands, which man opens up only when they are spent with exertion — when he sees that thanks to his efforts, other people can walk peacefully away. Hands are a landscape. When they crack, physical pain fills the wounds, throbbing freely like a stream. But man does not think of pain. Pain alone is not yet greatness, and his proper greatness he simply cannot name." [5]

Through physical work, which is born in the intimacy of the heart, the whole man can express himself and his human nature most fully. Man truly shows himself to be a human subject when he suffers.

The second part of the poem, "Inspiration," consists of two separate, numbered segments. It is perhaps the most difficult but also the most crucial section of the poem. Although it defies a simple and uniform interpretation, it nonetheless remains the key to the work as a whole. It focuses on the relationship between human will and its transposition into human labor. And this labor need not be physical; it may be any human effort undertaken strenuously and resulting in man's sublimation of the two balancing forces: anger and love.

Buttiglione explains the importance of anger in Wojtyła's philosophy of labor:

> Anger is a central category. In work, in the bloody wrestling against earth, man endangers his own life. The energy which the effort of mind and limb bring[s] to domination is an ever-present snare, ready to take revenge and to turn to human dominance. Man risks his life, endangering the responsibility which he has toward other men, toward his wife and children…. Loyalty and honesty are decisive facts about common work…. Work is a system of communication which binds men together in ethical relationships. Rage arises because of the resistance of matter and the

5 Ibid., 46.

untrustworthiness of men. Great is the anger of a workman against the lazy fellow who places him in jeopardy, or who unnecessarily makes his work a misery. Even greater is the anger toward an entire social system which is founded on unjust relationships, in which others seize the fruits of one's labors — not incidentally but systematically — and would make the laborers' existence more miserable in order to affirm their social dominance. Anger is born when the terrible seriousness of labor is not appreciated. It is in this anger that love is at stake in its definitive form. [6]

What, then, is an appropriate way to experience anger? Wojtyła suggests that balancing anger requires accepting the mutability of all matter, demands participation in the mystery of the transformation of all things. In extreme situations, participation in fulfilling the gift of existence becomes obvious. One such extreme situation is death: "I know you, splendid people, people with no manners or refinement. I know how to look into the heart of man without pretense or confusion. Some hands are for toil, some for the cross." [7]

What is the meaning of the affirmation that "some hands are for toil, some for the cross?" Rocco Buttiglione suggests that "the hands which belong to the cross are the hands of one who must die. In the following verse, there is the record of the incident in which a fellow worker was killed: there comes a time for everyone to belong to the cross, no one can escape this destiny. In another sense, the hands which belong to the cross are those of the priest, and in particular of the young man who meditates upon his priesthood." [8] In a sense, both of the meanings identified by Buttiglione overlap. Each death and each Holy Mass offered by a priest are a repetition of Christ's sacrifice.

The conclusion of the second stanza of Part Two contains a beautifully lyrical passage, an example of reflexive inner monologue where the lyrical "I" proclaims a very important truth: "So if you want to find your way from afar and enter, and remain in people, you must harness both these forces with words of utmost simplicity (your words must not break the fulcrum of love and anger). Then no one can extract You out of man's essence, or tear You away from him." [9]

6 Buttiglione, *Karol Wojtyła*, 248–49.
7 Wojtyła, "Kamieniołom" ["The Quarry"], in *Poezje i dramaty* [Poetry and Drama], 48.
8 Buttiglione, op. cit., 249.
9 Wojtyła, "Kamieniołom" ["The Quarry"], op. cit., 47.

Who utters those words? It cannot be ruled out that the voice heard as the lyrical "I" in the heart is the voice of vocation inspired by the Other calling upon the lyrical subject to fully engage in human affairs: "Then no one shall extract You out of man's essence, or tear you away from him." [10]

Part Three, "Participation," is perhaps the most unified in terms of both composition and subject matter. It is here that the poet utters some of his most famous words: "And there is silence again between the heart, the stone, and the tree. Any man can enter it. If he entered, he will remain himself. If he did not, then despite appearances, he is yet to participate in all the matters of the earth." [11] The key to the passage rests in the word "silence," as a quality and a signifier of quietude. This silence becomes a challenge and an exhortation. In its stillness, man can contemplate "the stone" and "the tree," which represent the raw materials hewn by human labor. The stone, like the tree, can be processed, shaped, and transformed into something useful for people. Such work can have meaning and fulfill a man, as long as he accepts it in the silence of his heart; as long as he enters into it as an internally free creator. Enslavement takes that creative agency away; it threatens to strip labor of its intrinsic value and deprives man of finding fulfillment in work — it takes away love and leaves him only with anger. And so man-laborer can only "remain himself" if he is internally free. For Wojtyła, to remain oneself means to be with the people, to be active with them and among them; to create within a group of free people, who understand the ultimate significance of the work they carry out. When one understands labor in this sense, it is no longer a curse, it does not demean man; it does not destroy him but, on the contrary, enriches him, liberates him, and transforms him by bringing love and anger into equilibrium. For work not only transforms the world of matter, but also creates man, one human being at a time.

It is no accident that "The Quarry" concludes with the section "In Memory of a Fellow Worker." In it, the tragic death of one of the stone quarry workers opens a sudden breach in the structure of the laboring community — of the one body: "He was not alone. His muscles were grafted onto a great crowd, as long as they could heave the hammer and pulsate with energy — but it only lasted while he felt the ground under his feet, until the stone crushed his temple and cut through the ventricles of his heart.... Violently, his time

10 Ibid.
11 Ibid., 51.

came to an end. The hands on the low-voltage dials jerked suddenly, then dropped to zero again." [12]

According to the materialistic conception, the body turns to dust "while the spirit — or, more precisely, the significance of death — becomes an integral part of the proletariat's righteous anger and enters its historical memory as demand for revenge. But this does not do justice to man's essence. It does not explain how anger matures, giving life truth and meaning. Marxism sees the motor of history in the enormous power of negativity that sweeps away all the social and cultural forms in which, for the time being, history is imprisoned. The future is born out of the present order." [13] In other words, the Marxist future is born on the ruins of the present, through destruction.

For Wojtyła, human life constitutes a finite whole — each life has a place and meaning, and this has been so throughout all human history. In each person a unique encounter with truth takes place, which holds a crucial significance for the history of individual man as such. Man is not only an indistinguishable part of the masses, a class, or history; he transcends all those categories with his personal depth, co-creating their very human meaning: "The man has taken with him the world's inner structure, where the greater the anger, the higher the explosion of love that feeds on it." [14] How then should we understand this mysterious sentence, which seems to express such a burning conviction? What does "the world's inner structure" mean for the poet, where the future, realized at the eschatological dimension, co-depends on love and anger — that is, two key aspects of the human person? The answer lies in the words, "The man has taken with him...." We can surmise that the poet means the moment of passing from life to death — and the love that stays in the hearts of the living, for all the anger at the loss.

The poet sees death as the end of a certain phase of the human journey, but also as the beginning of a new one. Death is an end but not an obliteration because a saving love endures even after death. It is love that gives the beginning to a new, unimaginable form of our existence, and a new meaning to what we have accomplished here on earth.

12 Ibid., 49.
13 Buttiglione, *Karol Wojtyła*, 250.
14 Wojtyła, "Kamieniołom" ["The Quarry"], in *Poezje i dramaty* [Poetry and Drama], 50.

TWELVE

Thinking My Country

*When I think my country—I give expression to myself and anchor
my roots; my heart tells me about it, as though it were a hidden
border, which runs from within me towards others, envelops us all
within a past more ancient than any of us: it is my origin ... when
I think my country—I want to enclose it within me like a treasure.
I keep asking how to multiply it, how to grow the space that it fills.* [1]

KAROL WOJTYŁA, "Thinking My Country"

KAROL WOJTYŁA'S "THINKING MY COUNTRY" IS REPRESEN-
tative of his approach to the theme of homeland; it arose from his reflections
on the concepts of nation and patriotism.

His native land is not identified here; there is no mention of Poland or
the Polish Republic in the text. And yet, the poem leaves no doubt that
it is about the author's own fatherland. The references to Polish history
and the timeline of events in the central part of the text are clear. The
poem invokes "the time of feudal partitioning and the golden age," and
then "golden freedom" and its tragic consequence: the loss of liberty.
The long struggle that follows and the ultimate "sacrifice of generations"
become necessary to regain the lost freedom, which is "dearer than life"
and "stronger than death." Neither concrete historical events nor proper
names or geographic locations are mentioned, but we know about which
nation the masterpiece speaks. [2]

1 K. Wojtyła, "Myśląc Ojczyzna" [Thinking My Country], in *Poezje i dramaty* [Poetry and
Drama], 79.

2 K. Dybciak, *Trudne spotkanie. Literatura polska XX wieku wobec religii* [Difficult Encounter:
Attitudes Towards Religion in Polish Literature of the 20th Century] (Arcana: Kraków, 2005), 220.

For Karol Wojtyła, homeland is the primeval Mother Earth. It is not an artificial social construct. As he puts it in *Memory and Identity*, "the very idea of 'native land' presupposes a deep bond between the spiritual and the material, between culture and territory.... The native land is the common good of all citizens and as such it imposes a serious duty.... The native land, then, is a complex reality, in the service of which social structures have evolved and continue to evolve, starting from primitive tribal traditions.... It still seems that nation and native land, like the family, are permanent realities." [3]

At the same time, Wojtyła grasps the integral links between the meaning of the terms "fatherland" and "nation": "In Polish, in fact—but not only in that language—the term *na-ród* (nation) comes from *ród* (generation, or birth); *ojczyzna* (fatherland, or *patria*), however, has its root in the term *ojciec* (father). The father is the one who, together with the mother, gives life to a new human being. This 'generation' by the father and mother is connected with patrimony, a concept underpinning the notion of *patria*. Patrimony—and therefore *patria*—are thus intimately linked with the idea of 'generating,' but the word 'nation' is also etymologically linked with birth." [4]

The country and the nation occupy a central place in "Thinking My Country." History plays itself out at the level of the nation rather than the clan. Through its participation in history, the nation becomes a part of humanity as a whole.

The poem presents the relations between the national and universal dimensions (understood in religious terms) of human life at their richest and most diverse. Throughout history, nations have played an important role in shaping individual personalities and the forms of collective life.

In "Thinking My Country," nationality is associated directly with language. Belonging to a nation gives man his native tongue, the tool with which he communicates with others. Linguistic analysis of the poem reveals its subject and the main addressee. The poet's observations are tinged with bitterness at first: the language with which he was endowed at birth is uncommonly difficult and understood only by few, forcing him always to translate himself to address the world: "The tongues of nations did not choose to assimilate the speech of my fathers, saying it was 'too difficult,' or 'superfluous'—at

3 John Paul II, *Memory and Identity*, 61, 66.
4 Ibid., 69.

the great gathering of nations we speak a language not our own. Our own language closes us in: it contains us rather than open us up."[5]

Language, the poet explains, is a primeval force of nature, an essential reality, a space where the spiritual life of man unfolds: "Beyond language a precipice opens ... the ocean of a universal human speech."[6] Therein lies history; therein the language Commons reside. Speech contains wisdom, and it hides a mystery. Yet the Polish tongue, the narrator laments, is not highly valued in the world: "there are no buyers for our thoughts on the world markets, for the price of our words is deemed too high."[7]

The poem turns to the shared fate of the nations of the Polish-Lithuanian Commonwealth: "You who have bound up your freedom with ours, forgive us!"[8] These words express the pain of lost independence and lost chances for coexistence in solidarity, friendship, and general unity, respectful of the cultural distinctness of each of the partners. They also reflect a sense of failure of this esoteric language to act as an effective ambassador for the cause of freedom.

Freedom is another prominent theme in "Thinking My Country." To be free is something of value in itself, a highly ranked member of the hierarchy of goods. Freedom is "a gift and a strife." As a gift, it points to its hidden source and exceptional value. Yet it is also strife, for it is not free — one can gain it only through an effort. Freedom is exceptionally "dear" because to be truly free is to live in accordance with the commands of conscience, and for that there is no price. And it is freedom of conscience, above all, that Wojtyła puts at the center of the poem. The domain of historical events should itself be judged and regulated by conscience; the importance of individual conscience draws its truth from "the Church of consciences" of fundamental reality. "Freedom has to be won continuously; it cannot merely be possessed. It comes as a gift but can only be kept through strife. Gift and strife are written into pages that are hidden, yet open. You pay for freedom with all your being — therefore call this your freedom, that through paying for it continuously you possess yourself anew. Through this payment, we

5 Wojtyła, "Myśląc Ojczyzna" [Thinking My Country], in *Poezje i dramaty* [Poetry and Drama], 91.
6 Ibid., 91.
7 Ibid.
8 Ibid., 92.

enter history and touch its epochs. Where is the demarcation line between the generations that overpaid and those who never paid enough? On which side do we stand?"[9]

The conclusion of the poem focuses on the "liturgy of history." Here we arrive at the work's core. The Christian liturgy of the Eucharist makes present the sacrifice of one's life; it brings salvation, reminds us of Christ's redemptive mission, and allows us to participate in it. Here the Church becomes the greatest fatherland, our own country: "Learning new hope, we travel across time towards the new land. And we will raise you up, ancient land, like a fruit of love of generations that transcended hate."[10]

* * *

The theme of fatherland also comes to the fore in the poem "Stanislaus," commemorating an eleventh-century martyr and saint by the same name, often thought of as Poland's Thomas Becket. Karol Wojtyła wrote the poem right after the passing of Pope John Paul I. As he would later explain to George Weigel, in this work he intended to pay his debt to Kraków. The poem focuses on martyrdom as both the source of Polish national consciousness and a universal model of Christian vocation.

The Church, the poet says, is inextricably tied to his native land, as if by marriage: It "bound itself to my land (he was told, 'Whatever you bind on earth will be bound in heaven') — thus the Church is bound to my land. The land lies on the banks of the Vistula; the tributaries swell in spring when in the Carpathian Mountains the snows thaw. The Church bound herself to my land so that all that is bound in it should be bound likewise in heaven."[11]

St. Stanislaus, martyred by the Polish king in 1079, was Poland's first saint. He was one of the earliest native Polish bishops, a predecessor of Karol Wojtyła as bishop of Kraków. Through his martyrdom just over one century after the country's sacramental induction into the community of Christian nations, "Poland was christened anew with the baptism of blood, so that it might forever be ready for new baptisms of hardships."[12] In Poland, the blood of martyrs fertilized "the soil of human freedom," itself marked by the breath of

9 Ibid., 91.
10 Ibid., 93.
11 Ibid., 106.
12 Ibid., 107.

the Holy Spirit. And thanks to the Holy Spirit, "nothing will tear you asunder ... word and blood walk together."

For Wojtyła, Poland is unique in finding national unity through strife and martyrdom: it is "the land of difficult unity; the land of people seeking their own way; the land of long-lasting divisions among the princes of one nation; the land subject to the demands of freedom for each from all. Finally, it is the land torn apart over the span of six generations, torn apart across the maps of the world. How badly torn her sons' fate! And yet, despite the country's suffering, Poland has remained 'united in the hearts of her people as no other land.'"[13]

Wojtyła saw in the nation's martyrdom throughout its history a bond that unified the Polish people — as did the martyrdom of Saint Stanislaus in the time of the country's Christian beginnings.

13 Ibid., 108–9.

THIRTEEN

Mysticism and the Sacred

KAROL WOJTYŁA WAS UNDOUBTEDLY A RELIGIOUS POET, and in his poetry the concept of the sacred is of crucial importance. His poetry reflects experiences born of faith and the presence of God.

The sacred is the principal subject of two of his poems: "Thought is a Strange Space" and "Profiles of a Cyrenean." In "Thought is a Strange Space," Wojtyła is inspired by the themes and characters of the Bible. The opening of the poem alludes to the Genesis account of Jacob's fight with an angel and his subsequent encounter with God "face to face."[1] "Profiles of a Cyrenean" serves Wojtyła as a starting point for reflection on human life and labor. The poem was published in *Tygodnik Powszechny* [The Catholic Weekly] in 1952 under the pseudonym of Andrzej Jawień, a pen name to which Wojtyła would occasionally return.

"Thought is a Strange Space" consists of four parts. The first and second treat the topic of labor, the third focuses on Jacob and his encounter with God; and the fourth contains a message to modern man, for whom the encounter with God is a crucial event. As Buttiglione remarks, "in 'Jacob,' the crisis of man's self-awareness is overcome by an encounter with the sacred. This uproots man from his tranquil belonging to the earth and, at the same time, introduces him to an unexpected dimension of the depths of his own personality."[2] In the poem, Wojtyła undertakes the daunting task of poetically depicting the moment of the opening-up of human consciousness by God, which preceded the arrival of the Divine Person. "That someone — the same one — opened up his consciousness completely, as an encounter with a child would, and, yet differently, unlike sheep or chattels. And He did not crush

1 Buttiglione, *Karol Wojtyła*, 242.
2 Ibid., 243.

them or push them aside, but embraced them so that they trembled lightly, exposing the fear within." [3]

The opening-up of consciousness precedes and indeed makes possible the opening-up of space and the entry of the human subject into the realm hitherto inaccessible to knowing and being: "And Jacob, too, trembled in Him, for never before had reality parted before him so suddenly." [4]

The encounter with the sacred restores man to himself. It makes the events of everyday life cease to be senseless and restores energy to man, through which he is able to incorporate the encounter into the sphere of his consciousness. However, getting to know the Lord and experiencing His presence takes place in solitude. This process takes on the character of a struggle against an image, because the senses and imagination block the heart of mystery. Man is so constructed that he is incapable of separating himself from his thoughts, imagination, and senses. Wojtyła asks whether man will be capable of embracing his inner reality and the mysteries of God, which no one can fathom.

At the same time, suffering is an essential element of man's existence. Suffering always takes place in a particular historical context. The poem alludes to the cruel realities of Stalinist Poland, stressing that the suffering of the Polish people leads to "fundamental transformations" and therefore acquires a special meaning. Through suffering, man "awakens in the depths of his greatest efforts," gains a different perspective, and becomes someone new. The greatest suffering, however, is man's blindness, "a lack of vision" of himself and inability to know who he really is. Man himself has to undertake the tremendous effort of self-discovery. Jacob took on that challenge: "If he suffers a lack of vision, he must brave the signs and reach that which hangs heavy in the deep and like a fruit ripens in the word. Is it to be the burden Jacob felt when stars had collapsed within him, tired like eyelids of sheep?" [5] Man must discover by himself the way to the truth, ultimately to that which is the most important reality: the Lord, his Creator. Jacob is an image of becoming human through strife. He fought with an angel at night, and only in the morning did he understand that he touched thereby the mystery of God and came to know his Creator.

3 Wojtyła, "Myśl jest przestrzenią dziwną" ["Thought is a Strange Space"], in *Poezje i dramaty* [Poetry and Drama], 42.
4 Ibid.
5 Ibid.

Jacob offers an example of a particular experience of God. He was close to nature, through which he experienced the greatness of God as the Creator of all things. He possessed a natural knowledge of God: "And this was Jacob the shepherd, never a stranger among the powers of the earth. He simply belonged among them, so that a mass of silent knowledge grew within him without inspiration; and though aware of thoughts at times, he was at a loss for words." [6] Reflecting at night, Jacob came to an inner knowledge that transcended his natural awareness of God. He experienced within himself the reality of God as a power that enclosed and overwhelmed him. "He bent under its weight." Here the poem does not speak directly about an experience of God, but of the Power that surrounds Jacob. As Saint Thomas Aquinas put it, God is known through His omnipotence. Only upon this experience can a personal knowledge of God as Father develop.

Turning deep within himself, the poem's anonymous narrator experiences the reality of his inner self. Through the thought that travels in limitless space, man touches "the clarity of things," that which is outside. If his thought could access only what is outside of him, the poet wonders, how can man ever grasp the internal essence of reality, reach the heart of the matter? For there is a moment in the process of discovery when man enters into himself and in the furthest reaches of his soul finds the presence of Him through Whom everything exists. "But when reality leans towards me and falls, its full weight upon me, it fills up with thought and settles in the deepest recesses of man, on whom I rarely tread—and whom I have not properly learned, though I know that I cannot disintegrate any further, for comprehension and a Thing in its completeness possess such an abyss." [7]

Through this experience the narrator touches the boundary of his existence and God's presence—the "Object" through whom he exists as the "subject" of knowing.

The poem ends with an address "To my fellow travelers," in which the narrator reminds us that one does not have to travel to the homeland of Jacob to find the spot where he encountered God. All one need do is reach within, where each human being carries the mystery of the presence of his Creator. "If you are looking for that place where Jacob wrestled, do not wander to the lands of Arabia, nor look for the brook on maps, for you shall find the tracks

6 Ibid.
7 Ibid., 43.

much nearer." [8] Jacob is a role model for modern man in search of God, struggling with his own thoughts. "Thought is a Strange Space" is a spiritual map leading to the discovery of God within the self.

<p style="text-align:center">* * *</p>

The theme of encountering the sacred returns in "Profiles of a Cyrenean." The poem focuses on the drudgery of daily life, where thought is weighed down by labor and exhaustion: "Imprison thought — if you can — imprison thought; let down its roots in the hands of craftsmen, in the fingers of women typing, eight hours a day, black letters hanging from their reddened eyelids." [9]

As Rocco Buttiglione puts it, "thought is an adventure which continually proposes itself to man. The risk of responsibility to the truth disrupts the banality of life, but in the face of it one may experience self-doubt and an obscure feeling of danger. It is the risk of losing oneself in the encounter with the mystery, which is both fascinating and terrible." [10] Wojtyła invites his reader to this encounter: "You had better go with the flow! Go with the flow, and don't hurt your feet — the flow will engulf you so that you will never feel the drowning. But then He shall come and place his own yoke on your back. You shall feel, you shall awaken, you shall tremble." [11]

Suspended at the threshold of the sacred, man cannot enter it on his own. It is Christ with his cross who awakens man from spiritual slumber, an awakening that occurs beyond death — and that is stronger than death.

Next appears a cast of characters: an actor, a melancholic, a blind man, and a schizothymic. These are ordinary people, but through their encounter with the sacred each is called to experience a personal drama. This encounter is a widening of consciousness which reflects Christ. "Eye-to-eye with Man…. My little world: justice squeezed with the clamps of norms! Your big world, Your great world: a diameter, a beam — He!" [12]

Having cracked the shell of the meaning of the word *justice*, man begins to delve into the mystery of life. Doing so reveals the world to him from a new, clearer perspective; it allows him to see the drama of his own life, to be found

8 Ibid., 44.

9 K. Wojtyła, "Profile Cyrenejczyka" [Profiles of a Cyrenean], in *Poezje i dramaty* [Poetry and Drama], 52.

10 Buttiglione, *Karol Wojtyła*, 244.

11 Wojtyła, "Profile Cyrenejczyka" [Profiles of a Cyrenean], op. cit., 52.

12 Ibid., 54.

in everyday events in which man either realizes or betrays his humanity. This is about love, death, work, fatherhood, and motherhood.

* * *

"Song of the Brightness of Water," written in 1950, was the first work in which Wojtyła revealed himself as a mystical writer. The poem is structured as a conversation between a Poet, a Master, and a Samaritan Woman, inspired by the dialogue between Christ and the Samaritan woman by Jacob's well. This is indicated by the quotation from the Gospel of John (4:1–26) with which the poem begins and by the titles of three of the eight cantos: "Looking into the Well at Sichar," "Words of the Woman at the Well," and "The Samaritan Woman."

The poem next depicts the meeting between Jesus and a man who recognizes God in him: "But multitudes tremble in You, transfixed by the brightness of Your words — like irises transfixed by the brightness of water. You know those people in weariness, know them in light."[13] It is Christ at the well in whom people discover their source, their beginning; they discover it in His heart, which reflects the faces of multitudes. Christ knows everyone; His word is light for them and endows their life with meaning.

A woman who speaks with Christ occupies the most prominent place in the conversation at Jacob's well. Through this conversation she is able to see the history of her own life anew. "From this moment on my ignorance closed behind me like a door through which You entered — comprehending all that I know not."[14] The woman at the well emboldens us — encourages us — to look inside ourselves in turn.

Christ gives the woman a new glimpse of her soul and of all the difficult questions of human fate. He recognizes her without opening His eyes: "He had a looking glass ... like a well ... shining deep. He needed neither to step outside of Himself nor lift His eyes to guess. He saw me in Himself. He possessed me in Himself. Comprehended me with no effort."[15]

Despite the pain of having learned about her weakness, and the ensuing shame, the woman does not feel humiliated but rather desires to change.

13 K. Wojtyła, "Pieśń o blasku wody" [Song of the Brightness of Water], in *Poezje i dramaty* [Poetry and Drama], 34.

14 Ibid., 32.

15 Ibid., 33.

She understands that this suffering can be borne only through love. Through the presence of God, all pain turns into love.

For Wojtyła, the Samaritan woman thus becomes a witness to an inner dialogue that takes place between Christ and each person who comes to Christ through "the wall of the evening." Each person has a chance to follow in this woman's footsteps and enter into a dialogue with Jesus, who will then unveil the truth about Himself. "You do not walk alone. Never, not for a moment do I leave your side. I become the truth within you, the deepest rupture of the life flowing inside you." [16] Man is never alone. Christ is always with him, His face marked by His suffering on the Cross. Christ encourages us thus to take up His cross. Nameless characters in conversation with Jesus, tired of their everyday struggle against evil, admit their human limitations, remembering: "We have blood." But the blood of Christ is not a human weakness — it is the instrument of salvation and as such determines the fate of man.

Jacob's well is an image of the soul of the Samaritan woman, where she discovers an image of Christ and an image of herself. This discovery leads to an experience of the presence of Christ. "This well binds me to You; this well brought me into You." [17] In this interior experience, the soul is raised to a new life, yet without remaining burdened by its past shame. "Oh how happy am I!" the Samaritan woman exclaims. Christ has extracted from her the weight of her old life, branded with sin, and introduced order and harmony into her heart. The meeting by the well in Sichar gives the Samaritan not only self-knowledge but also liberation and new life; she discovers herself anew. "And in the very depth, where I only meant to draw water with a pitcher, the brightness has clung to my pupils for so long…. I have found so much knowledge, so much more than ever before." [18]

"Song of the Brightness of Water" ends with an expression of delight — "Oh how good!" [19] — and a desire for Christ, whom the Samaritan woman discovered within herself, to remain forever in her heart.

16 Ibid., 34.
17 Ibid.
18 Ibid., 35.
19 Ibid.

* * *

Mystical experience is also the theme of the poem "Song of the Hidden God," which bears the date 1944, indicating that it was written during the Second World War, when Wojtyła had decided to enter the seminary in Kraków. According to Agata Przybylska, "'Song of the Hidden God' is a poetic 'report' whose plot is not grounded in facts or events, but in subjective experiences.... The poem deals with a religious experience of mystical nature, for the contact with God described here displays a simple and direct character, engaging man entirely—in his emotional and intellectual spheres—and leads to an inner transformation." [20]

The poem reflects elements of Carmelite spirituality. Consider this passage: "He is a Friend. You keep coming back to that winter morning. For so many years now you have believed, you have known for certain, and yet you are still filled with wonder. Bent over a lamp, a sheaf of light in a high knot above, you look up no more—why would you?—and you no longer know: out there, or here, deep under your closed eyes." [21]

This is a retrospective account, "a brief narrative invoking the conventions of the Augustinian *soliloquium* (a conversation of the protagonist with himself), whose topic is man's meeting with a Friend—with God." [22]

The action of the poem takes place on "a winter morning," in a lightened room with a desk. The protagonist, on whose behalf the narrator speaks, begins in a state of prayerful concentration which suddenly and unexpectedly turns into a kind of mystical experience that strengthens his faith: "For so many years now you have believed, you have been certain." [23]

Physical images are juxtaposed with spiritual images. The latter dominate, which is unsurprising given that the drama of "meeting with a Friend" takes place within the soul of the protagonist. The indicators of mental space are no longer physical objects but spiritual states such as "admiration," "concentration," "fear and trembling," "joy," and finally "wonder," which will be the entire meaning of eternity.

20 A. Przybylska, *Samotność możliwa w człowieku. Mistyczny aspekt* Poezji i dramatów *Karola Wojtyły* [The Possibility of Solitude within Man: The Mystical Aspect of the Poetry and Dramas of Karol Wojtyła] (Arcana: Kraków, 2002), 70.

21 K. Wojtyła, "Pieśń o Bogu ukrytym" [Song of the Hidden God], in *Poezje i dramaty* [Poetry and Drama], 23.

22 Przybylska, *Samotność możliwa w człowieku* [The Possibility of Solitude within Man], 91.

23 Wojtyła, "Pieśń o Bogu ukrytym" [Song of the Hidden God], op. cit., 15.

The protagonist's meditation is represented by the image of the "depth of closed eyes." A blind poet is one of the oldest *topoi* of European literature. One need only recall Homer, or his character Demodocus, a blind poet in the *Odyssey*. In the "Song of the Hidden God" Karol Wojtyła modifies this poetic convention, following in the footsteps of 15th- and 16th-century religious poetry, with its paradox and oxymoron, which was close to his heart. The poem does not deal with "barding" or prophesying about the future in the sense of announcing important events that would impact other people. It is about the "clairvoyance" that comes to a single individual as a kind of self-knowledge, an experience so powerful that language fails to express it. How, then, to interpret the phrase "seen deep under [his] closed eyes"? How can we see Him, who "is there" although "there is nothing here" ("only trembling!")? How to speak about what is conveyed "with words parsed from nothingness"? Instead of a clear description, we have a sequence of contradictory poetic images that come to life in a succession of non-linear thoughts that elude easy definitions and defy any attempt at a single interpretation. And yet there is an unequivocal sense of a Presence beyond words, beyond human comprehension.

Wojtyła presents a meeting between man and God as a sudden and unexpected encounter with the transcendent. On the one hand, it describes the foundation of faith; on the other, it is a turning point in the life of man experiencing the presence of God. During moments of mystical enlightenment, man discovers new horizons of his own existence. In meeting his Friend, the protagonist of Wojtyła's poem recognizes the essence of eternity. At the same time, he touches the living Mystery of the Other through a peculiar kind of spiritual vision. He experiences "fear and trembling," but also, and perhaps principally, an enormous joy at having met the Other and felt His Presence.

The truth about the Creator, who is not only all-present and omnipotent but who also takes care of man like a loving father, is the greatest discovery for the protagonist of "Song of the Hidden God." Finding God so near is a transformative event, a new beginning. It is an entrance, to employ Wojtyła's metaphor, into the field of "emanations of fatherhood."

Under the influence of this wonderful experience the protagonist of "Song of the Hidden God" falls in love and becomes enchanted with the visible universe. His confession of love can be treated as a motto for Karol Wojtyła's priestly vocation and a credo for his priestly and apostolic activities: "Love

clarified everything for me; love resolved everything. Therefore, I adore that Love, wherever it may be found." [24]

The consequence of "a meeting with God-Friend" is a hidden desire directed—as in Saint Paul's Hymn on Love—toward eschatological fullness, when "we shall see Him face to face": "I often think of that day of seeing, which shall be filled with wonder at the Simplicity of which the world is made and in which it [the world] resides untouched until now—and beyond now. And then the simple necessity: greater and greater longing for that day, the day that will embrace everything with such immeasurable Simplicity, with a loving breath." [25]

The crowning element of the mystical experience culminating in communion with Him who appeared on that winter morning in the bright center, piercing and transforming everything, is the desire to "return to Silence," which is synonymous with divine reality: "You are the Calm itself, the great Silence, set me free from my voice, and fill me with the trembling of Your being, trembling of the wind in the ripe waves of grain." [26] The meaning and power of these dramatic words—a young poet begging God for silence and freedom from speech, these "words found in nothingness"—would only become truly clear on April 2, 2005, when Karol Wojtyła passed from his earthly life to the House of the Father.

24 Ibid, 16.
25 Ibid., 21–22.
26 Ibid., 22.

FOURTEEN

Death

We pass through life toward death — such is the experience, and such is certainty. Passing through death toward life is a mystery.[1]

KAROL WOJTYŁA, "Meditation on Death"

"MEDITATION ON DEATH" WAS WOJTYŁA'S LAST WORK before his election as pope. It appeared under the pseudonym Stanisław Andrzej Gruda. The poem ponders the mysterious connection between the meaning of life and the meaning of death, considering the perspective of an ordinary person and of a missionary priest facing death for his faith in Christ.

> This is the intuition which is most of all present when we meditate upon the death of those who have affected our lives with special profundity. We experience their death as an injustice and by union with it we reach in vain over the abyss of human destiny which condemns everyone to death.... The fact which transforms the matter of the world is Easter. In it, by union with the death of Christ, man reaches beyond the abyss of death in order to retrieve, in complete loss of himself and in his return to earth, the plenitude of his self which in life was only occasionally present to his consciousness but which sustains his existence. To experience death in this way is for the first time genuinely to possess the elements of life, and beyond their apparent randomness and beyond their belonging to earth, because the whole earth is the body which is drawn up for the resurrection.[2]

1 K. Wojtyła, "Rozważanie o śmierci" [Meditation on Death], in *Poezje i dramaty* [Poetry and Drama], 83.
2 Buttiglione, *Karol Wojtyła*, 251.

"Meditation on Death" is divided into four parts, each viewing the problem of death from a different angle. First, in "Thoughts on Maturing," the poet paints an existential picture of passing away as a process of maturing in preparation for the ultimate meeting with God. To mature is to "descend to a hidden core," which is accompanied by the process of dying away. "The cells that can still awaken sensitivity grow calm; the body in its fullness reaches the shores of autumn."[3] When death approaches, "the surface moves towards the bottom" and "enters the depths." As the body is fading away, the soul "stands in the way of death" and more consciously seeks resurrection; it matures, prepares itself for "difficult encounters" to come.

Death for the poet is at once an end and a beginning, for death is a return to the beginning. As "the last day" nears, the "fear" of it may be experienced either as dread or as "the beginning of wisdom." Fear is not an escape, when one's passing occurs in the state of love. "We enter this space, depart from that beginning, and so slowly we return: there is maturity in love, which transfigures fear."[4]

Only love gives us a chance to mature in peace for the sake of the ultimate meeting, although it clashes with fear at the moment of death. Fear is a method of defense against death and simultaneously an attempt to return to "existence," to the being with whom man has become familiar during his life. And then there is love, drawing man toward God, in whom "being finds its entire future."[5] Man is, as it were, suspended between the past and the future. "When we find ourselves by the shores of autumn, fear and love explode in their contradictory desires."[6]

The second part of the poem presents the Paschal Mystery as the answer to the question of death. It is through the Paschal Mystery that man transcends the chasm of death in his soul's union with Christ — through losing himself completely and returning to earth anew — to find the fullness he has hitherto only been able to experience intermittently, yet which, from an ontological point of view, had always been part of the foundation of his being. Surviving death through unity with the risen Christ leads to taking possession of all the

3 Wojtyła, "Rozważanie o śmierci" [Meditation on Death], in *Poezje i dramaty* [Poetry and Drama], 97.
4 Ibid., 95.
5 Ibid., 96.
6 Ibid., 82.

elements of one's life — a life that is not only a sequence of random incidents but which also no longer fully belongs to this earth, for the whole earth is transfigured in the resurrection. "In this space, in the world's fullest dimension, YOU ARE, and therefore my being has meaning, and so does my slow descent into the grave, my passage unto death; and the decomposition which turns me to ashes of unique atoms participates in your Passover."[7]

"The currents of passing you cannot stop. They are many; they circle around, and create a field, where you too shall pass, reconciled, for something swells, the world grows around you."[8] Death is a fact of nature. Man becomes reconciled with the necessity of death as he watches the world fade away. As the existentialists put it, life is marching toward death. Yet all the same, man looks for hope. "You shall descend below, this you know for certain; you shall turn to dust, this you know for certain. You exist — by being future-bound, you are always death-bound; [death] always steps into your current."[9] Man can only transcend the necessity of death in the Paschal Mystery, which, paradoxically, leads to the end of life: "The Paschal Mystery, the mystery of Passing, in which the order is reversed, since we pass from life to death."[10]

Yet Christ reverses this process in His death and resurrection. The moment of the "passing" from death into life remains an unknown, however. The Eucharist, the Memento of the Passing, is the only proof of that mystery available to us in life. Death is inevitable: "The currents of passing you cannot stop."[11] However, death contains within itself a principle of growth, for death leads to life.

The third part of the poem deals with the primordial fear connected to the existence of man. It appears at the beginning of man's life and keeps growing until his death. However, man also carries hope within himself: "Sliding into death, I unveil the expectation, my eyes fixed on one place, one resurrection. Yet I close the lid of my body, and entrust to the earth the certainty of its decomposition."[12] Only Christ, who crossed the threshold of death and rose again, can overcome the necessity of passing from life into death. Only Jesus "can take our bodies away from the earth again."[13] Faith in Christ thus

7 Ibid., 99.
8 Ibid.
9 Ibid.
10 Ibid., 82.
11 Ibid.
12 Ibid.
13 Ibid., 96.

becomes a chance to overcome the fear of death: "Faith's last word is coming to meet the necessity of passing — the word that answers without contradicting existence (death alone contradicts)." [14] The third part ends with a prayer for the faith required to overcome the fear of physical death and accept with courage its mystery.

The fourth part, "Hope Reaching Beyond the Boundary," portrays hope as the opposite of death. Hope makes it possible to await the end peacefully; it endows our daily labors with meaning. It is like a ray of light that emanates from the empty tomb of Christ, "a site of great mystery."

By definition, hope can be confirmed neither through experience nor through knowledge; it builds upon the Resurrection, which is only known through faith: "I wrestle with so many people for my hope — no memory deposit of my own confirms my hope; nothing reconstructs hope in the looking glass of passing. Your Passover alone can." [15] Hope tears the poet from the embrace of death and passing and anchors our fear in faith. The poet experiences the power of the Holy Spirit, who opens up his heart to the reality of the transformation, the reality of the Paschal journey from death into life everlasting.

14 Ibid.
15 Ibid., 97.

The Dramas of Karol Wojtyła

FIFTEEN

A Few Remarks on
Karol Wojtyła's Dramas

KAROL WOJTYŁA WAS A MAN OF THE THEATER, AND HE
contributed to the theater not only as a performer but also as a playwright.
"His involvement with theatre, which continued for some time, was especially
significant. Through his manifold participation as dramatist, theoretician, and
for some of the time, 'non-acting' performer, Karol Wojtyła has contributed to
the development of a specific kind of theatre. His plays are the most important
part of that contribution." [1]

It was as a playwright that Wojtyła first revealed himself to the literary
world. His six plays reflect the principles he learned through his involvement
during World War II in the clandestine Rhapsodic Theater, which emphasized
the primacy of the spoken word over gesture and engaged—under penalty
of death—in cultural resistance against the German occupiers. In Decem-
ber 1939, at the age of nineteen, he wrote his first play, *David*, which is now
lost. Its existence is attested to in a letter to Mieczysław Kotlarczyk written
in 1939. [2] The remaining plays are *Job* (1940), *Jeremiah* (1940), *Our God's Brother*
(1944–50), *The Jeweler's Shop: A Meditation on the Sacrament of Matrimony
Passing on Occasion into a Drama* (1960), and *Radiation of Fatherhood* (1964).

According to the Polish poet and literary critic Bolesław Taborski,
Karol Wojtyła's plays, even the earliest ones, demonstrate remarkable the-
matic maturity, and deep philosophical preoccupation with the drama of
human existence:

1 K. Wojtyła, *The Collected Plays and Writings on Theatre*, translated by B. Taborski (Berkeley
and Los Angeles: University of California Press, 1987), 1.

2 K. Wojtyła, Letter of December 28, 1939, in Kotlarczyk and Wojtyła, *O Teatrze Rapsodyc-
znym* [On the Rhapsodic Theater], 312.

Despite their stylistic differences, [the plays] are in some respects monolithic, especially in their themes and their moral import, mature even in Wojtyła's work as a nineteen-year-old.... In fact, from the very beginning (even though some of the early plays are externally stylized) Wojtyła as a playwright was no one's debtor but consistently built his own vision of the drama of human existence: the vision of man's place on earth and in the divine plan of creation. In his plays he referred to the highest values in our culture, and at the same time, in the days when word and language were totally degraded and devalued by ideologies that demanded their subservience to shallow, often inhuman purposes, he aimed at the revaluation of words.... Karol Wojtyła's dramatic works belong to the sphere of poetic drama, though their style differs considerably from one play to another. In his plays, as in his poems, he is concerned not so much with external events as with exploring man's soul; it is there that the "action" often unfolds. The formal means he employs to develop the action are difficult but not uninteresting. Though form as such was probably not his primary concern, even in the early plays, nonetheless, instinctively or deliberately, he searched for new means of expression.[3]

Wojtyła's dramas draw upon two major influences. One is literary, namely Polish Romanticism and the literary movement "Young Poland," or Polish *fin de siècle*. The other is theatrical, namely Wojtyła's involvement with the Rhapsodic Theater of Mieczysław Kotlarczyk. "This source accounts for the emphasis on the word and the so-called rhapsodic intellectualism, which prefers ideas and thoughts as a framework rather than chronological narrative. Because of their great emphasis on the word, these works are often referred to as 'conversational plays,' or 'pieces for voices.'"[4]

International interest in the literary output of Karol Wojtyła, including his plays, arose only in the wake of his election to the Throne of St. Peter. Earlier, the playwright himself kept a certain distance from his plays, which he did not initially seek to publish. *Our God's Brother* and *Radiation of Fatherhood* appeared rather late, in 1979 — after his election as pope.

3 Taborski, Introduction to Wojtyła, *Collected Plays*, 15–16.
4 J. Ciechowicz, "Światopogląd teatralny Karola Wojtyły" [The Theatrical Thought of Karol Wojtyła], *Dialog* [Dialogue], no. 10 (1981), 116.

The premiere of *Our God's Brother* took place on December 13, 1980, at the Słowacki Theater in Kraków. After the opening night, an avalanche of reviews and literary reactions swept the land, assessing both *Our God's Brother* and the pope as dramatist.

Yet the initial Polish reviews were written in ignorance of the full extent of the pope's dramatic output. Only after *Poetry and Drama* had been published did a broader awareness of his work emerge. Theater critic Zygmunt Greń published the first serious review of the pope's entire dramatic corpus. "No one would have appreciated a man who claimed, and showed in his work, that the main element of theater is the word — and that *word* meant something significant. For centuries we have dealt with a contrary trend in the theater. For over 20 years now this trend has completely taken charge of the minds and ideas of the creators. Only a few have bucked it. And now they have received some long-awaited relief and succor." [5]

According to Father Janusz Pasierb, Wojtyła's dramaturgy "is Mickiewiczan, Polish, Slavic, and — in this view — Romantic.... We observe with admiration how a young author ... deploys archaisms in his language, how he immerses himself in its historical depths, and how he reveals his love for his mother tongue." [6]

Literary historian Jarosław Maciejewski's take on the link between Wojtyła's dramas and Romantic literature is quite astute. "*Job* and *Jeremiah* are plays which belong to the expressionist current in Polish drama, and to the post-modernist retreats from the temptation of aestheticism. One can discern their suggestions of the historiosophical and scenographical visions of Wyspiański (*Akropolis*), the influence of the emotional-associative rhetoric of the hymns of Kasprowicz, and the stylized archaic Polish and folk elements of Zegadłowicz. However, there are also discernible traces of Słowacki and of the dilemmas of Polish history the latter had broached." [7] Yet at the same time, Maciejewski points out, "Just like the Polish Romantic tragedies *Forefather's Eve, Kordian,* and *The Un-divine Comedy*, Karol Wojtyła's *Our God's Brother* is a play focused on the main protagonist and his dramatic transformation in his attitude towards God, nation, and man.

5 Z. Greń, "Powołanie" [Vocation], *Życie Literackie* [Literary Life], no. 50 (1980), 24.

6 J. Pasierb, "O *Bracie naszego Boga*" [On *Our God's Brother*], *Communio*, no. 1 (1981), 14.

7 Maciejewski, "Karol Wojtyła i Jan Paweł II wobec literatury" ["Karol Wojtyła and John Paul II on Literature"], 6–8.

As in the romantic plays, scenes in *Our God's Brother* serve to focus on and explore the hero's inner conflict." [8]

Maciejewski detects the influence of another Polish Romantic poet, Norwid, in Wojtyła's play *The Jeweler's Shop*. "The author took up the muted Norwidian themes: the matter of wasted and broken love; the crucial role of tenderness and compatibility of hearts in marital relations. Even the symbolism of the engagement ring evokes Norwid's plays (*The Ring of a Great Lady* and *Pure Love in a Seaside Swim*)." [9]

Polish literary critic and historian Stefan Sawicki identified an implicit trilogy among Wojtyła's dramas: *Our God's Brother, The Jeweler's Shop*, and *Radiation of Fatherhood* "align as a triptych. The author subordinated them as successive links in one chain of thought, which was expressed in the first words of the cycle: This shall be an attempt to penetrate man." [10] The artistic continuity and anthropological theme of these plays can be seen in the development of the character of Adam who appears in each of the three plays. "From the real Adam Chmielowski in *Brother of Our God* to the unknown moralist Adam of *The Jeweler's Shop* ... up to this Adam of the divine mystery in *Radiation of Fatherhood*, he is presented as everyman, 'everyone and eternal,' a man who experiences the reality of divine fatherhood." [11]

Bolesław Taborski describes Wojtyła's dramaturgy as "departing from our habits and theatrical tastes. It is difficult and complex, unconventional — even, surprisingly, experimental. In the epoch of a theater open to all superficial, skin-deep impressions, experiences, and excesses, this is a dramaturgy penetrating into the depth of man and often playing itself out in his innermost reaches, and, to this end, employing challenging yet extremely intriguing formal means." [12]

Taborski analyzes Wojtyła's plays chronologically from 1939 until 1964. He argues that Wojtyła's dramas represent "a modern form of a mystery-play."

8 Ibid., 7–9.
9 Ibid.
10 Z. W. Solski, "Ojcostwo i tożsamość" ["Fatherhood and Identity"], in *Przestrzeń słowa. Twórczość literacka Karola Wojtyły — Jana Pawła II* [The Expanse of the Word: The Literary Output of Karol Wojtyła-John Paul II], eds. Z. Zarębianka, J. Machniak (Kraków: Św. Stanisława, 2006), 430.
11 J. Ciechowicz, "Z Wadowic w świat. Karol Wojtyła i teatr" [From Wadowice into the World: Karol Wojtyła and Theater], in Zarębianka and Machniak, *Przestrzeń słowa* [The Expanse of the Word], 365.
12 Taborski, *Karola Wojtyły dramaturgia wnętrza* [Karol Wojtyła's Dramaturgy of the Interior], 14.

Jeremiah is a good example: "This most Polish of all Karol Wojtyła's dramas is no less universal than the others.... There are not too many contemporary plays which would so readily lend themselves to performance in a church and which reflect such an appreciation of the liturgy and the order of the Holy Mass. While writing his drama, Wojtyła most likely did not know Eliot's *Murder in the Cathedral*.... But at Wyspiański's cathedral (from *Acropolis*) no Mass is celebrated. For Wojtyła *sacrum* has a cardinal meaning." [13]

Taborski's remarks draw attention to Wojtyła's discretion in expressing religious sentiments. "In his plays, and also in his poetry, the author rarely invokes God by his name or addresses him directly. His presence is discernible, but it is not overwhelming.... The Jeweler can be taken to signify the voice of conscience. Conscience is something both human (meaning that it should be present in a man) and given by God. Thus, there is no contradiction between the divine and human attributes of the Jeweler." [14]

Taborski stresses that Wojtyła "failed to take care of his 'literary business.' As a poet, he published little and rarely. As a playwright, he did not submit his works to theaters. He only published one of them.... And thus emerges one of the leading religious poets in our literature, and also a distinctive playwright, who has an original idea of the theater. This is not the first incident with us of a late discovery of an outstanding writer." [15]

Indeed, the dramas of Karol Wojtyła are an attempt to search for God and to experience His presence in everyday life. At the same time, his plays attempt to depict man in various everyday situations, struggling with trials of fate and suffering (*Job* and *Jeremiah*). They also force us to ponder human love and the sacrament of marriage (*The Jeweler's Shop*). They focus on the mystery of fatherhood and point to the mission of the father in the family (*Radiation of Fatherhood*).

Karol Wojtyła's plays reveal to us not only the secrets of the poet's soul, but also his joys and fears. These works constitute an attempt to understand that which is incomprehensible in the ever-new mystery of life. Wojtyła's plays are not only the key to understanding the Polish pope, but also an aid to us in comprehending ourselves, our fate, the essence of love, human relations, and the personal relationship between man and God, the Creator and Redeemer.

13 Ibid., 15.
14 Ibid.
15 Ibid., 16.

SIXTEEN

Job and *Jeremiah*

JOB CAME IN 1940 FROM THE PEN OF A YOUNG STUDENT OF
Polish literature at the Jagiellonian University, when Poland was stricken by
war and occupation. In a letter to Mieczysław Kotlarczyk, Wojtyła wrote:
"I have written a new drama, Greek in form, Christian in spirit, eternal
in substance, like *Everyman*. A drama about suffering: *Job*. Some people
here quite like it. It is partly the result of my reading of the Old Testament.
I have read David's Psalms, the Book of Job, the Book of Wisdom, now the
Prophets." [1]

In the biblical story of Job, a righteous and good man occupies the most
prominent place. It is surprising, however, that in Wojtyła's play we do not
hear Job appealing to have his former status restored. He does not yearn to
have material goods returned to him. The lamentation of Job stems here rather
from his love of God — from the longing of man for the Creator.

Wojtyła's drama is based on the Book of Job. "The requirements of his genre
lead the author to adopt a number of dramatic devices, although he always
remains close to the ideas and the story line of the original. The dramatiza-
tion of a biblical story necessitates the substitution of dialogue for narrative
speeches, the introduction of new characters, and the fuller development of
some barely mentioned in the biblical account.... The long monologues are
broken up and replaced with dialogue. The statements of Eliphaz, Bildad,
and Zophar are much shorter than those in the Bible; so are the speeches of
Job, who actively participates in the dialogue. There is a further significant
variation on the biblical story. Always reluctant in his poetry to mention God
directly, Wojtyła also avoids bringing him into the drama as a character. The
speaker of the narrative Prologue quotes only Satan's words directly ... [the]

1 Taborski, Introduction to *Job*, in Wojtyła, *Collected Plays*, 19.

Prologue and Epilogue [are] both ... [Wojtyła's] own, though they are close to their biblical counterparts."[2]

The form of *Job* is the author's own. The language resembles the Young Poland literary style. *Job* is written entirely in verse, partly blank and partly rhymed. Moreover, Wojtyła has added the Chorus and four servants.

"The external drama in the Book of Job is in fact contained in the biblical prologue, which narrates in a compressed manner Satan's two discourses with God about testing Job and describes all the misfortunes that subsequently befall him. The emphasis is on Job's internal drama and its narrative presentation through the arguments concerning the reasons for his suffering that are put forward by the four friends, countered by him, and revealed clearly by God."[3]

This extraordinary play concerns not only the biblical story of Job but also the Polish nation's experience of the cruelty of war in September 1939 and the human suffering that followed. "The play's narrative line follows the biblical story rather closely, with Job's circumstance representing Poland's suffering under the Nazi jackboot—an adaptation of nineteenth-century Polish Romanticism and its identification of dismembered Poland as the suffering 'Christ of nations.'"[4]

Taborski also notes that "the playwright sees action as taking place both 'in the Old Testament—before Christ's coming' and 'in our days,' which he calls 'Job's time—for Poland and the world.' Like Job in his day, the author's country and the suffering world at war wait for judgment and 'for Christ's Testament' to be realized.... Like Job, they should live in hope that their 'Redeemer liveth.'"[5]

Wojtyła focuses on the inner drama of the innocent Job in his undeserved sufferings; Job's wife gains greater prominence in the play than in the biblical account; in the former she experiences along with Job a testing of faith.

Marek Skwarnicki argues that *Job's* significance lies in the play's symbolic meaning: there are parallels between Job's suffering and the trials of the Polish nation throughout its history. "The choice of this particular character as the 'hero' of a rhapsodic drama was most certainly not accidental during this

2 Ibid., 21.

3 Ibid., 20–21.

4 B. Taborski, "Kardynał Wojtyła—poeta dramaturg" [Cardinal Wojtyła—poet-playwright], in *Tygodnik Powszechny* [Catholic Weekly], no. 1 (1981), 2.

5 B. Taborski, Introduction to *Job*, in Wojtyła, *Collected Plays*, 23.

period of national and individual suffering which suddenly befell the Poles, immersing them in a truly 'Job-like' situation. The young Wojtyła's drama is an attempt to probe the mystery of suffering, crowned with a 'Romantic' vision of Job, who in the depth of his misery and devastation suddenly sees Christ, discovers the liberating impact of His cross, and discovers the meaning of sacrifice." [6]

Suffering is not intended by God, but it is allowed by Him as a consequence of man's free will. Even if evil can destroy man, it can also, if man be united with Christ, become a means to transform him and permit him to participate in the glory of Jesus. God is thus present in suffering; He does not leave man alone but gives him His only-begotten Son. This faith allows man to accept his suffering in union with Christ and join in His work of salvation.

It is interesting to note that God never appears in the play; Elihu delivers the Lord's lines from the biblical account (Job 39–41). Elihu is present from the beginning of the play as a witness to all the utterances of Job to his friends. He admonishes the protagonists, worships God, acclaims His justice, and prepares the arrival of the Son of Man. Elihu's words, according to the Holy Bible, are meant to prepare the way of the Lord. Elihu does not comfort Job, but in a vision he prophesies the sufferings of God's servant, the Messiah to come.

Karol Wojtyła's *Job* is not only a reflection on the meaning of suffering discovered in Christ, but also a consolation for a suffering nation that sought comfort in God during the war. Only through Christ does suffering become the way of liberation and salvation. "And He sent His Son. And God's Son founded a New Covenant, on His sacrifice, passion, and suffering. This suffering forms the surest base — this suffering transforms us, puts the New Covenant in men's hearts, like a new day of creation." [7]

According to Krzysztof Dybciak, Wojtyła's work "impresses with its fine command and versatility of style, and more broadly with its ability to understand disparate psyches and to speak in many tongues. This feature is important for all literary creativity and even more so for the missionary and apostolic activity of the future bishop of Kraków and Rome." [8]

One is also impressed by the depth of thought of a twenty-year-old author who looked to the Divine Word for understanding of his suffering and, at the same

6 M. Skwarnicki, "Wstęp" [Introduction], in Wojtyła, *Poezje i dramaty* [Poetry and Drama], 6.
7 K. Wojtyła, *Job: A Drama from the Old Testament*, in *Collected Plays*, 73.
8 Dybciak, *Karol Wojtyła a literatura* [Karol Wojtyła and Literature], 86.

time, hope for the future. He shifts from the suffering of Job to that of Christ in order to turn to his contemporaries with words of comfort and encouragement.

Wojtyła endeavored to portray man's life and his relationship with the Creator through the story of Job. More specifically, he wanted to depict the openness of man toward God, made possible most completely in human suffering. Only by losing everything in life can man, like Job, hear the voice of God.

<p style="text-align:center">* * *</p>

On August 7, 1940, Karol Wojtyła mentioned to Mieczysław Kotlarczyk a play he had just written, saying: "I carry the stuff in me for a long time…until it is completed within me, it will not let me write it…. I must confess to you that I am attached most to what I have called, for the moment at least, *Jeremiah*." [9]

Jeremiah presents the biblical story (interspersed with elements of Polish history) in dramatic form, in three acts. "*Jeremiah* is not, strictly speaking, a historical play. It is not concerned with external events and facts, though it alludes to them, but with ideas and attitudes, with a vision of Polish history." [10]

A key theme in *Jeremiah* is the fall and rebirth of the nation. It is also about truth as a moral concept. Truth here is understood as leading a decent life, emulating the right norms of behavior, acting in congruence with faith, and following the voice of God. Wojtyła brings together three different historical figures as the characters in this drama: Fr. Piotr Skarga (1536–1612), Stanisław Żółkiewski (1547–1620), and Andrzej Bobola (1591–1657). This seems to reflect a carefully considered choice. "Father Peter [is] based on Piotr Skarga, a Jesuit priest, a theologian, a fervent preacher at the royal court, and a writer, who uttered many a dire warning that Poland would fall should it fail to put its house in order…. The second major character is the Hetman, Stanisław Żółkiewski, based on the great general and patriot who defeated the Russians and occupied the Kremlin…. The third major character in the play is Brother Andrew, based on the Jesuit missionary, preacher, and teacher Andrzej Bobola, murdered by rebellious Cossacks. Canonized in 1938, he must have had particular relevance for the author of the drama as the newest Polish saint." [11]

Dybciak comments on the significance of *Jeremiah*'s style as well as the

9 Taborski, Introduction to *Jeremiah*, in Wojtyła, *Collected Plays*, 76.
10 Ibid.
11 Ibid., 80.

philosophical aspects of the play: "From the stylistic point of view, this play is more finished than *Job*. One was put off by the latter's exuberant archaization, a bit humorous in its stage directions. (This was certainly an understandable affectation for a student of Polish modernist writers, Wyspiański in particular, a great playwright and theatrical reformer, enamored of elaborate stage directions.) Having read *Jeremiah,* one has no doubt that the author was blessed with poetic talent." [12]

The drama takes place on two chronological planes: the Lent of 1620 and the time of the prophet Jeremiah—during the reign of Joachim, up to the beginning of the Babylonian captivity (605 BC). Jeremiah received a difficult task from God. He was obliged to give warnings of the danger threatening the Jewish nation: "Stand in the Lord's porch, in Jerusalem / stand in the porch of the Lord's House / stand before the prince Jehoiakim; / speak and proclaim the Word." [13] In the face of the coming disaster the prophet called the people to repent, and to desist from theft, adultery, and murder; and most of all he warned them against sacrificing to pagan deities.

The first act of *Jeremiah* takes place in the "antechamber of the divine house," in a small chapel, where we spot two imposing angels who usher in Father Peter—Piotr Skarga. The angels announce God's call to him to become a contemporary Jeremiah. "The Lord has decreed—their conscience you are. You must shake them, shake them hard." [14] In dialogue with the angels, Father Peter expresses his regret that the conscience of his flock is hardened and no word moves them. He falls before the cross and begs God for the power of the Holy Spirit to fulfill his mission as a prophet and call on the people to repent and change their hearts. "You are the judge, You are the curb! Inspire me with words to overcome their might! Words are not enough—send the Spirit to shake them inwardly, worry their souls! Words are not enough, not enough. One must catch hearts to kindle them, furrow hearts as with a plough, and root up the weeds—root them out." [15]

Speaking to the king, Jeremiah points to a rope around his neck, which is the symbol of the slavery awaiting the Jewish nation for its infidelity to God. Then the prophet launches into an exhortation full of warnings and threats:

12 Dybciak, *Karol Wojtyła a literatura* [Karol Wojtyła and Literature], 87.
13 Wojtyła, *Jeremiah,* in *Collected Plays,* 99.
14 Ibid., 97.
15 Ibid., 98.

"If you do not repent, O people—O Jerusalem! Jerusalem! / —the foe will come through smoke and fire!" The vision of a disaster ends the scene with Jeremiah, and the action of the drama shifts to the dimension indicated at the beginning, with Father Peter in the forefront. Like an Old Testament prophet, Father Piotr Skarga prays to God to reverse the disaster threatening Poland. He can see clearly the horrors of war menacing the nation, and the destruction and suffering of innocent people. He asks of God the reason for suffering, and expresses his desire to become the martyr who fights for the nation. "Why did You put me with Jeremiah, among my people, in Jerusalem? Why did the vision You sent show dishonor? Do You now not accept burnt offerings?! — A burnt offering am I." [16]

Act Two takes place in a church, where Father Peter addresses the assembled faithful from his pulpit. Here, in a prophetic vision, Piotr Skarga sees prostitution, theft, and other abominations as the causes of the forewarned collapse of the fatherland. "Thievish hearts! Everyone for himself, / but naught for her—your Mother Poland. / Thievish hearts! When the ship is sinking, everyone counts and clings to his bundles, unmindful of the water that fills and sinks it." [17] The preacher thus calls on the people to abandon their self-interest and care for the Commonwealth—for the threatened Republic.

Father Peter entreats the people to love their motherland as a mother. His sermon resembles a prayer begging God to have mercy on His people. The Polish Jeremiah descends from the pulpit and becomes engrossed in deep prayer. That is when the Hetman, the chief military commander—based on the Grand Crown Commander Stanisław Żółkiewski—approaches him. The commander confesses his sins and weaknesses and asks for a blessing in the mission awaiting him. Because of the danger facing the nation, the Hetman declares his readiness to fight. He asserts that to be able to defend the homeland, one must first destroy all flaws within oneself: "Force oneself, avenge on oneself / all those sins and pernicious ways, / mark out the road to excellence and brightness /map it out with an archangelic sword." [18] The Hetman is ready to defend the homeland and to renew the spirit of the nation.

Act Three takes place in the same church, in 1620, the year of the Polish army's defeat at Cecora. In the presence of the Polish king Sigismund III Vasa,

16 Ibid., 109.
17 Ibid., 113.
18 Ibid., 119.

the monks chant the Lamentations of Jeremiah. As they chant, a messenger knight enters the temple with news of the defeat of the Crown Commander Żółkiewski's armies at Cecora. "I stand before you in woe — / I have rushed here from the fields of Walachia, from the gorges beyond the Dniester, where swords were broken in fighting, / where still glory remained. / He went against the Ottoman might — / the lord of Żółkiew devout — / with his brave breast he opposed it; and when a spear pierced his chest, his corpse lay in the field / for the infidel to defile. / Hear me, most noble King! Hear me, monks on the benches! I rush here from the bloody fields of Cecora." [19]

After the messenger has spoken, the monks call upon the prophet Jeremiah to appear before them and release the consoling power of his lamentations. Father Peter joins them in singing of the bravery of the Crown Commander and the death of his knights. "I, a man who sees the centuries of suffering and misery. / Thus did it come to pass you had to die? O brother, brave friend!" [20]

And so in the face of defeat, hope appears, "a new dawn" that heralds the coming of victory. Despite the defeat, the efforts of Żółkiewski are not in vain. Father Peter encourages all to uphold the divine law, for it has the power to protect man from misfortune and helps him survive the tempests of history with his soul intact. "Who carries the Covenant also carries life. / The people must not abandon the Covenant / lest they lose life, the torch being extinguished. / The Covenant is a torch, burning in sacrifice." [21] The sacrifice offered by the nation cleanses hearts and ennobles the people. It makes them righteous before God and man.

The conclusion of the drama is an exhortation to a crusade. Wojtyła takes up another theme: "the tradition of *antemurale*, or a bulwark, according to which Poland acts as the bulwark of Christendom and Western civilization. In the 17th century, the eastern despotisms were the threat. During the Second World War, the fascist totalitarianism approaching from the West became a lethal enemy. The truth is perhaps that Poland is a movable rampart." [22]

More so than Wojtyła's other works, *Jeremiah* is a defense of the principle that "everything can be the working of Grace; one should know how, and above all want, to cooperate. As the parable of talents teaches us. Well, I think that

19 Ibid., 132.
20 Ibid., 134.
21 Ibid., 143.
22 Dybciak, *Karol Wojtyła a literatura* [Karol Wojtyła and Literature], 99.

one should be able to respond to Grace with Humility. So in this dimension the struggle for Poetry will be a struggle for Humility." [23]

23 Taborski, Introduction to *Jeremiah*, in Wojtyła, *Collected Plays*, 91.

SEVENTEEN

Our God's Brother

Generally speaking, the essence of man is in his historical inexhaust-
ibility. The extra-historical element is embedded in him; indeed, it
is the very wellspring of his humanity. Any attempt to comprehend
man implies reaching into the wellspring. [1]

KAROL WOJTYŁA, *Our God's Brother*

OUR GOD'S BROTHER IS CRUCIAL TO UNDERSTANDING THE
work of Karol Wojtyła. This is undoubtedly his masterpiece; it is here that he
contrasts most keenly the attitude of the artist with that of the man of ethical
action. This is a political drama, although it answers questions about poli-
tics through anthropology. The play recounts events from the life of Adam
Chmielowski, yet it is not a typical biographical drama.

"Karol Wojtyła's plays are not 'plays' in the conventional sense of the term,
and *Our God's Brother* is certainly not a conventional biographical drama,
although it follows the trajectory of Adam Chmielowski's life in broad outline.
An example of the Kotlarczyk-Wojtyła 'inner theater,' the play is an attempt to
communicate Brother Albert's struggle to identify and live out his vocation.
The play's main 'action' takes place in the conscience of Adam Chmielowski,
who is 'becoming' Brother Albert throughout the drama." [2]

Stanisław Dziedzic and Jan Okoń have noted that *Our God's Brother*, written
in prose, differs from the earlier "Polish literary" dramas by the young Wojtyła,
written in verse. It is an expression of "spiritual transformations within the
author himself and a testimony to his transition from a Polish literary-artistic
personality to a philosophical-theological thinker." [3]

1 Wojtyła, *Our God's Brother*, in *Collected Plays*, 188.
2 Taborski, Introduction to *Our God's Brother*, in Wojtyła, *Collected Plays*, 147–48.
3 S. Dziedzic, "Znaki wspólnych powinności—Brat Albert i Karol Wojtyła" [The Signs of

Karol Wojtyła began writing *Our God's Brother*, his first mature play, when he was twenty-five, during his last year at the Kraków seminary. He worked on it between 1945 and 1950. One should pay attention to the historical context within which he wrote the drama. As Stanisław Dziedzic observes, "When he undertook the project, Poland and Europe were experiencing a tragedy of horrific violence and social injustice connected to the Nazi occupation. The threat of a new totalitarianism — communism — was taking shape ever more clearly and the vision of the state of the so-called dictatorship of the proletariat was becoming ever more real. When he finished the final version of the drama a few years after the war, the Poles were facing harsh challenges born of an increasingly menacing and totalitarian system of Stalinist communism." [4]

Wojtyła decisively rejected the Marxist conception of man and the Marxist understanding of the dynamics of history, evil, and violence in social relations, and this is clearly reflected in his drama. "The author of *Our God's Brother* observed in the revolutionary movement a social reaction that traced its source to injustice and the alienation of man in an atomized society of battling egos, both individual and collective. Wojtyła denied, however, the alleged inevitability of the connections between these historical events and revolution. Further, he dismissed materialistic reductionism as misrepresenting the purpose of human life. He concluded that "anger must explode," but the last sentence leaves no doubt about his judgment of this explosion and its consequences: [in resisting this anger] "I know however for sure that I have chosen a greater freedom." [5]

The future pope had long been fascinated by Adam Chmielowski, later known as Brother Albert. A well-known painter from Kraków, he decided to abandon his artistic career and devote his life to the poor, in whom he saw Christ. He struggled with his thoughts and desires, and finally chose, as he put it himself, "more freedom." He took the name of Brother Albert and made a shelter for homeless men his permanent residence. Karol Wojtyła felt an affinity with Brother Albert: he, too, walked away from art (he left literature and the theater) to devote himself to God and to helping others; his good works and service to God extended to his love of country, which always played a role in Wojtyła's decision-making. Chmielowski participated in the anti-Russian

Mutual Obligations — Brother Albert and Karol Wojtyła], in Zarębianka and Machniak, *Przestrzeń Słowa* [Expanse of the Word], 369–85, 376–77.

4 Ibid., 378.

5 Dybciak, *Karol Wojtyła a literatura* [Karol Wojtyła and Literature], 96–97.

January Uprising of 1863, known as the most Polish of all national uprisings. It impressed itself indelibly on the national psyche, and Karol Wojtyła recognized its deep significance. In May 1963, during the January Uprising's centennial, Karol Wojtyła spoke of that armed struggle for freedom: "It cost the Poles a lot of casualties on the fields of battle. It cost [Poland] even more victims in the torture chambers of Siberia. But that was necessary.... Everyone in 1863 who sprang up to fight against horrific violence realized what they risked. Therefore, their actions possess an inner greatness. They are endowed with the deepest nobility. They point to some kind of power of the human spirit, while, simultaneously, they are capable of igniting that power within others." [6]

After he became pope, the playwright discussed his debt to Adam Chmielowski in his autobiographical works *Gift and Mystery* and *Rise, Let Us Be on Our Way*. In *Gift and Mystery*, he explains: "I was deeply inspired by the figure of this courageous man.... Brother Albert has a special place in the history of Polish spirituality. For me he was particularly important, because I found in him a real *spiritual support and example* in leaving behind the world of art, literature and the theatre, and *in making the radical choice of a vocation to the priesthood*.... Many writers have immortalized the figure of Brother Albert in Polish literature.... I too, as a young priest, when I was curate at Saint Florian's Church in Cracow, wrote a dramatic work in his honor, entitled *The Brother of Our God*. This was my way of repaying a debt of gratitude to him." [7]

Our God's Brother is among the most structurally rich of Wojtyła's works:

> The action occurs in several places. The playwright juxtaposes several characters, differentiated psychologically and ideologically. The dialogues are not overloaded with theorizing and tend to be smoothly blended into dramatic situations. An analysis of the play's composition proves that its creator is a man of theater, who understands stage dynamics and who constructs effective theatrical events. The penultimate scene is particularly magnificent. It takes place between three people, except the third person is The Crucified. He was ushered into the literary creation as He who was addressed by Brother Albert. Earlier, Jesus witnessed a conversation between monks and caused a change in the human soul. [8]

6 Ibid., 92–93.
7 Wojtyła, *Gift and Mystery*, 31, 33.
8 Dybciak, *Karol Wojtyła a literatura* [Karol Wojtyła and Literature], 97.

The main theme of Wojtyła's drama is a man's calling, and, more precisely, his struggle to convert himself into a gift for others and to abandon his ego. This is on display clearly when Chmielowski abandons his comfortable life and takes a vow of poverty and service to man. *Our God's Brother* is also about the struggle to learn the value of human freedom, and, more broadly, the meaning of human existence. Adam, who expresses Wojtyła's convictions, believes that the only social transformation worthy of a human being takes place through the Cross. It is "a transformation of the fall of man into good, and of his slavery into freedom." [9] The play finds a resolution in the words Brother Albert utters on his deathbed, when a workers' revolt has broken out in the city. "And what? After all, you know that anger must explode. In particular, when it is great. [*He paused.*] And it will last because it is just. [*He reflects even deeper. Then he adds another word, as if for himself, although everyone is listening attentively.*] I know however for sure that I have chosen a greater freedom." [10]

There is another dimension to *Our God's Brother*. Through the play, Wojtyła analyzes the problem of revolutionary violence. Three types of action in human history are represented by three protagonists in the drama: the main hero, Adam — Brother Albert; his friend Maks, an artist; and a revolutionary called the Stranger. "There has been considerable speculation about possible models for the Stranger. Pope John Paul II has confirmed that the character is 'Crypto-Lenin,' an adaptation by the playwright of the never-confirmed legend that Chmielowski and Lenin met, perhaps in Zakopane, while the latter was living in and around Kraków in 1912–1914." [11]

Maks is a proponent of individualism. He advances his vision of a libertarian society with unfettered competition in all areas of life. For Maks, individual success is the ultimate test of a human being. Adam denies the validity of this approach, for he believes rather in full solidarity with man. His idea of the meaning of life is to serve the poor. This does not mean lowering oneself to the level of one's inferiors, but elevating oneself to fraternity with fellow human beings in the worst possible situations. The Stranger personifies anger and revolution. He tries to transform the anger of the oppressed into class struggle, which he views as the only way to effect the revolutionary explosion that is the starting point of the struggle for power. Adam becomes the

9 Wojtyła, *Our God's Brother*, in *Collected Plays*, 153.
10 Ibid., 243.
11 Weigel, *Witness to Hope*, 114.

Stranger's adversary. "The 'greater freedom' chosen by Brother Albert was a freedom that the Stranger, Crypto-Lenin, regarded as a swindle of the poor. Karol Wojtyła has never doubted that Brother Albert had it exactly right, and Crypto-Lenin exactly wrong." [12]

Our God's Brother was staged in Kraków in 1980, but it immediately ran afoul of the communist authorities. The play served as a reminder that the Church is a place of freedom in the world, for it is witness to Messianic liberation that shall free man and guide him to a better future. "Brother Albert did not defend the Church as such, but he defended human dignity through the Church and the Truth to which it bears witness. Compared to Lenin, he indeed chose 'greater freedom.'" [13]

In *Our God's Brother* Karol Wojtyła wrote a profoundly gripping drama about human life. In it he reaches to the source of man's humanity, where "the supra-historical element" dwells. This entails an honest search for the truth about man, an attempt to capture the unique moment when a total liberation of man occurs.

12 Ibid., 115.

13 M. Lawson, "The Pope's Other Self," *Tablet,* December 14, 1996, 7; see also J. Luxmoore, J. Babiuch, "Did Karol Wojtyła See and Rescue the Good in Marxism?," *National Catholic Register,* January 26–February 1, 1997, 7.

EIGHTEEN

The Jeweler's Shop

Love is a constant challenge, thrown to us by God, thrown, I think,
so that we should challenge fate. [1]

KAROL WOJTYŁA, *The Jeweler's Shop*

KAROL WOJTYŁA COMPLETED *THE JEWELER'S SHOP* EARLY
in 1960. It is at once a meditation and a poetic drama. "The divergence between
what lies on the surface and the mystery of love constitutes precisely the source
of drama. It is one of the greatest dramas of human existence." [2]

The Jeweler's Shop "is a meditation on love. In this work, the thought is
harmonically expressed in simple and quiet rhythms, so polished that its depth
is an occasion not of difficulty but of perpetual wonder. The problem which
the text poses to a facile understanding is the same as that which life offers;
one moves easily from meditation on the text to meditation on the enigma
of one's own destiny—its drama and its mysterious profundity." [3]

Wojtyła's subtitle for this play is *A Meditation on the Sacrament of Mat-*
rimony, Passing on Occasion into a Drama. He suggests that, in a way, *The*
Jeweler's Shop fails to meet the requirements of a classical stage drama. "He
does so consciously. That is because he follows the directives provided by
Mieczysław Kotlarczyk for the Rhapsodic Theater.... In this type of theater
human gesture, countenance, and action in general count for less. Written with
great care for beauty and expression, the dialogue reflects what happens in
the human mind.... The domination of word over gesture indirectly restores
the superiority of thought over the movement of the body on stage, gestures,

1 Wojtyła, *The Jeweler's Shop*, in *The Collected Plays*, 312.
2 Ibid., 301.
3 Buttiglione, *Karol Wojtyła*, 252.

and man's physical reactions to others." [4] Such concerns furthermore reflect Wojtyła's understanding of the love between a woman and a man.

The Jeweler's Shop tells the story of three couples who experience the purpose and the problems of love in different ways. "Stefan and Anna must come to grips with their estrangement. Teresa with her widowhood, all of the characters with their children going their separate ways after marriage. Accepting all the consequences, Christopher takes Monica away." [5] The protagonists uncover before us the deepest secret of their souls, their yearnings, sorrows, and disappointments. They endeavor to fathom something intangible: love. One marvels at "the psychological astuteness of the description of the initial stage of marriage, the process of the disintegration of the marital union, and the continuity between parents and their children." [6]

In Act One Teresa and Andrew are betrothed and marry. Their union is based upon true love, mutual respect, support, and understanding. The history of this couple's love is presented in a simple, calm rhythm: "Love—love pulsates in temples, in a human being it is transformed into thought and will: Teresa's will to be Andrew, Andrew's will to be Teresa. Strange, yet necessary—and again to leave each other, because a human being will not endure in another forever and a human being will not do. How can it be done, Teresa, that you may stay in Andrew forever? How can it be done, Andrew, that you may stay in Teresa forever? Since a human being will not endure in another / and a human being will not do." [7]

Teresa reminisces at the beginning of the play: "Andrew has chosen me and asked for my hand. It happened today between five and six in the afternoon. I don't remember exactly, I had no time to look at my watch, or catch a glimpse of the clock on the tower of the old town hall. At such moments one does not check the hour, such moments grow in one above time.... Andrew turned around and said, 'Do you want to be my life's companion?' / That's what he said. He didn't say: do you want to be my wife, / but: my life's companion. / What he intended to say must have been thought over." [8]

4 A. Jawień (Karol Wojtyła), "Dramat Słowa i Gestu" [A Drama of Word and Gesture], in *Tygodnik Powszechny* [The Catholic Weekly], no. 14 (1957), 5.

5 Taborski, Introduction to *The Jeweler's Shop*, in Wojtyła, *Collected Plays*, 274.

6 A. Jawień (Karol Wojtyła), "Dramat Słowa i Gestu" [A Drama of Word and Gesture], op. cit., 5.

7 Wojtyła, *The Jeweler's Shop*, in *Collected Plays*, 291–92.

8 Ibid., 279.

It took Andrew a long time to get to truly know Teresa. "I do not even remember if our first meeting / was marked by a kind of presentiment.... After a time I realized she had come into the focus of my attention, / I mean, I had to be interested in her, / and at the same time I accepted the fact that I had to. / Though I could have behaved differently from the way / I felt I must, / I thought there would be no point. / There must have been something in Teresa that suited my personality.... I decided then to seek a woman who would be indeed / my real 'alter ego' so that the bridge between us / would not be a shaky footbridge among water lilies and reeds."[9]

Hitherto Andrew, the protagonist, had particular convictions about love. He conflated love with sensuality:

> I wanted to regard love as passion — as an emotion to surpass all — I believed in the absolute of emotion. / And that is why I could not grasp / the basis of that strange persistence of Teresa in me, / the cause of her presence, / the assurance of her place in my "ego," / or what creates around her / that strange resonance, that feeling "you ought to." / So I avoided her cautiously, deliberately evaded / everything that could cause even the shadow of a guess. / Sometimes I even tormented her in my thoughts, / while seeing in her my tormentor. / It seemed to me she pursued me with her love, / and that I must cut myself off decisively. / Thus grew my interest in Teresa; / love grew, in a sense, from resistance. / Or love can be a collision / in which two selves realize profoundly / they ought to belong to each other, even though they / have no convenient moods and sensations. / It is one of those processes in the universe which bring a synthesis / unite what was divided, broaden and enrich what was limited and narrow.[10]

Love is that decisive point on the road to destiny where a man and a woman meet:

> Then Andrew took me by the hand / and said, "Let's go in, Teresa; / we'll choose our rings." ... The jeweler looked long into our eyes. / Testing for the last time the fineness of precious metal, / he spoke seriously, deep

9 Ibid., 280–81.
10 Ibid., 281.

thoughts, / which remained strangely in my memory. / "The weight of these golden wedding bands," he said, "is not the weight of metal, / but the density of man, / each of you separately / and both together.…"[11] It is the weight of constant gravity, / riveted to a short flight. / The flight has the shape of a spiral, an ellipse — and the shape of the heart.… Ah, the proper weight of man!… And in all this — love, / which springs from freedom, / as water springs from an oblique rift in the earth."[12]

The love of Teresa and Andrew, however deep, was destined to be short-lived and not entirely fulfilled. It ends tragically when Andrew is killed in the war. Christopher is the fruit of their love.

The second act opens with the recollections and trepidations of Anna. She believes that Stefan does not love her anymore. "I must have thought — since he doesn't react to my grief.… It was as if Stefan had ceased to be in me. Did I cease to be in him too?"[13]

As this might suggest, the story of Stefan and Anna concerns a marital crisis. When infatuation with one's beloved passes, sometimes only indifference and anger remain. Stefan took love for granted. He saw no reason to renew it and to transcend himself. At the same time, in the drudgery of everyday life, Anna had trouble renewing the consciousness of the gift she made of herself. A "breach" occurred. Anna would later admit: "I could not reconcile myself to this, / nor could I prevent / a rift opening between us.… But since / the rift in our love became a fact, / I have often looked at golden wedding rings — / the symbols of human love and 'marital faith.' / I remember the past appeal of that symbol / when love was something indisputable, / a melody played on all the strings of the heart. / Later the strings became gradually muted / and neither of us could do anything about it."[14]

Deeply hurt by Stefan's indifference, Anna attempts to make contact with other men. When she tries to sell her wedding ring, the Jeweler responds by saying: "This ring does not weigh anything, / the needle does not move from zero / and I cannot make it show / even a milligram. / Your husband must be alive — / in which case neither of your rings, taken separately, will

11 Translation slightly modified by author.
12 Ibid., 286–88.
13 Ibid., 294, 296.
14 Ibid., 274.

weigh anything — only both together will register. / My jeweler's scales / have this peculiarity / that they weigh not the metal / but man's entire being and fate." [15]

Here we encounter the Schelerian theory of value. "Values cannot be reduced to emotion. They persist at a deeper level, which is that of conscience, even if awareness barely registers them or even denies them. It is then above all that faithfulness is necessary." [16]

Yet Anna and Stefan's waning love must live on thanks to their children. "Now they must render an account of the responsibility which they took in generating them. In order to give a reason for this responsibility they are obliged not to resign at the failure of their own love but to take it up in their hand — because if their union is stabilized in their children, it must have a human profundity and a value which their disagreements have obscured." [17]

Teresa and Andrew's son Christopher, and Anna and Stefan's daughter Monica, bear in themselves the stigma of their parents' human limitations. The children carry in them the wounds of their parents, yet in face of the pain they restore unity to the family.

Monica inherited the split of her parent's love. In consequence, her own relationship with Christopher began with fear of love. Christopher tries to heal it. Monica is afraid to love:

> And yet I am afraid, and also afraid for you. / Before that, for a long time I was afraid of you, and for myself. / Your father went away and died, and yet the union remained / — you were its spokesman, the love passed to you. / My parents live like two strangers, / the union one dreams of does not exist, / where one person wants to accept, and to give, life for you.... I was long afraid of love for this very reason. Today / I am still afraid of love, of that challenge to man. / You are taking a difficult girl, sensitive to a fault, / who easily withdraws into herself, and only with effort / breaks the circle / constantly created by her "ego." You are taking a girl / who absorbs / more than you can give, perhaps, and herself gives most sparingly. [18]

15 Ibid., 297.
16 Buttiglione, *Karol Wojtyła*, 257–58.
17 Ibid., 262.
18 Wojtyła, *The Jeweler's Shop*, in *Collected Plays*, 311, 313.

To address Monica's fears, Christopher responds: "I cannot go beyond you. One does not love a person / for his easy character. Why does one love at all?… I couldn't say. Love outdistances its object, / or approaches it so closely that it is almost lost from view…. When the wave of emotion subsides, what remains will be important. / All this is true, Monica. And do you know what gives / me most joy? / That there is so much truth in us that somehow we / read ordinary things more easily from the heart of these / exultations." [19]

Yet Monica and Christopher carry in themselves the love that their parents failed to express in their marriages. The hope for their parents' redemption lies in them, the past and the future together. Out of love for Monica, Christopher helps bring about the reconciliation of her parents. He is the one who restores faith in love and unity to Monica. In a conversation with his mother, Christopher says: "It was strange, dearest mother, the story of my love / for Monica — whom I had to win over for herself, / and also for her parents … people have their depths, not only the masks on their faces." [20]

Another important character in *The Jeweler's Shop* is the Jeweler himself. The Jeweler serves as the bond between the three couples. "The Jeweler seems to stand for Divine Providence, for the power of moral judgment…. That he does not appear on stage is consistent with Wojtyła's practice: as a rule, neither his plays nor his poetry call God by name or invoke Him directly; His presence is felt but not imposed. True, Andrew and Anna quote the Jeweler's words and describe his shop and his behavior, but for all we know he could be just an eccentric shopkeeper. In a realistic play this would certainly be the case, but not in this poetic mystery…. As with Adam, we cannot pinpoint this mysterious character with absolute (one is tempted to say physical) certainty. We do not see him — only the characters in the drama sometimes do. Thus another interpretation is possible." [21]

The protagonists run into one another in front of his store. "The jeweler's store symbolizes the sacrament of marriage and the particular gift of faith which bestows upon marriage the consciousness of a permanent and definite character without altering the fundamental dynamics of its nature. A wedding band is a ring which marks the faithfulness of the married couple and the

19 Ibid., 313.
20 Ibid., 316.
21 Taborski, Introduction to *The Jeweler's Shop*, in Wojtyła, *Collected Plays*, 271–72.

acceptance of an unknown destiny." [22] As seen above, the Jeweler himself claims: "my jeweler's scales have this peculiarity, that they weigh not the metal but man's entire being and fate." [23]

The Jeweler's reflections concern the profound complexity of human feelings, the ups and downs of those people whose character prevents them from maturing sufficiently to partake in the greatest mystery of human life, which is love. The weaving together of human beings, the incompleteness and immaturity of man, and, along with it, the desire for unity in love and an equally strong drive to separateness are all reflected in the following remark by the Jeweler: "This rift, this tangible, this ultimate depth / — this clinging, when it is so hard / to unstick heart and thought. / And in all this — freedom, / a freedom, and sometimes frenzy, / the frenzy of freedom trapped in this tangle." [24]

The Jeweler acts as a voice of conscience and wisdom, a stranger to the characters, but also a source of faith — and strength. Another mysterious character, Father Adam, seemingly extraneous or peripheral to the relationships at the center of *The Jeweler's Shop*, also plays a significant role in the drama by helping the main characters find through love "the essence of their lives." [25]

> The figure of Adam answers those who wonder how the author of the play, who never married or had a family, could delve into the problems of human love and marriage with such insight. The first act of the play refers to mountain hikes and rambles. As a priest Wojtyła used to go with young people on excursions to the country. They called him uncle. Their companion and friend, he was also an adviser and witness to their friendships, budding loves, problems. Each year during the 1950's he undertook a two-week trip to the mountains and another around the Masurian lakes, until 1958, when he became a bishop.... If Adam can be called a confessor, the Jeweler can be called the voice of conscience. A conscience is both innately human (all men should have one) and God-given.... Trying to help others, he analyzes human love with great perception, particularly when observing Anna's distress in Act 2.... Adam, a *porte-parole* for the author, here opposes purely hedonistic and self-centered love, which absorbs

22 Buttiglione, *Karol Wojtyła*, 350.
23 Taborski, Introduction to *The Jeweler's Shop*, in Wojtyła, *Collected Plays*, 298.
24 Wojtyła, *The Jeweler's Shop*, in *Collected Plays*, 289.
25 Taborski, Introduction to *The Jeweler's Shop*, op. cit., 270.

only a part of the human being.... Having thus, in an existential leap, transcended the sphere of *amor* and reached that of *caritas*, the concept expressed in St. Paul's First Epistle to the Corinthians, Adam concludes: "That, too, is the ultimate sense of your lives." Then he directly calls out the names of all six characters. After their self-realization and renewal, they must pick up the threads, start again, carry on.[26]

Father Adam plays a significant part in the drama. Adam has experienced the history of man from the inception and knows his truth. "Adam lives in sin; indeed, he is its beginning. However, because of that, he knows the truth about sin and he does not let himself be swayed by any ideology. He also knows the truth about the hope that God gave to man despite sin. Therefore, Adam tells Anna about the Lover who is about to come and tells her the parable of the wise and foolish virgins. He even lifts the veil of life for her so that she can recognize the wise bridesmaids among the people passing by."[27]

Adam is a mentor who explains for the other characters the deeper meaning of their feelings. He teaches that human love is incomplete: "Sometimes human existence seems too short for love. At other times, it is, however, the other way around: human love seems too short in relation to existence — or rather, too trivial. At any rate, every person has at his disposal an existence and a love. The problem is: How to build a sensible structure from it?... That, too, is the ultimate sense of your lives."[28] He warns against committing the sin of marital infidelity.

The Jeweler's Shop is a poetic drama, even though a few monologues contain some prose. Wojtyła also introduces a chorus into the play, similar to the choruses in Greek drama. The chorus appears twice in the play. "In their first appearance, they are witnesses to, and guests at a wedding, commenting on the action and offering a lyrical reflection on the union of two persons and its inherent dangers; in their second appearance, they function more symbolically, considering the behavior of the foolish virgins unprepared for the coming of the Bridegroom, but their reflections also relate to the particular characters in the drama."[29]

26 Taborski, Introduction to *The Jeweler's Shop*, in Wojtyła, *Collected Plays*, 270, 273, 275.
27 Buttiglione, *Karol Wojtyła*, 348.
28 Taborski, Introduction to *The Jeweler's Shop*, op. cit., 270–72.
29 Ibid., 268.

Wojtyła presents an unusual dramatic structure, "developed through interrelated monologues.... Voices emerge from nowhere and disappear into a void after uttering a remark (which usually echoes a character's thoughts); snippets of dialogue recount recollections in the minds of the main characters. The inner development in *The Jeweler's Shop* is dramatized in both past and present, as if to reflect a metaphysical perspective."[30]

The message of *The Jeweler's Shop* is clear: Love is a power that does not impose itself upon man from the outside but rather is born inside him, in his heart, as his innermost possession. In turn, Love demands a dialogue with the inner being and the truth of another person. Only this dialogue, which transcends emotion, touches upon the sphere of being that we call a vocation.

For Wojtyła, the love between a man and a woman is a fundamental value. It is virtually a "prayer" of the joined hearts of two people, who are unified through their gift to each other of their entire selves in both biological and axiological dimensions. The beloveds accompany each other's every thought. "The other becomes a way leading to fulfillment of one's own destiny. This is a way that allows me to become what I really am. Man is similar to a butterfly imprisoned in a cocoon. He is freed only through the experience of love. Meeting another person allows that to become apparent which was contained in the subject, that of which he was unaware himself. He who never experienced such a meeting will die without having emerged from his cocoon. Thus, he shall never fully realize his greatness."[31]

A marriage that grows out of love and destiny, and realizes itself on the road to vocation, is the meeting and subsequent interior transformation of persons. Marriage is the reality of two people; at the same time, it is that "human experience which causes God to be understood by man."[32]

The Jeweler's Shop is a study of the phenomenon of love, and at the same time a reflection on despair and bitterness. It is a philosophical work displaying Karol Wojtyła's great faith in man and in that love which is a good accessible to everyone. The play reflects a hope that one day we will see the true face of love and hear the voice of transcendent Love. Wojtyła invites us all to experience true love, remembering that "love is not an adventure.

30 Ibid., 269.

31 S. Grygiel, *L'uomo visto dalla Vistola* [Man Seen from the Vistula] (Bologna: CSEO, 1978), 48.

32 Buttiglione, *Karol Wojtyła*, 358.

It has the taste of a complete human being. It has the weight of his kind and the weight of his entire fate. It cannot be but a moment. Man's eternity passes through it." 33

33 Wojtyła, *The Jeweler's Shop*, in *Collected Plays*, 303.

Radiation of Fatherhood

IN MAY 1964, KAROL WOJTYŁA PUBLISHED A SHORT POEM entitled "Reflection on Fatherhood," under the pseudonym A. J. (Andrzej Jawień). In November 1979, a longer work on the same theme appeared: the play *Radiation of Fatherhood*.

The play was subtitled *A Mystery*—a term with both theatrical and theological connotations. According to Polish theologian Józef Tischner,

> This text grew out of Christian inspiration, and the tradition of Christian thinking deeply permeates it. In this tradition we find the central idea of this work: that of the *Highest Interaction,* the basis of and model for all human interaction. It is the idea of *one triune God.* What is He? A divine interaction of Persons.... According to the Christian faith man was created in God's image and likeness. So there must be in man a reflection of the Holy Trinity. Where can this be found? In his capacity for creative interaction. Here we come across the key principle of St. Augustine's thought: in order to understand man, one must look at him through God; and to come nearer to the mystery of God, one must take a good look at man. Understanding is moving along a circle. And the ultimate meaning of the radiation of fatherhood is that fatherhood creates man and enables him to understand himself.... The work attempts to lead us to the origins of all human drama rather than to a particular drama, although its point of departure is a particular drama, even a tragedy. *Arche*-drama works on three levels. The highest level, shown to us at the very end [of the play], can be called the level of religious revelation of the mystery of one triune God. The next level is that of the first and third parts [of the play], which frame the central part. This level can be called the level of faith.... The third part presents the drama of a child

who has lost her father but has found an adoptive father, so that she can be his child although she is not his child. [1]

For Tischner, the key to Wojtyła's work

> is the idea of the creative interaction of persons [which] can be expressed as follows: Thanks to you I become myself, and thanks to me you become yourself. The experience of creative interaction is mysterious. I know that alone I am myself. I know that alone you are yourself. Each of us lived for himself even before we met. Yet we could not be ourselves without each other. Fatherhood and motherhood are good examples here. The father has a right to say, I am father. And the mother has the right to say, I am mother. But the mother becomes a mother thanks to the father; they give birth to each other.... In the creative interaction of persons lies the nucleus of a drama. One could argue that all dramas in the world describe the courses of interaction — the creative and the destructive. [2]

Radiation of Fatherhood is a continued reflection upon the themes of *The Jeweler's Shop*. It takes up fundamental concerns of human existence: loneliness, fatherhood, motherhood, and opening up to others. The play concentrates on the inner life of its characters, to the point that the outside action almost entirely disappears. It is the drama of a man who overcomes his loneliness by opening himself up to marriage as such rather than through fatherhood and motherhood.

The play is universally considered to be one of the most difficult yet also most important works of Karol Wojtyła. Critics disagree, however, about the nature of the work's form and character. According to Zofia Zarębianka, Wojtyła "essentially introduces a totally new form, outside the conventions both of Kotlarczyk's theater of the word, and of his inner drama." [3] Wojtyła's "inner drama" is unique, reaching beyond the Rhapsodic Theater, because it "creates its own dramatic reality": "The world of external events is not so

1 J. Tischner, "Radiation of Creative Interaction," bulletin to the play *Radiation of Fatherhood* at the Rozmaitości Theatre (Warsaw, June 1983), 14.

2 Ibid., 16.

3 Z. Zarębianka, "Dojrzewanie do śmierci, dojrzewanie do ojcostwa w poetyckiej antropologii Karola Wojtyły" [Maturing into Death and Maturing into Fatherhood in the Poetic Anthropology of Karol Wojtyła], in Zarębianka and Machniak, *Przestrzeń Słowa* [Expanse of the Word], 326.

much expressed by the dramatist directly as absorbed into the 'inner space', the psychological space, of the protagonist, where it exists timelessly, in projections into the past or future (that is, in the memory of the hero or in his prophecies), supported by the author's knowledge of history, or even theology." [4]

Zygmunt Solski argues that "at the level of form, the drama takes on the appearance of a hybrid.... *Radiation of Fatherhood* is a clear turn to the form of 'mystery drama,' which Wojtyła himself invoked by putting the word *Mystery* in the subtitle.... He employed here a montage of parallel scenes connected to one another by ranks, as was the practice in medieval mystery plays. However, the author produced a text without any use of epic style and with the number of scenes and actors reduced to a bare minimum." [5] Krzysztof Dybciak has argued that the play eludes easy theoretical categorization even at the level of literary genre: "The text must be placed on the boundary between literature and discourse, for it contains many developed ethical musings, and even linguistic ones, such as lengthy inquiries into the meaning of the word *mine*.... Aside from the theological and philosophical discourses, it is full of aphorisms, which given their poetic value we might better call 'aphoristic metaphors.'" [6]

A quotation from the First Epistle of Saint John the Apostle about the mutual witness of the Father, the Word, and the Holy Spirit prefaces the work and reminds us that here we are faced with a mystery play. The protagonist calls himself Adam. This is the name of the first man, the first sinner, and also that of one of the main characters of *The Jeweler's Shop*, indicating that the work concerns the universal reality that touches every person.

The protagonist ponders himself and his life. "Adam desired to resemble God in terms of power. This is an obvious parallel to Promethean Marxist atheism and the Marxist vision of human *praxis* as a way of manipulating nature and subordinating it to oneself. Man has achieved a great deal of success here, but at the end it proved insufficient. Further, the success led him to create a false image of God." [7]

At the beginning of the first act, Adam declares himself an everyman figure. "All this is connected with the name Adam given to me. Through this

4 Taborski, Introduction to Wojtyła, *Collected Plays*, 16.
5 Z. W. Solski, "Ojcostwo i tożsamość" [Fatherhood and Identity], in Zarębianka and Machniak, *Przestrzeń Słowa* [Expanse of the Word], 338, 342, 341.
6 Dybciak, *Karol Wojtyła a literatura* [Karol Wojtyła and Literature], 101.
7 Buttiglione, *Karol Wojtyła*, 360.

name I must encounter every man; at the same time everything in this name that every man contributes can be made commonplace or even be devalued. I have a difficult name."[8] Adam dwells outside himself and simultaneously reaches into his personhood.

In solitude, Adam discovers in himself the experience of fatherhood. In his fatherhood, he resembles God the Father, but he feels lonely in his fatherhood. Adam failed, however, to handle the task assigned him by the Lord; he declined his responsibility. He discarded the mystery of the "radiation of fatherhood" and entered the way of loneliness, committing at the same time the sin born out of distrust of God. There remained only his ego, his "I," and a desire to possess everything through himself, while forgetting God Who is the Giver of life. The Lord, however, despite his sin of egoism, restores him to the dignity of human fatherhood. "You enter into what I call loneliness, and You overcome my resistance. Can one say that You force Your way in or only that You enter through a door that is open anyway?"[9] God enters man, who is tainted by sin. And at the same time He shapes him through love, because only this makes man able to love. Love is thus a sign of God's presence in the human soul.

For Wojtyła, fatherhood is an experience of God's love in us. The Lord reaches the heart of the male precisely through a child and breaks down his loneliness. "You want me to love. You aim at me through a child, through a tiny daughter or son—and my resistance weakens."[10] It is the child who frees in the man the ability to love and thereby restores the image of the Lord in him.

Toward the end of Act One we meet Mother. She is a sign of hope within a hopeless situation of sin, loneliness, and suffering. She knows the mysteries of human existence through her motherhood. "A woman knows infinitely more about giving birth than a man."[11] Her motherhood constitutes an expression of fatherhood as well, for without the father it would be impossible to conceive the child: "Still, motherhood is an expression of fatherhood. It must always go back to the father to take from him all that it expresses. In this consists the radiation of fatherhood."[12] Thus the child points to the father, through whom the woman enters into her motherhood.

8 Wojtyła, *Radiation of Fatherhood*, in *Collected Plays*, 335.
9 Ibid., 338.
10 Ibid.
11 Ibid., 340.
12 Ibid., 341.

Act Two of *Radiation of Fatherhood* is entitled "The Experience of the Child." Here, a young woman named Monica relates her experience of her father — Adam. The origins disappear in the past of a little girl who does not remember her earliest childhood. She knows her father largely through her mother's recollections of him. For Monica, her father and mother are like two trunks of one tree, tightly woven together.

In the child's heart a love grows toward her father. The longer he remains absent, the more powerful his daughter's love becomes. Monica creates a mental image that expresses her yearning for him. The experience of the father and the experience of the child converge during a journey in a forest, where a danger meets the child on the road: a snake. Adam is passing by and thinks he must protect the child. A feeling of paternal responsibility, care, love, and affection surfaces. At first the snake scares Monica, but the thought that her father is standing beside her calms the girl down. Her father becomes present in her through her sense of security. She ceases to be afraid. Next, Monica submerges her feet in a stream and muses on the mystery of life. "I am putting my feet in the water. What a soothing coolness, / what freshness, what rebirth! / Life enters anew into all my cells. / Ah, as I am being born anew from this forest stream, / I ask: Be water for me! / I ask: Be water for me!"[13] Water is the symbol of life and, simultaneously, of a new birth for Monica.

Act Two ends with the confession of a happy girl who calls Adam her father: "I feel, I feel my body anew and my soul! / You took me by the hand then / and guided me."[14] It seems that Adam and Monica have matured into their roles and found fulfillment in them.

Act Three is entitled "Mother." It is identical in form to Act One. The character Mother is a symbol of all mothers. She reminds us of the hardships of motherhood, the pain of childbirth, the challenges of parenting, and the worries that appear with the coming of new life. Mother replaces Adam here as the main protagonist. Mother is a somewhat mythical person who in various ways represents Eve, Mary, and the Church. Mother complements fatherhood through motherhood. She is aware that man is suspended between love and solitude. Whereas love opens man up to another, loneliness locks him up within itself. Woman — and so wife and mother — enters the world with a mission. "When I give birth to children, they are not only mine but

13 Ibid., 350.
14 Ibid., 359–60.

also his. Thus I restore to him at least a shadow of the fatherhood that he has renounced from the beginning, unable to renounce it altogether." [15]

Mother concentrates in herself a "love stronger than loneliness," [16] and this love constantly offers to restore fatherhood to Adam. Adam, however, chooses solitude, "to remain himself and not to be anyone else." He speaks to God: "Yes, it could happen in the end that You will put aside our world. You may let it crumble around us and, above all else, in us; then it will transpire that You remain whole only in the Son, and He in You, and whole with Him in Your Love. Father and Bridegroom. And everything else will then turn out to be unimportant and inessential except this: father, child, and love." [17] Thus the play concerns divine fatherhood as much as human fatherhood.

Radiation of Fatherhood is the work of a great philosopher and theologian, and a gifted artist. "It is a treatise but also a modern mystery drama that demonstrates, through profound reflection, through poetry, and through unusual theatrical means, the drama of human existence, a dilemma of today's man, 'exiled from his deeper personality yet condemned to probe it.'" [18]

15 Ibid., 361.
16 Ibid., 360.
17 Ibid., 364.
18 Taborski, Introduction to *Radiation of Fatherhood*, in Wojtyła, *Collected Plays*, 331.

Pope John Paul II as Writer: An Appreciation

by Krzysztof Dybciak

In artistic creativity, more than in any other endeavor, a human being reveals himself to be "in God's image" and fulfills this role, above all, by shaping the wondrous "matter" of his own humanity and, consequently, exercising the creator's dominion over the world that surrounds him. The Divine Artist, in showing the human artist his gracious indulgence, lends him His spark of transcendental wisdom and calls him to partake of His creative power.

Letter of his Holiness Pope John Paul II to Artists (1999)

CHRONOLOGICALLY, KAROL WOJTYŁA WAS FIRST A WRITER, then a Catholic priest, and finally the pope. Without his writings in a variety of literary forms and styles, from poetry and drama to sermons and philosophical and theological treatises, he would not have become the head of the Catholic Church. Had he not been elected as successor to Saint Peter, his writings would have remained unknown outside of Poland—but most of all, his works would have been ineffective, archaic, even idiosyncratic. Karol Wojtyła's originality as a writer derived from his courage in giving literature a sense of higher purpose. He possessed the intellectual audacity to reject the minimalist paradigms of creativity in vogue throughout his life. On the contrary, he invoked the great Biblical and Christian tradition, the Word Incarnate and transubstantiated: transformative for man, local communities, and humanity at large. This is the tradition of the Old Testament prophets and, in modern times, of the Romantics, in particular the Polish Romantics.

He understood the role of the writer (in accord with the views of his literary countrymen) as that of a servant of the Word and revealer of ultimate truths, which are fundamentally transcendental. According to Wojtyła, a contemporary poet, playwright, or novelist ought to be an anthropological conduit of the Divine Voice, a discoverer of living, eternal, and non-relative truths. He subscribed to such an aesthetics and philosophy of literature from his college days, and treated his election as successor of Saint Peter in 1978 as a chance to promote his personal model for literature and other arts. This was an opportunity to act through signs (not only verbal ones: he was, after all, a man of the theater), to give witness of the truth of Christianity, to transform contemporary people and to bring them nearer to Christ.

Wojtyła proposed an account of the task of an author utterly at odds with that generally advanced in 20th-century academia. According to the avant-garde artistic theories and practices that dominated the last century, the writer is meant to experiment with a variety of verbal forms, analyze psychological matters, and serve as social critic and supporter of socio-economic or cultural revolution. But Wojtyła ascribed different functions to a writer — his were ancient, for they reached back to the times of the prophets, and yet remained necessary at the turn of the 20th century. His poetry and drama were ascetic in their formal modesty. They were contemplative, almost prose-like in form, and reflective of religious and anthropological experiences rather than being self-absorbed.

Yet this turn away from aesthetic refinement, ornamentation, and subjectivism did not diminish the literary ambitions reflected in these works. On the contrary, in the context of artistic tendencies of the second half of the 20th century — tendencies that gradually morphed into the reign of postmodernism — the purpose of John Paul II's writings ran deeper, for he was successor to the prophets and Romantics. He drew also from the deeper cultural tradition of the West by developing in an original way the concept that the nations of Europe's eastern borderlands comprise the *Antemurale Christianitatis*, or the bulwark of Christendom, a buffer protecting the West from the destructive influences of nihilistic forces pushing into Europe across the continent's eastern borders — be they the Mongols or the Ottomans. For centuries Poland identified itself with that role. With Soviet communism threatening the Western values of modern Christendom, Wojtyła, together with Stefan Cardinal Wyszyński (known in his native Poland as the Primate

of the Millennium) saw the need for Poland to continue as a cultural defender of Euro-American civilization against the offensive of totalitarian Russian communism and an internationalist liberal and libertine nihilism. These two Polish thinkers, both also princes of the Catholic Church, transformed and redefined the nature of a traditional defensive program: their new campaign designed to protect Western Civilization had neither a military nor an economic dimension. Instead, the defense was to be cultural, the front line running through the world of spiritual values and symbols. In this way Wojtyła not only modernized the concept of cultural defense but updated the philosophy of Polish Messianism, in which one nation played the role of a savior among nations, analogous to Christ. The ideology of Messianism proclaimed the intrinsic value of a nation tasked, not with special privileges, but with responsibilities: fighting for freedom, serving universal values, and sacrificing for the good of mankind — in solidarity with other nations and not, as often happens, for the sake of expansion and domination over other peoples. It is no surprise, then, that the Polish pope introduced into contemporary Catholic thought the idea of national theology, which he unveiled in the last book he published during his lifetime, *Memory and Identity.*

John Paul II tried to create universal sacral signs, and even to become a sign himself. He quite consciously sought to add a symbolic dimension to all his endeavors. His gestures became part of his idiom. For example, he would kiss the ground immediately upon disembarking from his plane. During audiences at the Vatican, he would shake hands with people from all over the world, making sure his gestures were as clear as possible and his non-verbal communications universally meaningful. He celebrated the liturgy with a singular appreciation for the theatricality of the ritual and felt at ease with millions of people in attendance. In keeping with the realism of Christian philosophy, he tried to infuse the body with meaning, so that it would communicate spiritual truth. After all, if we were created "in God's image," the body of each human being, even the weakest of men, bears the stamp of his Creator. Such an understanding must have informed his decision as an elderly pope not to conceal the afflictions of old age, bearing witness to Christian and humanistic values and to the merit of offering one's sufferings for one's neighbor and the Church. For him, the process of dying and death itself represented not only the disintegration of human matter but also our return to the home of our Heavenly Father, a faith-filled immersion into eternity.

Restoring dignity to the human body as well as filling all aspects of the individual human life with significance was, then, the essence of John Paul II's artistic originality. While he strove to deepen the art of the word, he wished also to bring *life* closer to the word, to bring prosaic reality closer to literature by imbuing all human existence with deeper meaning. This artistic tendency stems from Romanticism, Polish Romanticism in particular. Let us recall what the great poet and Christian thinker Adam Mickiewicz wrote in his *Lectures on Slavic Literature*:

> Jesus Christ is not a creator of any doctrine or of any legislation in the ordinary sense of the word; he did not establish any system.... To his faithful, he gave something more real, positive, and at the same time more demanding, and that is his person, his life, and his history.... That spirit, which works, which rises, and which eternally seeks God, receives, through this same higher light, the so-called word; and the man who has received it becomes a revealer. It is not a system, then, that appears before man's eyes, but — as we have said — the word.... This divine light, which needs but a single man to reveal itself, later develops, for it is a living word; it develops into systems, schools, and, above all, deeds.[1]

And so the written word comes to life in the actions it inspires — literature becomes incarnated in human deeds.

In his poetry and prose, John Paul II invites his reader to join him in discovering certain values. This artistic and philosophical attitude allows the author to move beyond the derision and destructiveness of the often grotesque styles and forms so pervasive in the second half of the 20th century. The elevated style and noble attitude of the moralist differentiated Karol Wojtyła particularly from the purveyors of postmodern "coolness," programmatic superficiality, alienation of artistic language from reality, and the pursuit of entertainment above all else — or as one social critic put it, "amusing ourselves to death."

The notion of a contemporary imitation of Biblical prophets or "bards" of Polish Romanticism might seem an archaic fantasy, incompatible with modern civilization. And yet there is a powerful piece of evidence that John Paul II's art of the word (and *Word*) is not only theoretically compelling, but also of great

1 A. Mickiewicz, *Literatura słowiańska*, kurs trzeci [Paris 1843], in *Dzieła. Wydanie Rocznicowe* [*Slavic Literature*, third course, in *Anniversary edition*], vol. 10 (Warsaw: *Czytelnik*, 1998), 18, 162–63.

practical value. That evidence is the history of Europe throughout the latter part of the 20th century, with its great developments that influenced the global situation and indirectly reverberated in both the Americas and Asia. None of the sober-thinking historians, or the millions of ordinary participants in the great social events of East-Central Europe and north and central Asia, doubts that the Polish pope was one of the individuals most responsible for the fall of the totalitarian-atheistic communist system. The collapse of the Soviet empire occurred mostly through peaceful means, the power of the Word. It was the ideas and values of the free world, with their chiefly Christian or otherwise religious roots, that determined this breakthrough in the life of a multitude of nations. And it was John Paul II who was the great herald of the Word that transformed man and liberated him from both temporal and eschatological dangers.

Unfortunately, the relevance of John Paul II to more recent global transformations is less obvious, precisely because the power of the Word, indeed of any word, is being questioned. Like values, words fall prey to relativist reinterpretation: clarity of meaning is being lost and truth becomes obfuscated. Commenting on the mass media and the role of the Church in society, John Paul II stated in his characteristically elevated yet personal style: "The Church, because it respects the truth, must point out that the mass media may twist the truth and destroy hope.... It is hard for us to imagine the employees of the media torn away from their own cultural foundation. A man who works in this field must serve in a most objective way, without transforming himself into a hidden purveyor of depravity driven by the interests of a group, conformism, or the desire for profit."

John Paul II's personalism brought unique qualities to the realm of dialogue with the creators of postmodern civilization. This personalism took on the role of a defensive strategy aiming to resist the tendency to reduce man to a consumer of images and banal messages. It defended the truth of created and supernatural reality against the onslaught of fictitious images. The Holy Father urged individuals to cultivate the ability to choose in order to develop spiritual resilience against the pressure of the nihilistic commercial media. He stressed the need to resist pernicious ideological trends and draw instead from the traditions of humanity's great cultural and religious heritage. It is worth noting here that these warnings about contemporary social communication technologies did not come from a technically unsavvy Luddite. On the contrary, John Paul II was the first pope to appreciate and take advantage

of modern means of communication in his missionary work — which he did nimbly and energetically.

* * *

John Paul II had much to say also about the economy, which he called to be free of exploitation or envy within what he referred to as the "Civilization of Love." Anchoring himself on the philosophical and theological foundation of a commitment to the freedom and activity of the human person, the Holy Father stressed the value of the right to private property, the free market, entrepreneurship, and the virtues of diligence and frugality. Nor did he forget about justice and care for the poor, even if he kept his distance from Marxist and post-Marxist ideologies of total equality to be achieved through violence — the dictatorship of the proletariat. He knew the experience of real communism too well. [2] The pope especially disdained its materialism, which failed to appreciate the spiritual dimension of labor. Already in his poem "The Quarry" (1956), Wojtyła displayed a profound grasp of this issue. Thirty years later he would discuss this question at length in Gdańsk, the birthplace of the free and democratic labor movement Solidarity: "Labor cannot be treated — ever or anywhere — as a commodity because man cannot be a commodity for another man; he must be a subject. He enters labor through his entire humanity and his entire personhood.... Indeed, as a person he is not only a 'laborer' but also a co-creator of the masterpiece formed at the work-station."

Only an artist or a writer could conceive even physical labor as co-creating a masterpiece, or take notice of the creative elements in all honest human activity. As a creative endeavor, labor endows every human being with the capacity to partake of divine creation. John Paul II's *Letter to Artists*, then, is not really addressed to painters, sculptors, composers, or fellow writers but to all who shape "the wondrous matter of [their] own humanity." It also serves as a reminder of the dignity of man derived from being made in God's image. And so every human person, however humble, can open up to that "spark of transcendental wisdom" that God lends man when he "calls him to partake of His creative power," be it in a quarry or a writer's study.

2 The social views of John Paul II are presented in his encyclicals *Laborem exercens* (1981), *Sollicitudo rei socialis* (1987), and *Centesimus annus* (1991), and in his last book, *Memory and Identity*.

INDEX OF PROPER NAMES

ABOUT THE AUTHOR

MONIKA JABLONSKA is an entrepreneur, lawyer, consultant, and business executive. She is currently working on her PhD dissertation, on social business. At the United Nations Conference on Sustainable Development in Rio de Janeiro in 2012, Monika launched her own social business called Nurture the World to feed hungry children around the world. She runs projects in the USA, Brazil, and Europe. In 2015, she received a Special Recognition Award from the American Institute of Polish Culture in Miami for her Nurture the World project. Monika was also nominated for Businesswoman of the Year in 2016. *Wind from Heaven* has previously been published in Poland, Brazil, and Colombia.

Made in the USA
San Bernardino, CA
06 March 2018